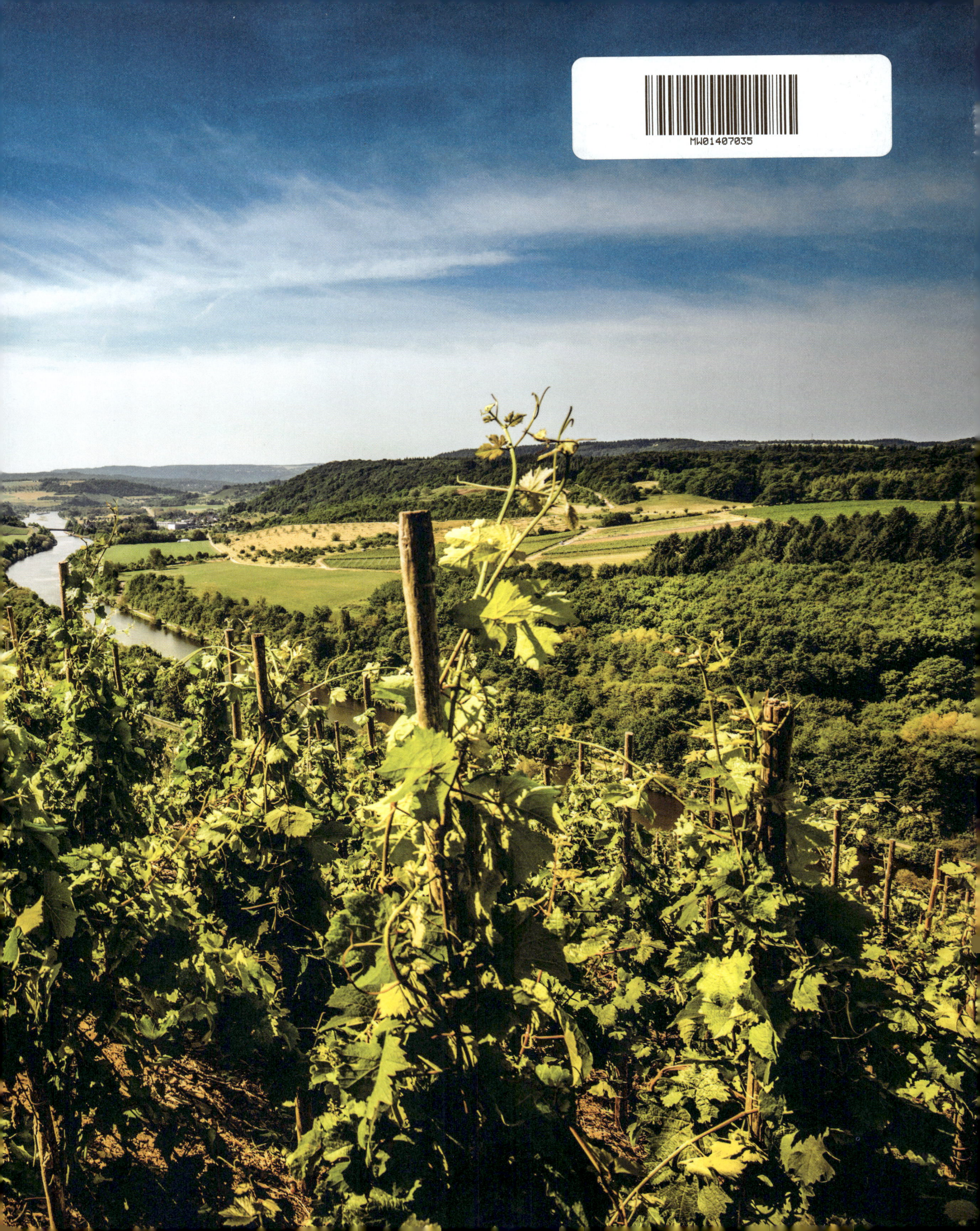

GERMANY

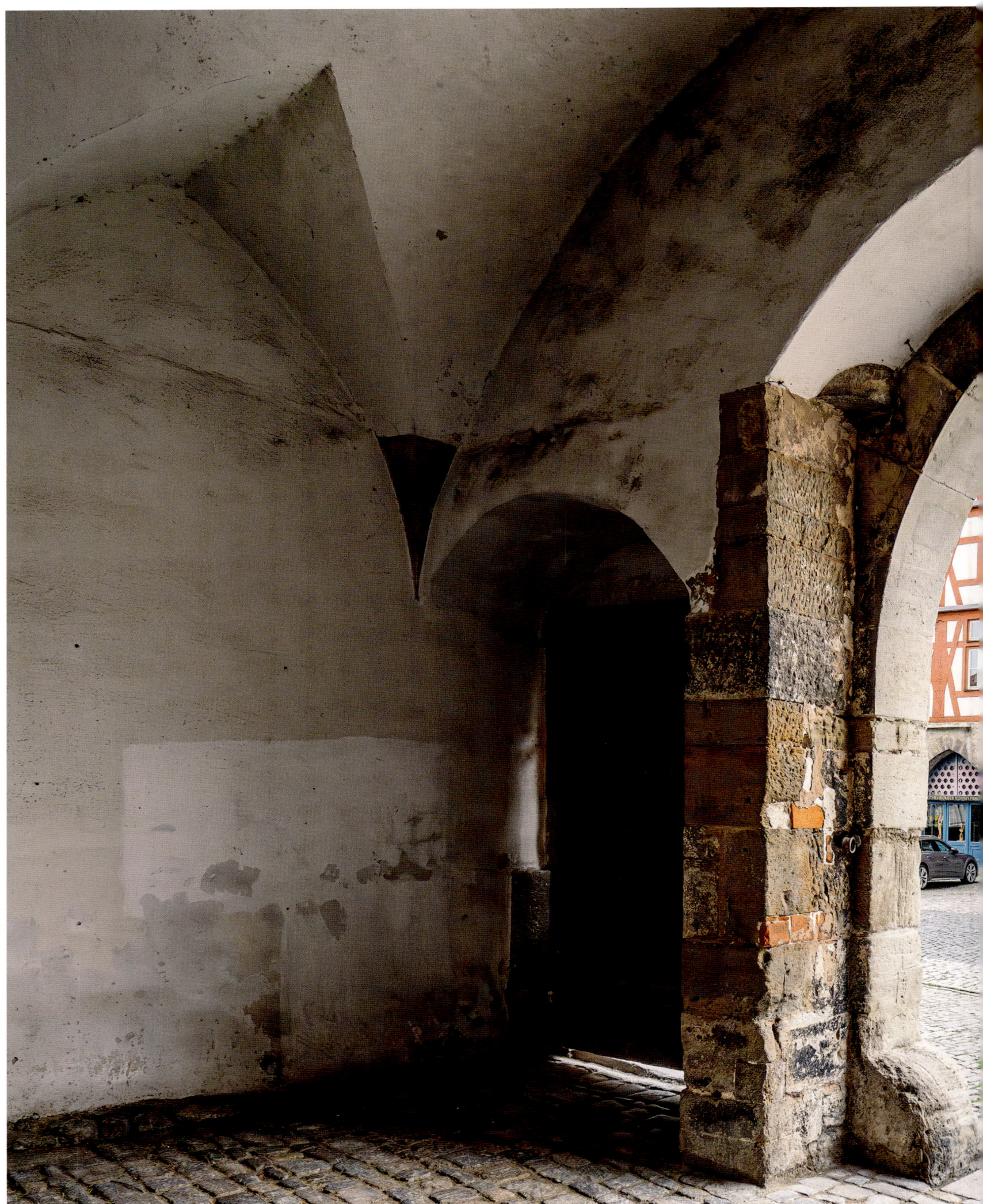

Angelika Taschen

GREAT ESCAPES GERMANY

THE HOTEL BOOK

TASCHEN

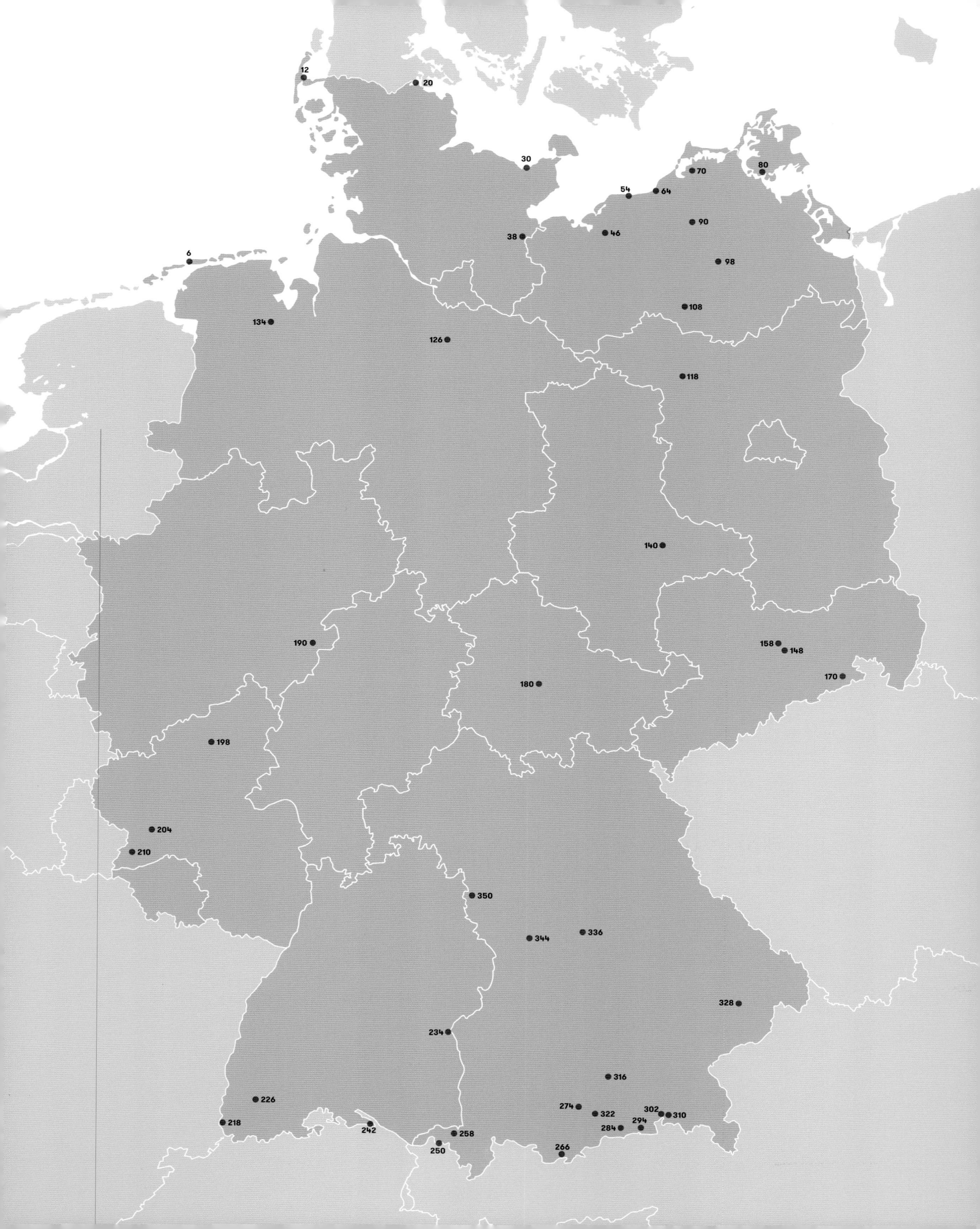

CONTENTS

NIEDERSACHSEN
6 *Seesteg Norderney*, Norderney, Nordsee

SCHLESWIG-HOLSTEIN
12 *Severin's Resort & Spa*, Keitum, Sylt, Nordsee
20 *Aarskogs Boutique Hotel*, Glücksburg, Ostsee
30 *Weissenhaus Private Nature Luxury Resort*, Weißenhaus, Ostsee
38 *Die Reederin*, Hansestadt Lübeck

MECKLENBURG-VORPOMMERN
46 *Seehotel am Neuklostersee*, Nakenstorf
54 *Grand Hotel Heiligendamm*, Bad Doberan, Ostsee
64 *Hotel Neptun*, Rostock-Warnemünde, Ostsee
70 *Kranich Museum & Hotel*, Hessenburg/Saal
80 *Gut Üselitz*, Poseritz, Rügen, Ostsee
90 *Gutshaus Rensow*, Rensow
98 *Glamping im Gutspark*, Malchin, Mecklenburgische Seenplatte
108 *St. Oberholz Retreat*, Leizen, Mecklenburgische Seenplatte

BRANDENBURG
118 *St. Oak*, Kyritz

NIEDERSACHSEN
126 *Stimbekhof*, Bispingen, Lüneburger Heide
134 *Resort Baumgeflüster*, Bad Zwischenahn

SACHSEN-ANHALT
140 *Bauhaus Dessau Atelierhaus*, Dessau-Roßlau

SACHSEN
148 *Hotel Villa Sorgenfrei*, Radebeul
158 *Burgkeller Meißen*, Meißen
170 *Schloss Prossen*, Bad Schandau, Sächsische Schweiz

THÜRINGEN
180 *Hotel Stadthaus Arnstadt*, Arnstadt

NORDRHEIN-WESTFALEN
190 *Waldhaus Ohlenbach*, Schmallenberg-Ohlenbach, Sauerland

RHEINLAND-PFALZ
198 *Purs*, Andernach am Rhein
204 *WeinKulturgut Longen-Schlöder*, Longuich an der Mosel
210 *Gut Cantzheim*, Kanzem an der Saar

BADEN-WÜRTTEMBERG
218 *Le Rossignol*, Blansingen, Efringen-Kirchen
226 *Spielweg*, Münstertal, Schwarzwald
234 *Hotel Schiefes Haus Ulm*, Ulm
242 *Zum Egle 1336*, Konstanz, Bodensee

BAYERN
250 *Alpenloge*, Scheffau, Allgäu
258 *Ansitz Hohenegg*, Grünenbach, Allgäu
266 *Schloss Elmau*, Elmau bei Krün
274 *Kloster Beuerberg*, Eurasburg
284 *Berghotel Altes Wallberghaus*, Rottach-Egern
294 *Tannerhof*, Bayrischzell
302 *Gasthof Alpenrose*, Samerberg
310 *Stubn in der Frasdorfer Hütte*, Frasdorf
316 *Gut Sonnenhausen*, Glonn
322 *Gasthof Zantl*, Bad Tölz
328 *Hofgut Hafnerleiten*, Bad Birnbach
336 *Engelwirt Apartments*, Berching
344 *Gasthof Gentner*, Gnotzheim, Franken
350 *Romantik Hotel Markusturm*, Rothenburg ob der Tauber, Franken

358 Photo Credits
360 Imprint

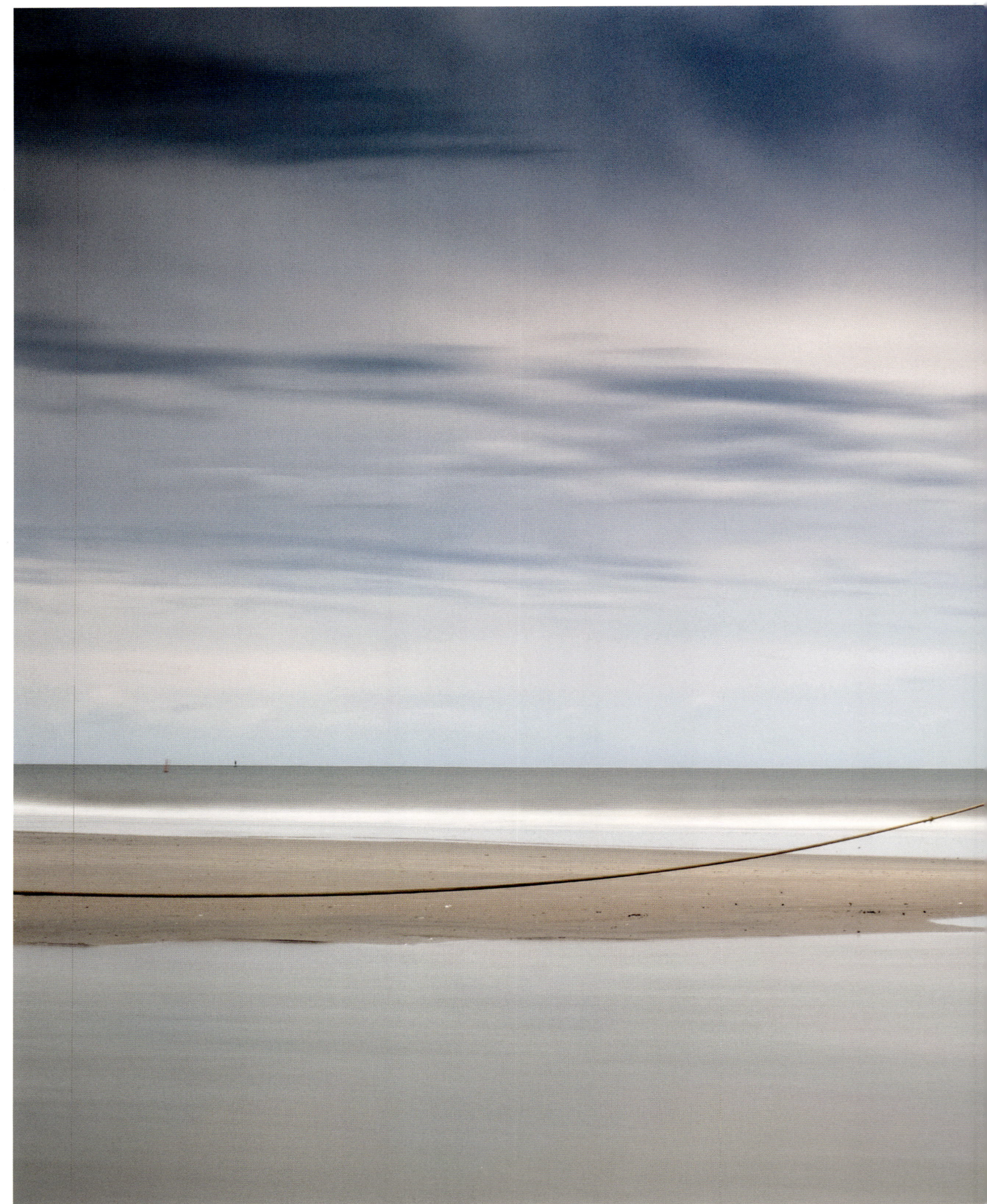

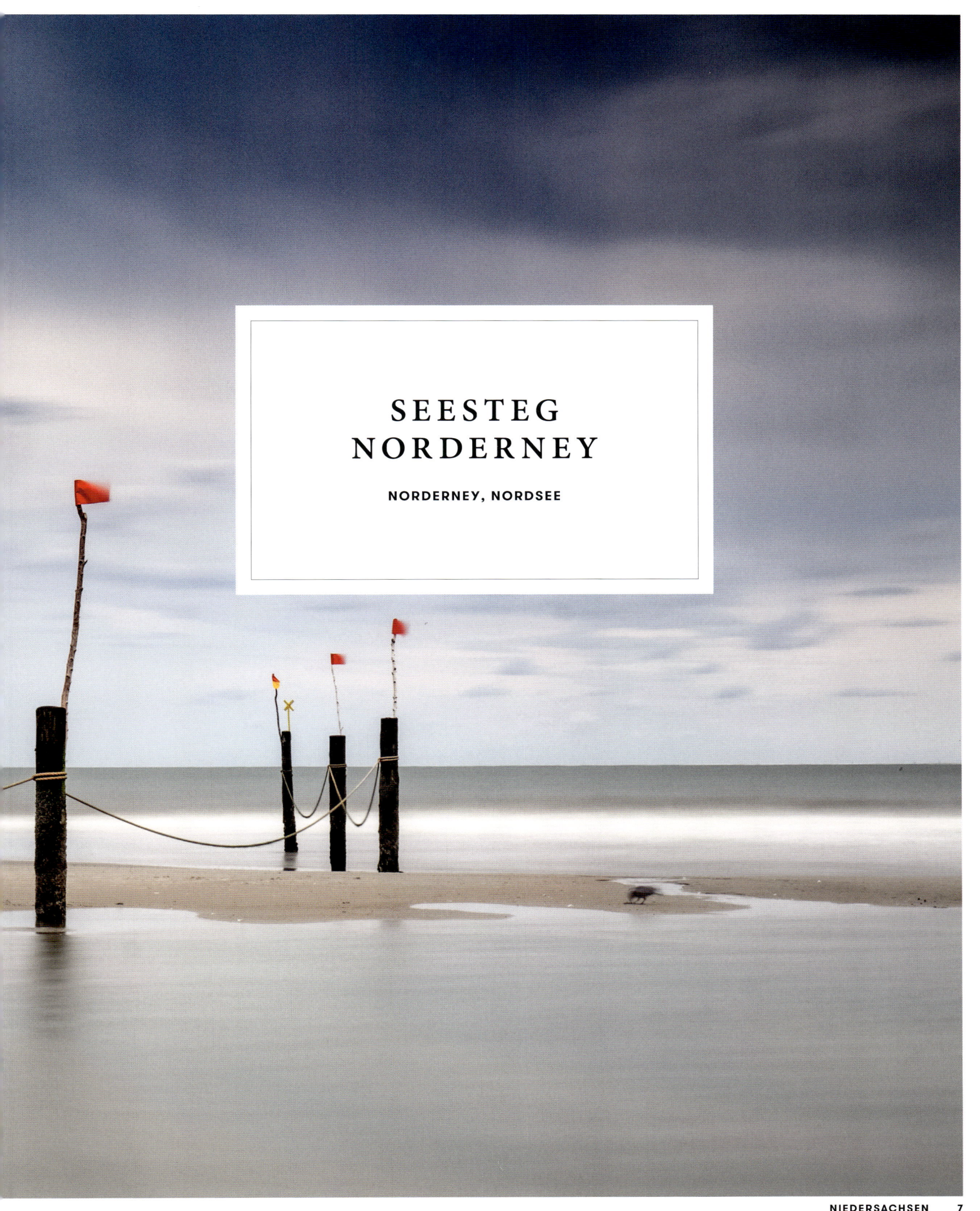

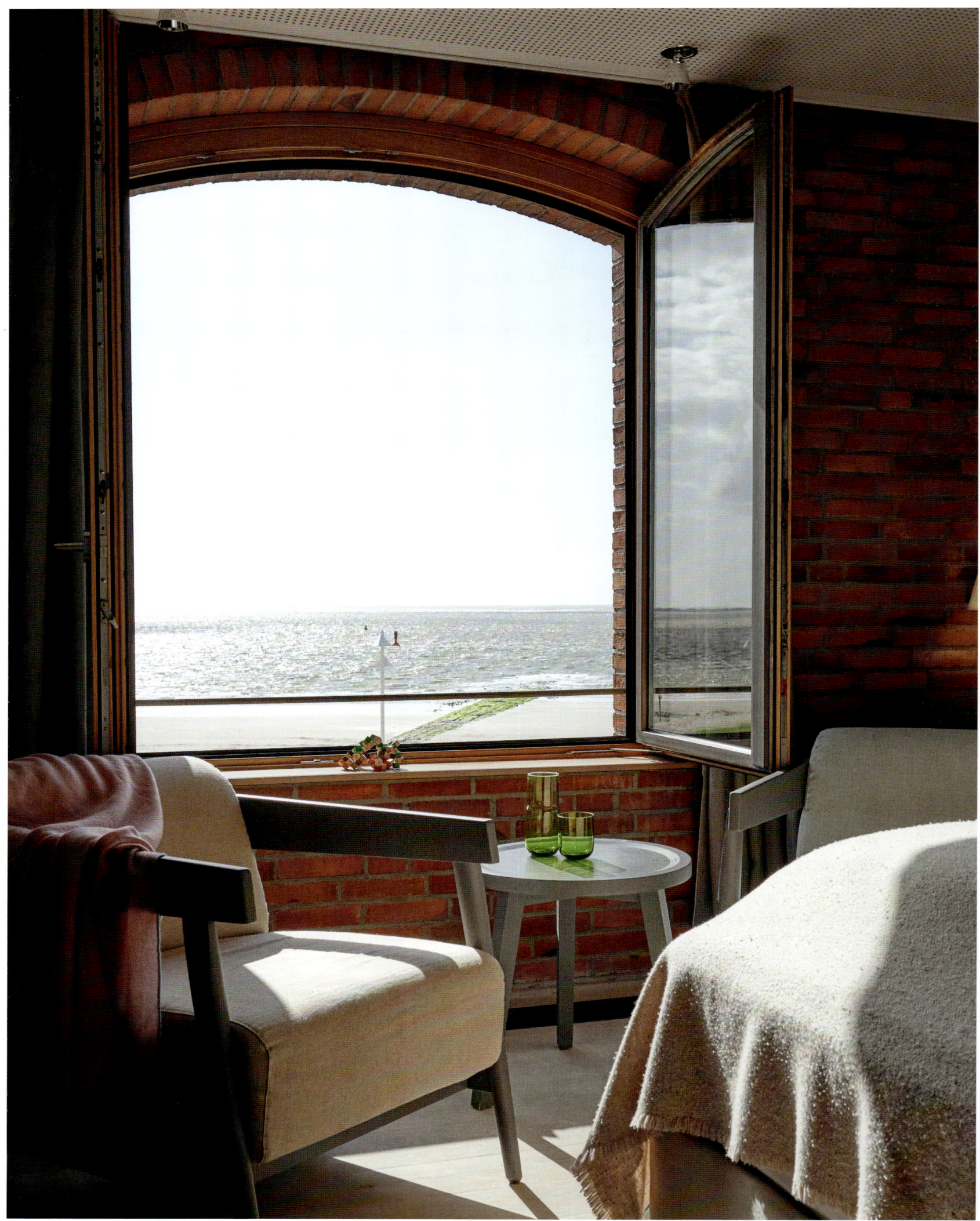

NIEDERSACHSEN

SEESTEG NORDERNEY

Damenpfad 36a, 26548 Norderney
Tel. +49 4932 893 600 · empfang@seesteg-norderney.de
www.seesteg-norderney.de

LOVE OF THE ISLAND

In the past, aristocrats and industrialists took their holidays in the fashionable seaside resort of Norderney, and Reich Chancellor von Bülow had a summer residence there. The long Steesteg Norderney building was a storehouse at that time: the wooden boards of the pier and the beach basket-seats of the island were kept here during the stormy winter. When the brothers Marc and Jens Brune, an architect and a hotelier, bought the storehouse, they aimed to retain its characteristic red façade and replaced its masonry, porous and impregnated with salt, with 60,000 hand-made bricks. The old boards were put to new use as wall paneling, and the owners placed a modern, set-back story with glass fronts and a rooftop pool onto the historic section of the building. The swimming pool and the guest rooms command a view far out over the North Sea (the penthouses with their own balconies and the lofts with high ceilings and direct access to the sea are especially sought-after). The relaxed and elegant atmosphere of the rooms is matched in the restaurant, proud possessor of a Michelin star for some years now, and thanks to its terrace and lounge with open fire perfectly equipped for the East Frisian weather, which is known to change hour by hour. The hotel staff, experts at spontaneously adapting leisure plans according to the weather, organize yoga sessions or walks over the sands, sailing trips or flights around the island. Back at the Seesteg, guests can then book a spa treatment using marine treasures – the sea-salt peeling and the salt-ball massage are very soothing. ◆ Book to pack: "Selected Verse" by Heinrich Heine, who spent the summers of 1825 and 1826 on Norderney

DIRECTIONS *By the beach in the far west of Norderney. The ferry to the island from Norddeich takes 1 hour (it is best to leave cars on the mainland, as driving is not permitted on Norderney) and light aircraft fly there from nearby airports such as Hamburg* · **RATES** *€€€–€€€€* · **ROOMS** *18 rooms and suites* · **FOOD** *Breakfast à la carte. For lunch and dinner, excellent dishes inspired by the island and fine wines are served* · **HISTORY** *The storehouse was built in 1895. The present owners bought it at the end of 2006 and opened the luxury hotel in 2007. In 2024 two more suites were added* · **X-FACTOR** *A successful blend of past and present*

INSELLIEBE

Früher urlaubten in dem mondänen Seebad Norderney Industrie und Adel, Reichskanzler von Bülow hatte hier eine Sommerresidenz. Der lang gezogene Bau des Steestegs Norderney diente damals als Lagerhalle: In stürmischen Wintern wurden hier die Holzbohlen der Seebrücke und die Strandkörbe der Insel aufbewahrt. Als die Brüder Marc und Jens Brune die Halle kauften, wollten der Architekt und der Hotelier dessen charakteristische rote Fassade bewahren und ersetzten die salzdurchtränkten, porösen Steine durch 60 000 handgefertigte Klinker. Die alten Bohlen fanden als Wandverkleidung neue Verwendung, und auf den historischen Teil des Gebäudes platzierten die Eigentümer ein modernes Staffelgeschoss mit Glasfronten und Dachpool. Vom Schwimmbecken wie auch von den Räumen geht der Blick weit über die Nordsee (besonders begehrt sind die Penthouses mit eigenem Balkon und die Lofts mit hohen Decken sowie direktem Zugang zum Meer). So entspannt und elegant wie in den Zimmern ist die Atmosphäre auch im Restaurant, über dem schon seit Jahren ein Michelin-Stern strahlt und das mit Terrasse und Kaminlounge bestens gerüstet ist für das ostfriesische Wetter, das sich bekanntlich im Stundentakt ändern kann. Die Mitarbeiter des Hotels sind Meister im spontanen Anpassen von Ferienplänen und organisieren je nach Witterung Yogastunden oder Wattwanderungen, Segeltörns oder Rundflüge. Zurück am Steg bucht man am besten eine Behandlung im Spa mit den Schätzen der See – das Meersalzpeeling und die Salzkugelmassage sind eine Wohltat. ◆ Buchtipp: „Die Nordsee" von Heinrich Heine, der die Sommer 1825 und 1826 auf Norderney verbrachte

ANREISE *Ganz im Westen von Norderney am Strand gelegen. Man erreicht die Insel ab Norddeich in knapp 1 Stunde mit der Fähre (das Auto möglichst auf dem Festland lassen; auf Norderney herrscht Fahrverbot) oder mit Kleinflugzeugen von nahen Flughäfen wie Hamburg* · **PREISE** *€€€–€€€€* · **ZIMMER** *18 Zimmer und Suiten* · **KÜCHE** *Frühstück à la carte. Mittags und abends gibt es ausgezeichnete, von der Insel inspirierte Gerichte und erlesene Weine* · **GESCHICHTE** *Die Lagerhalle entstand 1895. Die heutigen Besitzer erwarben sie Ende 2006 und eröffneten das Hotel 2007. 2024 wurden zwei weitere Suiten hinzugefügt* · **X-FAKTOR** *Eine gelungene Verbindung von Geschichte und Gegenwart*

POUR L'AMOUR D'UNE ÎLE

Autrefois, pontes de l'industrie et grands noms de la noblesse venaient passer leurs vacances dans la station balnéaire mondaine de Norderney. Le chancelier Von Bülow y possédait une résidence d'été. La bâtisse tout en longueur servait alors d'entrepôt : lors des hivers tempétueux, on y entreposait les planches de la jetée et les chaises longues parsemant les plages de l'île. Quand les frères Marc et Jens Brune, respectivement architecte et hôtelier, ont racheté le hangar, ils ont souhaité conserver sa façade rouge caractéristique mais ont remplacé les pierres poreuses d'origine, rongées par les embruns, par 60 000 briques façonnées à la main. Les anciens madriers ont été recyclés en revêtement mural et, sur la partie historique du bâtiment, les propriétaires ont conçu une mezzanine moderne avec baies vitrées et piscine sur le toit. Depuis ce bassin, comme depuis chaque pièce de l'hôtel, la vue s'étire loin sur la mer du Nord – les penthouses avec balcon privé et les lofts hauts de plafond avec accès direct à la mer sont particulièrement prisés. L'atmosphère élégante et détendue des chambres se retrouve au restaurant, au-dessus duquel brille depuis des années déjà une étoile Michelin ; sa terrasse et la cheminée qui trône au salon en font un refuge parfait face au climat versatile de la Frise orientale. Le personnel de l'hôtel sait adapter le programme des activités à tous les aléas et organise de main de maître cours de yoga ou randonnées dans les vasières, croisières en voilier ou vols panoramiques. Lorsqu'ils regagnent le ponton, les connaisseurs réservent une séance au spa pour parfaire leur expérience des bienfaits de la mer – le peeling au sel marin et le massage aux boules de sel sont une bénédiction. ◆ À lire : « La Mer du Nord » de Heinrich Heine, qui passa les étés 1825 et 1826 à Norderney

ACCÈS *Situé tout à fait à l'ouest de Norderney, sur la plage. L'île est accessible en 1 h à peine depuis Norddeich par le ferry (laisser si possible la voiture sur le continent ; elle sera interdite de circulation à Norderney), ou par avion léger depuis des aéroports proches comme celui de Hambourg* · **PRIX** *€€€–€€€€* · **CHAMBRES** *18 chambres et suites* · **RESTAURATION** *Petit-déjeuner à la carte. Au déjeuner et au dîner, vous pourrez déguster d'excellents plats inspirés de l'île, accompagnés de vins raffinés* · **HISTOIRE** *L'entrepôt a été construit en 1895. Les propriétaires actuels l'ont acheté fin 2006 et ont ouvert l'hôtel de luxe en 2007. Les deux suites les plus récentes ont été ajoutées en 2024* · **LES « PLUS »** *Un mariage réussi entre passé et présent*

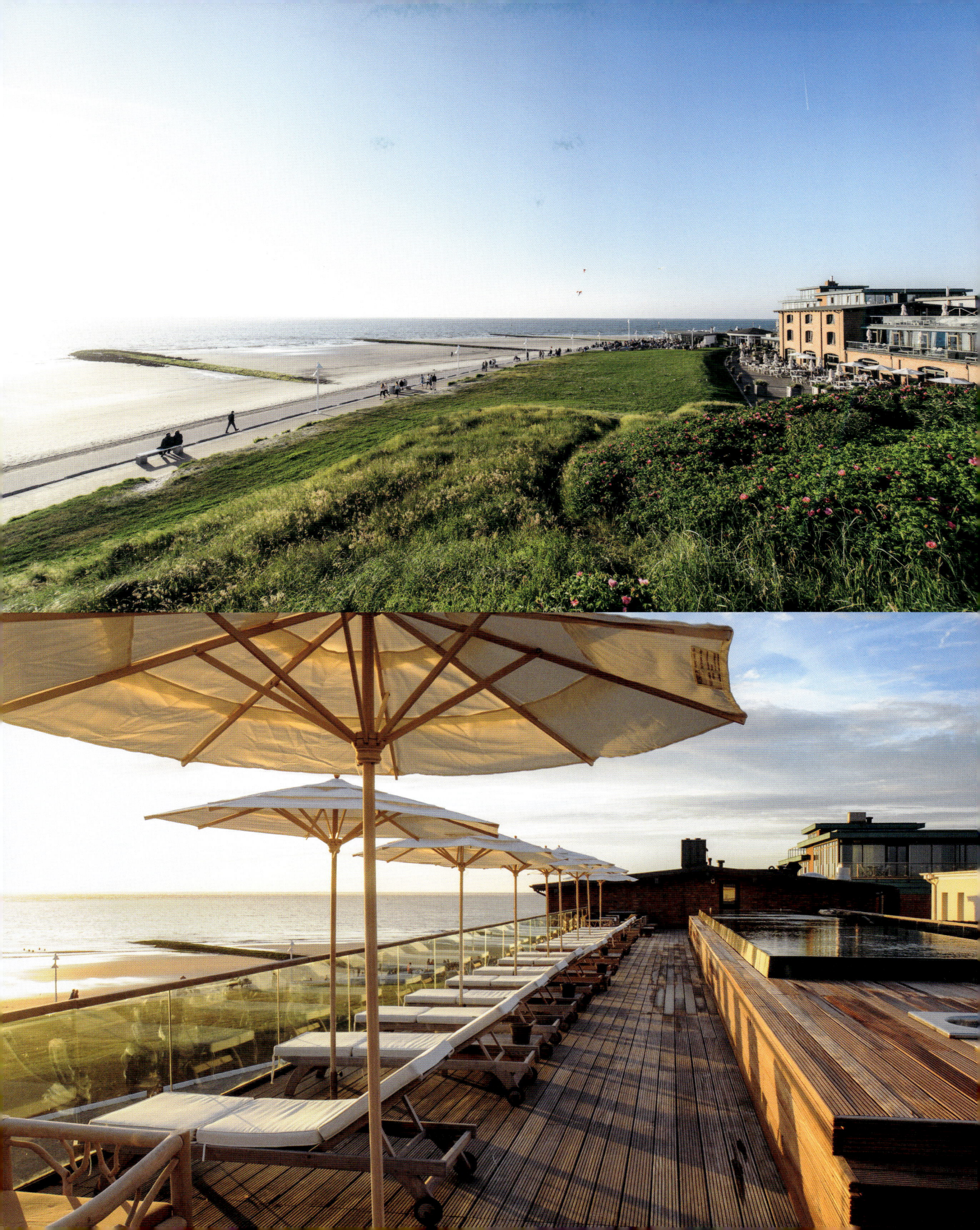

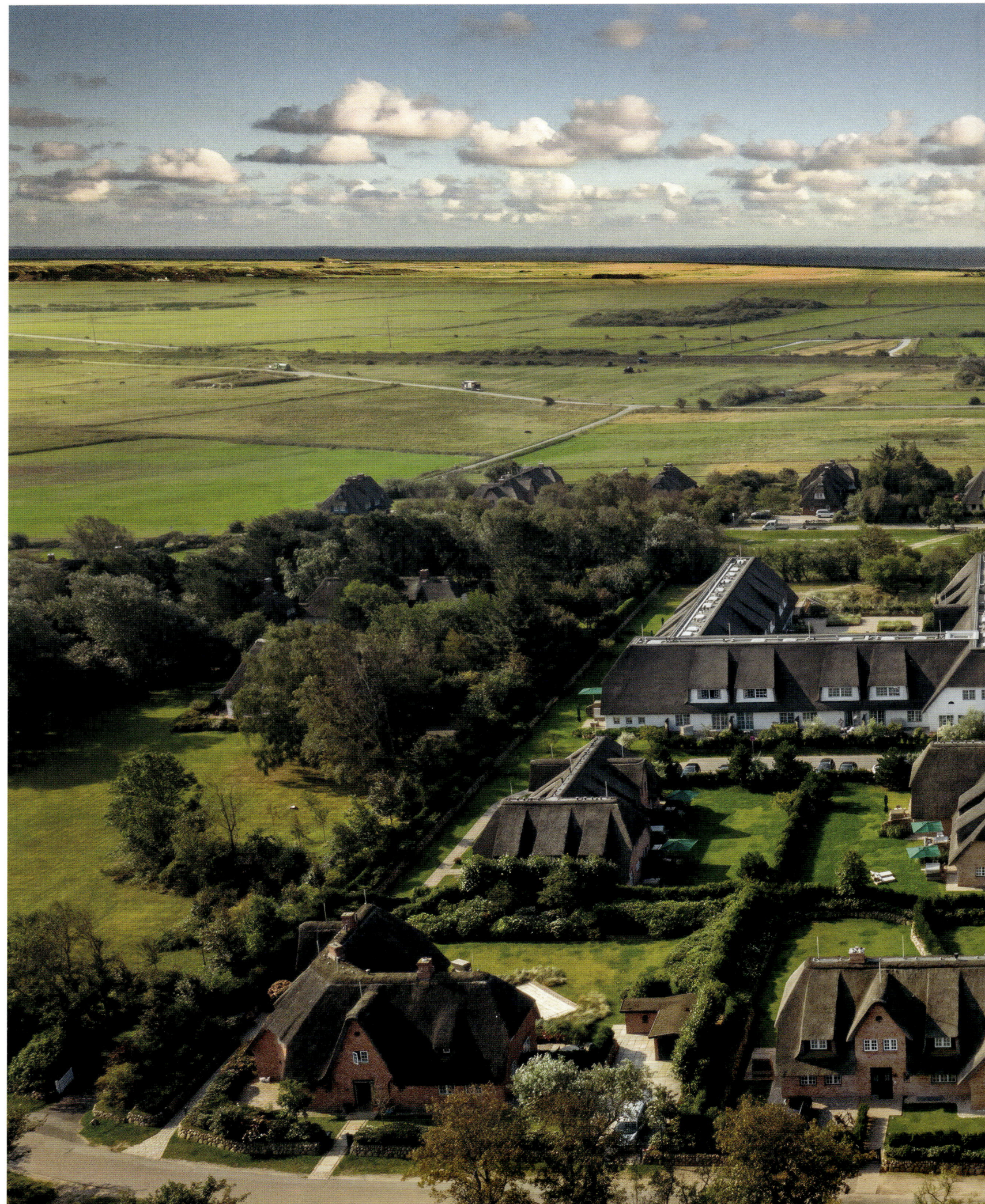

SEVERIN'S RESORT & SPA

KEITUM, SYLT, NORDSEE

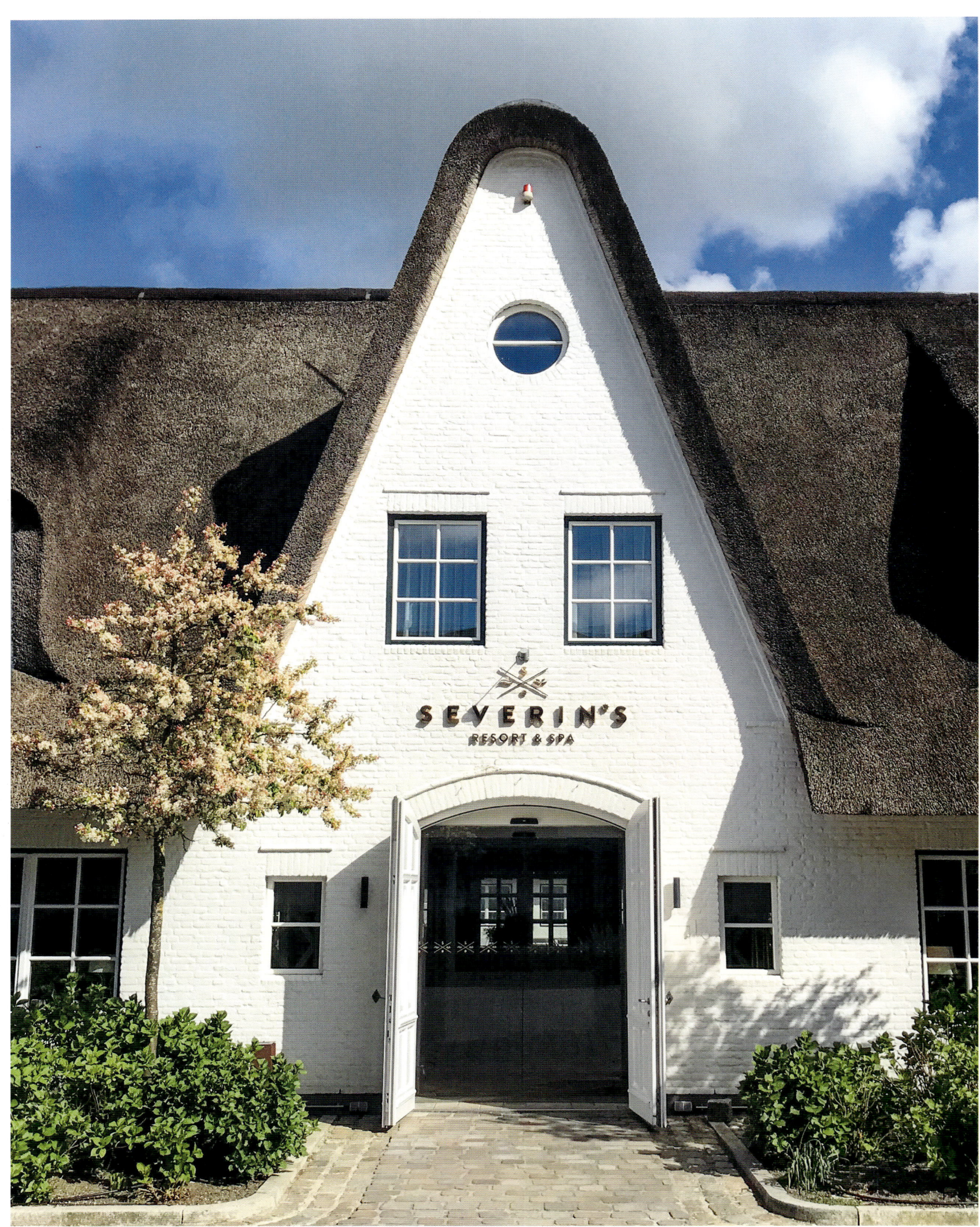

SEVERIN'S RESORT & SPA

Am Tipkenhoog 18, 25980 Keitum, Sylt
Tel. +49 4651 460 660 · info@severins-sylt.de
www.severins-sylt.de

IN THE CAPTAIN'S VILLAGE

In the days when Sylt did not yet live from tourism, but from whaling, Keitum was the heart of the island. The pastor was based here, there was a school, a doctor, and the island's first pharmacy – and the mariners who made a good living from the sea also lived here. Most of the thatched captains' houses were built in the 18th century, and are now surrounded by rose gardens with low stone walls, known locally as "Frisian walls." These pretty houses and well-tended gardens, like the basket seats on the beaches, are among the typical sights of Sylt, and it is worth taking a stroll through the narrow streets of Keitum to find the most photogenic ensemble. A little way outside the village center lies Severin's Resort & Spa, which contrasts with the historic cottages through its modern style. It also has one of the largest thatched roofs in Europe with a surface of 54,000 square feet, which protects the interiors of the S-shaped building from the North Sea wind and weather. Alongside luxurious rooms and suites, the resort has high-class restaurants and an award-winning spa where the treatments are based on the "Sylt energy compass" and use the beneficial properties of the island flora, its sun, wind and water. The fascinating quality of the surrounding nature is shown by the Wadden Sea, which lies on the hotel's doorstep and is a Unesco World Heritage site. More than 10,000 species of animals and plants live there in the rhythm of the tides – and on a guided tour guests can discover at least a small part of this abundance. ◆ Film to watch: "The Ghost Writer" (2010), in which many outdoor scenes show Sylt and its ferry (though the action supposedly takes place in the USA in Martha's Vineyard)

DIRECTIONS *Keitum is on the east side of Sylt, around 10 minutes' drive from Westerland, where there is an airport and the rail embarkation station for cars* · **RATES** *€€€€* · **ROOMS** *62 rooms and suites in the main building, 22 apartments, 5 villas* · **FOOD** *"Tipken's by Nils Henkel" was awarded a Michelin star in 2024 for its seasonal gourmet cuisine; "Hoog" serves Sylt specialties. The hotel also has a bar, a lounge, and a wine cellar stocked with almost 1,000 bottles* · **HISTORY** *Opened in December 2014* · **X-FACTOR** *A small sister hotel, Landhaus Severin's, stands on the Morsum Cliff, a protected natural site with geological layers around 10 million years old*

IM KAPITÄNSDORF

Als Sylt noch nicht vom Tourismus lebte, sondern vom Walfang, war Keitum das Herz der Insel. Hier gab es ein Pastorat und eine Schule, einen Arzt und die erste Apotheke der Insel – und hier wohnten die Seemänner, die dem Meer ihren Wohlstand verdankten. Die meisten der reetgedeckten Kapitänshäuser entstanden im 18. Jahrhundert und stehen heute in Rosengärten mit niedrigen Steinmauern, die im Volksmund „Friesenwälle" heißen. Die hübschen Häuser und gepflegten Gärten gehören wie die Strandkörbe zu den typischen Sylt-Bildern, und ein Bummel durch die Gassen von Keitum lohnt sich, um das fotogenste Ensemble zu finden. Wer ein Stück aus dem Ortskern hinausgeht, kommt zum Severin's Resort & Spa, das den historischen Katen einen modernen Stil entgegensetzt und eines der größten Reetdächer Europas besitzt: Das Schilfrohrdach hat eine Fläche von 5000 Quadratmetern und schützt die Räumlichkeiten der s-förmigen Anlage vor Nordseewind und -wetter. Neben luxuriösen Zimmern und Suiten umfasst das Resort auch feine Restaurants und ein preisgekröntes Spa, in dem die Anwendungen nach dem „Sylter Kräftekompass" ausgerichtet sind und das die wohltuende Wirkung der Inselflora sowie von Sonne, Wind und Wasser nutzt. Wie faszinierend die Natur ringsum ist, beweist auch das Wattenmeer, das gleich vor der Hoteltür beginnt und zum Unesco-Welterbe zählt. Im Rhythmus von Ebbe und Flut leben dort mehr als 10 000 Tier- und Pflanzenarten – bei einer geführten Wattwanderung kann man zumindest einen kleinen Teil davon aufspüren. ◆ Buchtipp: „Falscher Glanz" von Eva Ehley (spielt zum Teil im Hotel)

ANREISE *Keitum liegt auf der Ostseite von Sylt, rund 10 Fahrtminuten von Westerland entfernt, wo es einen Flughafen und eine Autoverladestelle gibt* · PREISE *€€€€* · ZIMMER *62 Zimmer und Suiten im Haupthaus, 22 Apartments, 5 Villen* · KÜCHE *„Tipken's by Nils Henkel" bekam 2024 einen Michelin-Stern für seine saisonale Gourmetküche verliehen, das „Hoog" serviert Sylter Spezialitäten. Zudem hat das Hotel eine Bar, eine Lounge und einen mit nahezu 1000 Flaschen bestückten Weinkeller* · GESCHICHTE *Im Dezember 2014 eröffnet* · X-FAKTOR *Am naturgeschützten Morsum-Kliff mit seinen rund 10 Millionen Jahre alten Erdschichten steht das kleine Schwesterhotel Landhaus Severin's*

AU VILLAGE DU CAPITAINE

Lorsque Sylt ne vivait pas encore du tourisme mais de la pêche à la baleine, Keitum était le cœur battant de l'île. On y trouvait un pastorat, une école, un médecin et la première pharmacie de l'île, et c'est ici qu'habitaient les marins enrichis par la mer. La plupart des maisons de capitaine au toit de chaume ont été bâties au XVIIIe siècle, agrémentées de jardins et de roseraies et cernées de murets en pierre appelés des « talus frisons ». Les jolies chaumières et leurs jardins soignés font partie, comme les corbeilles de plage, des images typiques de Sylt, et l'ensemble paraît plus photogénique encore lorsqu'on flâne dans les ruelles de Keitum. Quand on s'éloigne un peu du centre du village, on arrive au Severin's Resort & Spa, dont l'architecture moderne contraste avec les vieilles bâtisses. Il possède un des plus grands toits de chaume d'Europe : 5 000 mètres carrés de paille de roseaux protègent le complexe en forme de S du vent et des embruns de la mer du Nord. Outre des chambres et des suites luxueuses, l'établissement comprend des restaurants raffinés et un spa primé, dont les soins sont organisés selon la « boussole des forces de Sylt », autour des vertus de la flore de l'île, du soleil, du vent et de l'eau. L'estran local, inscrit au patrimoine mondial de l'Unesco, vient presque lécher le seuil de l'hôtel et rappelle combien la nature environnante est fascinante. Plus de 10 000 espèces animales et végétales y vivent au rythme des marées – une promenade dans la vasière avec un guide permet d'en observer au moins une partie. ◆ À lire : « L'Homme au cheval blanc » de Theodor Storm

ACCÈS *Keitum est située sur la côte est de Sylt, à environ 10 min de route de Westerland, où se trouvent un aéroport et la station d'embarquement sur l'auto-train* · PRIX *€€€€* · CHAMBRES *62 chambres et suites dans la maison principale, 22 appartements, 5 villas* · RESTAURATION *« Tipken's by Nils Henkel » a reçu en 2024 une étoile Michelin pour sa cuisine gastronomique de saison et le « Hoog » sert des spécialités de Sylt. L'hôtel dispose aussi d'un bar, d'un salon et d'une cave à vin de près de 1 000 bouteilles* · HISTOIRE *Ouvert en décembre 2014* · LES « PLUS » *Le petit hôtel jumeau Landhaus Severin's se trouve sur la falaise protégée de Morsum, dont les strates de terre colorée vieilles de 10 millions d'années sont une rareté géologique*

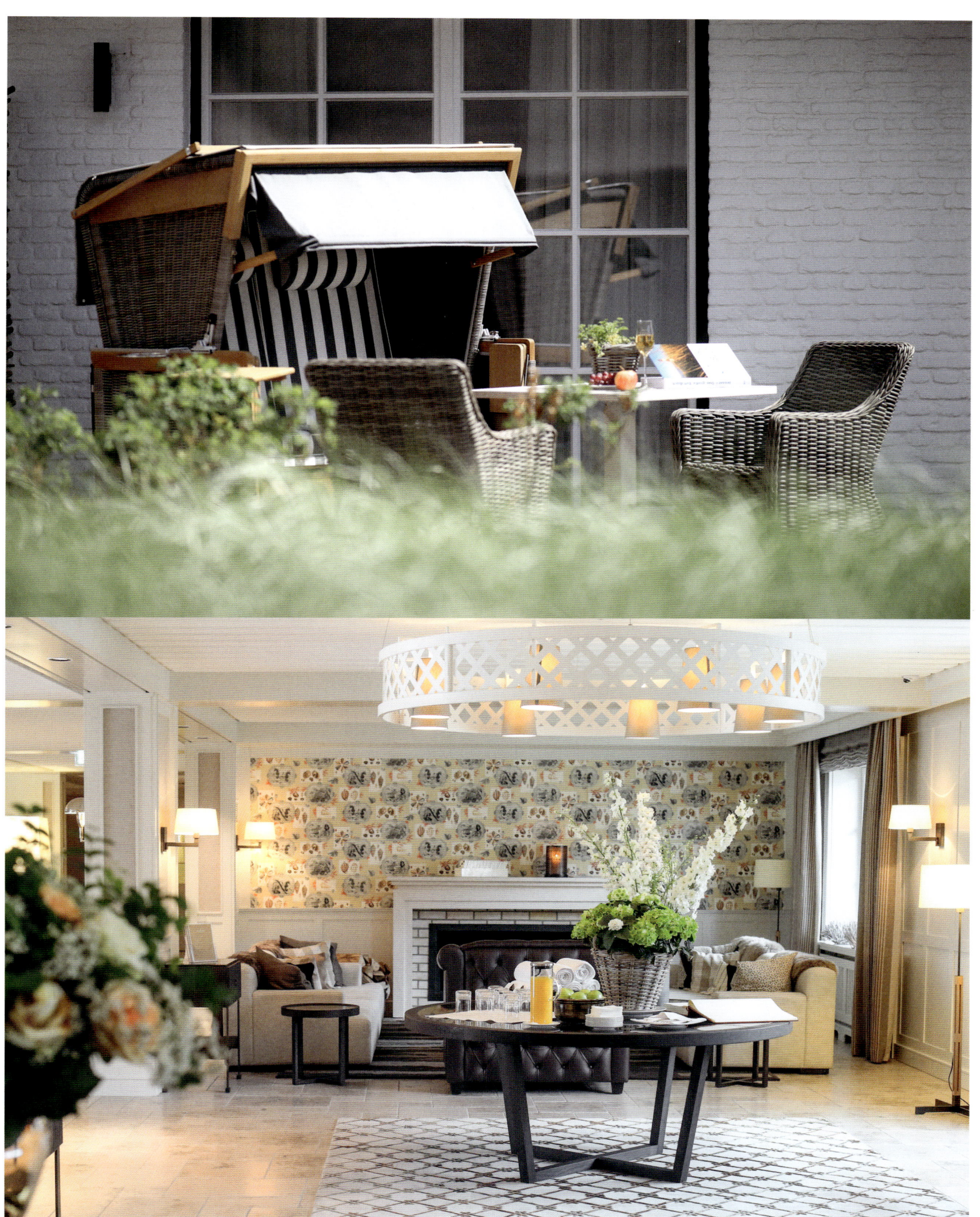

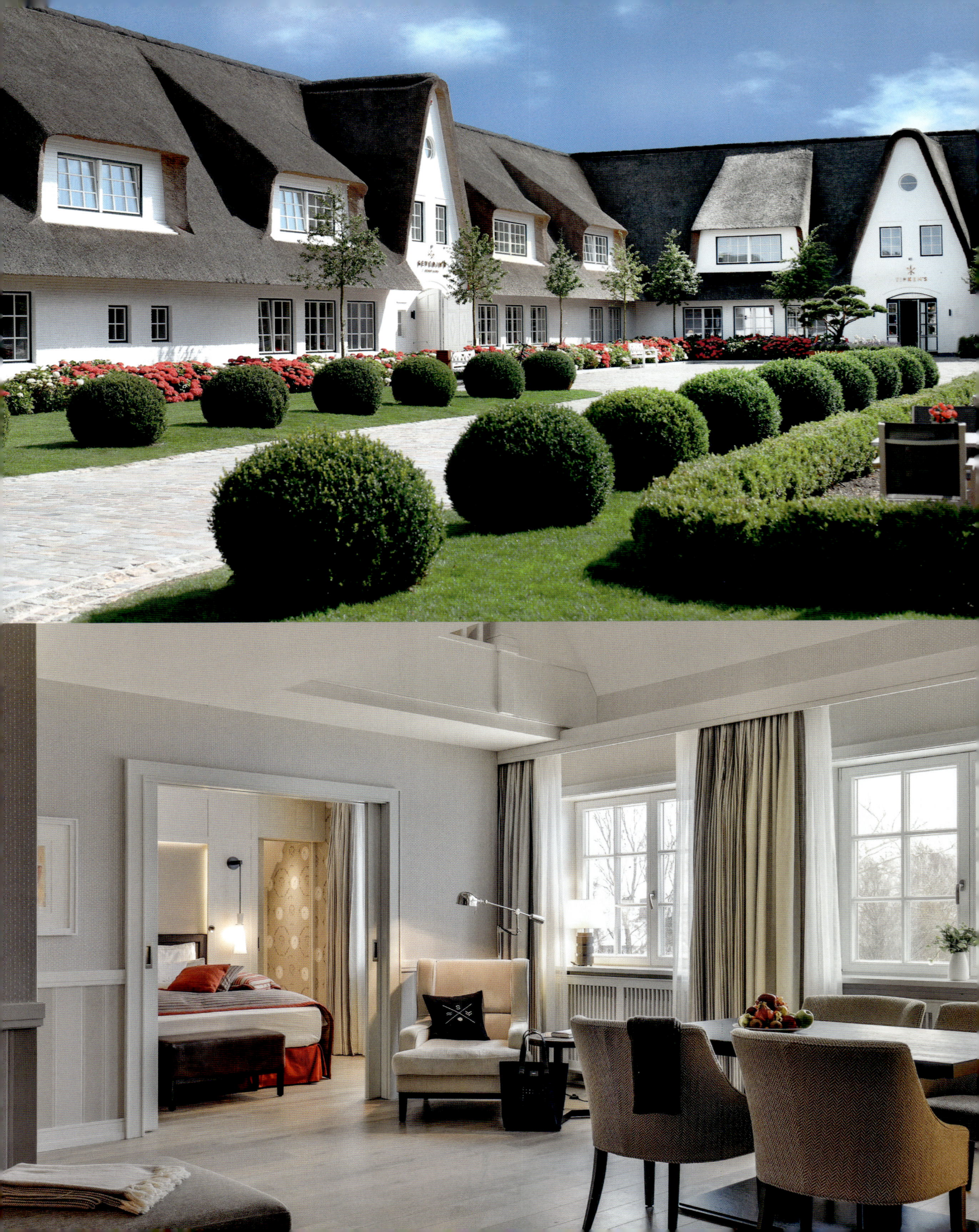

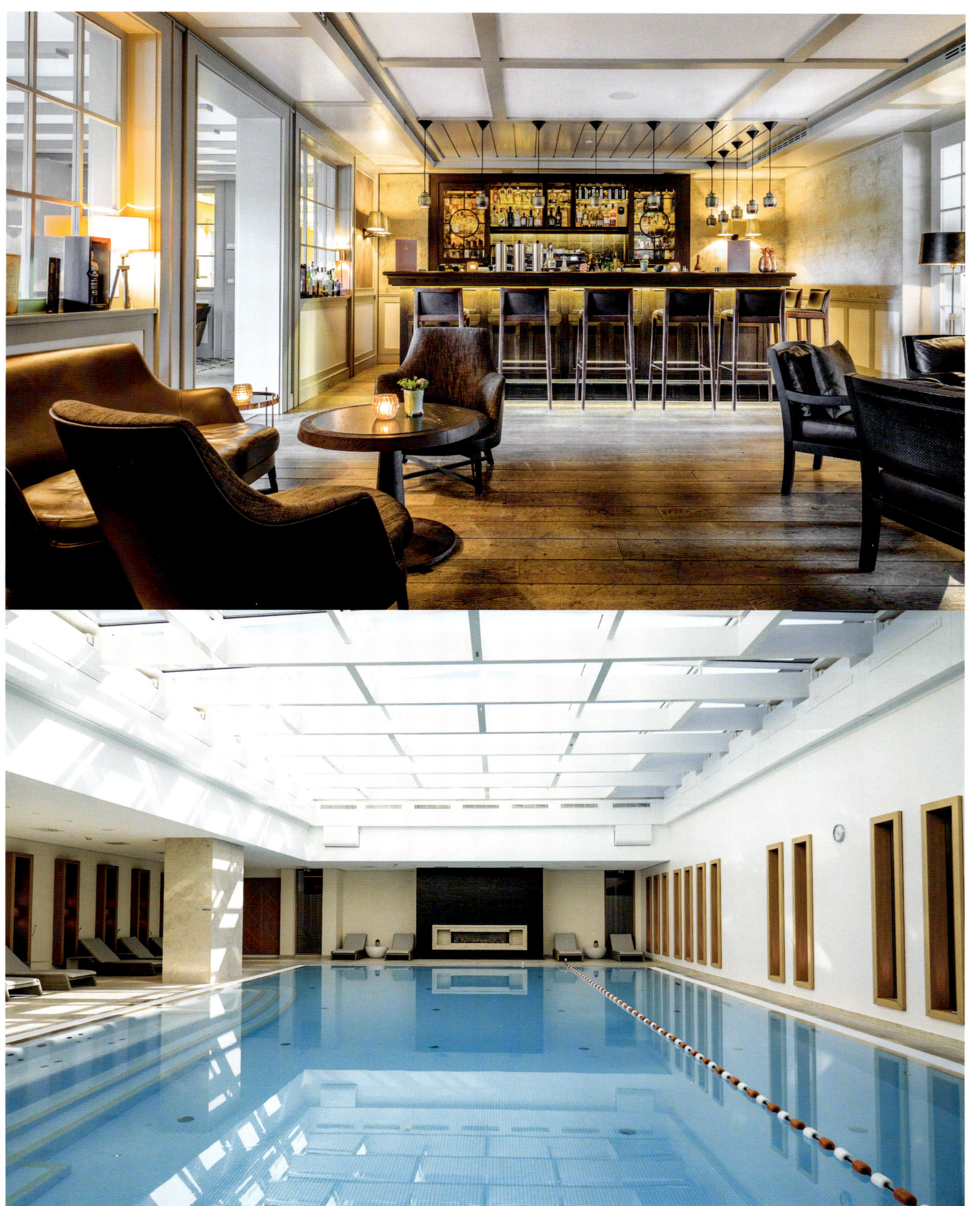

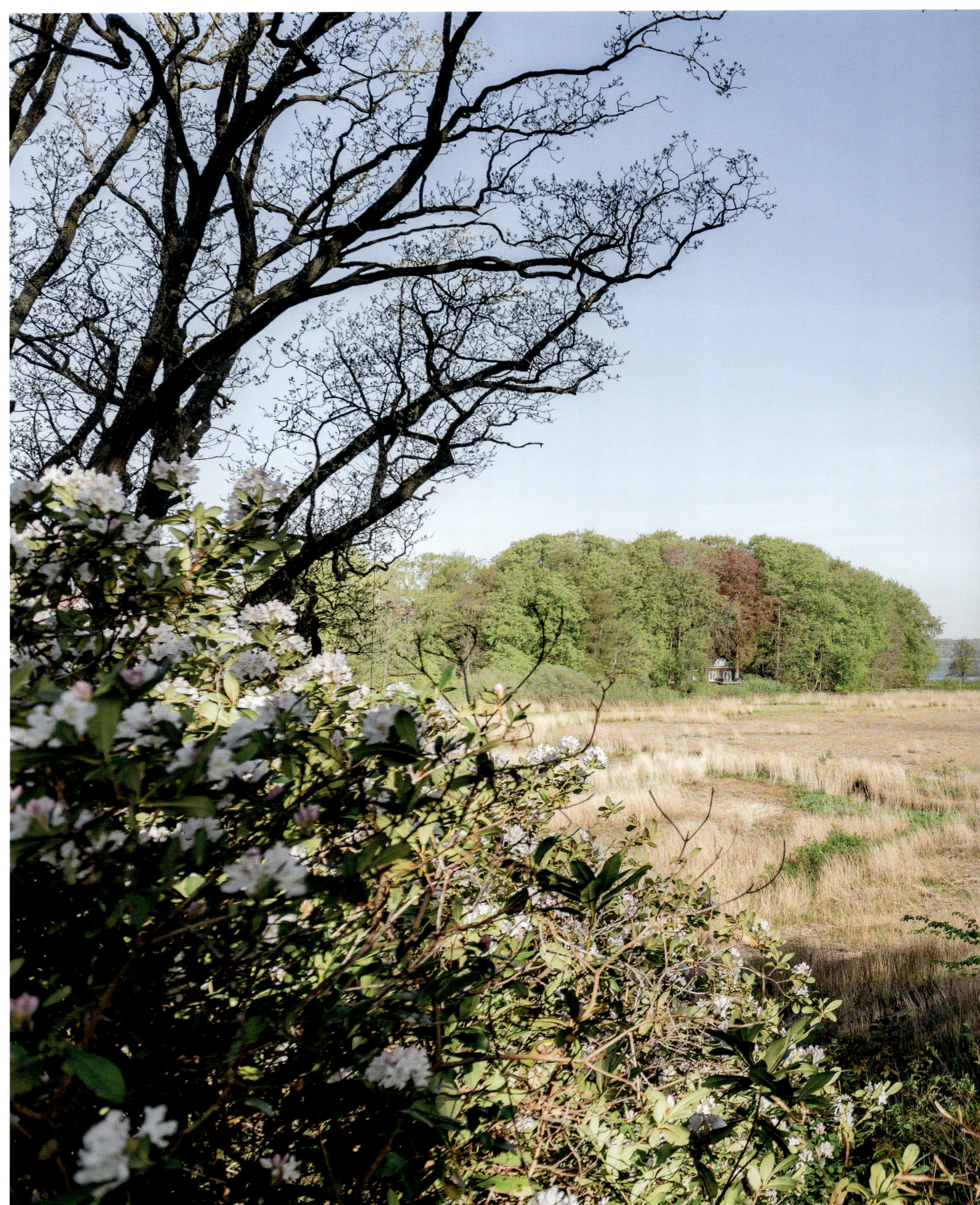

AARSKOGS BOUTIQUE HOTEL

GLÜCKSBURG, OSTSEE

AARSKOGS BOUTIQUE HOTEL

Paulinenallee 5, 24960 Glücksburg
Tel. +49 4631 444 8774 · hei@aarskogs.de
www.aarskogs.de

VILLA WITH A VIEW

In 1898 Olga Claudius, a great-great-niece of the German poet Matthias Claudius, who wrote a much-loved poem "Der Mond ist aufgegangen," ("The Moon Has Risen"), had this villa built as a boarding school for girls. Here she taught the daughters of the wealthy to converse in English and French, to paint and make music, and to play tennis and croquet – in short, everything that seemed essential for young ladies who wanted to make a good match in Glücksburg society. Later the building served as an auxiliary hospital, a maternity clinic and a recuperation home, before the Aarskog family bought it in 2012 and turned it into a hotel. Positioned on a hill in the pleasant district of Sandwig near the beach, it has a view across the Schwennau Valley and the Flensburg Fjord to Denmark. As close to the border as this, the neighboring land makes its presence felt: guests are greeted with a friendly Danish "velkommen!," sleep in rooms with a touch of Scandinavian feeling, and drink tea from A.C. Perch's in Copenhagen – in cups with the royal blue-and-white design, of course. In warm weather, the garden with its ancient trees is a favorite spot to linger. Guests can take breakfast there on the terrace, lie in the sun with a good book, or have a sauna in the summerhouse. Only a stone's throw away is the finest sandy beach of this seaside town, and a short walk leads to Glücksburg Castle, a lakeside Renaissance residence straight from a fairy tale. ◆ Book to pack: "The Danish Dynasty – A History of the House of Glücksburg" by Taylor Brooks, about the dynasty that owned Glücksburg Castle and produced members of the royal families of Denmark, Norway, Greece and Britain (Prince Philip)

DIRECTIONS *15 minutes by car northeast of Flensburg, a drive of just under 2 hours from Hamburg airport* · **RATES** *€–€€* · **ROOMS** *16 rooms and suites* · **FOOD** *Breakfast for late risers is served in the bright dining room with its stove* · **HISTORY** *From April 2014 onwards the guesthouse was known as Smucke Steed, and was renamed Aarskogs Boutique Hotel in 2024* · **X-FACTOR** *Hygge in Schleswig-Holstein*

VILLA MIT AUSSICHT

1898 ließ Olga Claudius, eine Urgroßnichte des deutschen Dichters Matthias Claudius, der das wunderschöne Abendlied „Der Mond ist aufgegangen" schrieb, diese Villa als Mädchenpensionat bauen. Hier unterrichtete sie höhere Töchter in englischer und französischer Konversation, im Musizieren und Malen und brachte ihnen Tennis und Krocket bei – kurzum alles, was damals unerlässlich schien für junge Damen, die eine gute Partie machen wollten. Später fungierte das Haus als Hilfskrankenhaus, Entbindungs- und Erholungsheim, ehe die Familie Aarskog es 2012 erwarb und künftig als Hotel nutzte. Auf einem Hügel im gepflegten Strandviertel Sandwig gelegen, schaut es über das Schwennautal und die Flensburger Förde bis nach Dänemark. So nahe der Grenze ist das Nachbarland auch sonst ziemlich präsent: Die Gäste werden mit einem freundlichen „velkommen!" begrüßt, schlafen in skandinavisch angehauchten Zimmern und trinken Tee von A.C. Perch's aus Kopenhagen – natürlich in Tassen mit königlichem blau-weißem Design. An warmen Tagen wird der von uralten Bäumen gesäumte Garten zum Lieblingsplatz. Man kann dort auf der Terrasse frühstücken, mit einem guten Buch in der Sonne liegen oder im Gartenhaus saunieren. Nur einen Steinwurf entfernt verläuft der schönste Sandstrand des Ostseebades, und auch das Glücksburger Wasserschloss, eine Renaissance-Residenz wie aus dem Märchen, ist nur einen Spaziergang entfernt. ◆ Buchtipp: „Gedichte und Prosa" von Matthias Claudius

ANREISE *15 Fahrtminuten nordöstlich von Flensburg gelegen. Bis zum Flughafen Hamburg sind es knapp 2 Fahrtstunden* · **PREISE** *€–€€* · **ZIMMER** *16 Zimmer und Suiten* · **KÜCHE** *Im hellen Speisesaal mit Ofen wird ein Langschläfer-Frühstück serviert* · **GESCHICHTE** *Seit April 2014 war die Pension unter dem Namen Smucke Steed bekannt. 2024 wurde sie in Aarskogs Boutique Hotel umbenannt* · **X-FAKTOR** *Hygge in Schleswig-Holstein*

UNE VILLA EN SURPLOMB

En 1898, Olga Claudius, une arrière-petite-nièce du poète allemand Matthias Claudius, l'auteur du poème « La jeune fille et la mort », fit bâtir cette villa pour y ouvrir un pensionnat de jeunes filles. Elle enseignait aux filles de la bonne société locale l'art de la conversation en anglais et en français, la musique et la peinture, mais aussi le tennis et le croquet – autant de compétences qu'une demoiselle de l'époque se devait d'acquérir pour espérer un beau mariage. La villa servit plus tard d'hôpital auxiliaire, de maternité et de maison de repos, avant que la famille Aarskog ne l'achète en 2012 pour la transformer en hôtel. Perchée sur une colline du coquet quartier balnéaire de Sandwig, elle offre une vue plongeante sur la vallée de la Schwennau, le fjord de Flensbourg, et le Danemark au loin. La frontière est proche, si bien que le pays voisin est très présent : les clients sont accueillis par un chaleureux « Velkommen ! », dorment dans des chambres d'inspiration scandinave et boivent le thé de la maison A. C. Perch's de Copenhague – dans des tasses blanches aux motifs bleu roi, comme il se doit. Aux beaux jours, le jardin bordé d'arbres centenaires devient un havre de paix privilégié. On peut prendre le petit-déjeuner sur la terrasse, se prélasser au soleil avec un bon livre ou au sauna agencé dans le pavillon de jardin. La plus belle plage de sable de la station n'est qu'à un jet de pierre de là, tout comme le féerique château de Glücksbourg, qui date de la Renaissance et semble flotter sur l'eau miroitante qui le ceint. ◆ À lire : « Anthologie bilingue de la poésie allemande »

ACCÈS *Situé à 15 min en voiture au nord-est de Flensbourg. L'aéroport de Hambourg est à 2 petites heures de route* · **PRIX** *€–€€* · **CHAMBRES** *16 chambres et suites* · **RESTAURATION** *Un copieux petit-déjeuner pour lève-tard est servi dans la lumineuse salle à manger avec cheminée* · **HISTOIRE** *Depuis avril 2014, la pension était connue sous le nom de Smucke Steed. Elle a été rebaptisée Aarskogs Boutique Hotel en 2024* · **LES « PLUS »** *Hygge au Schleswig-Holstein*

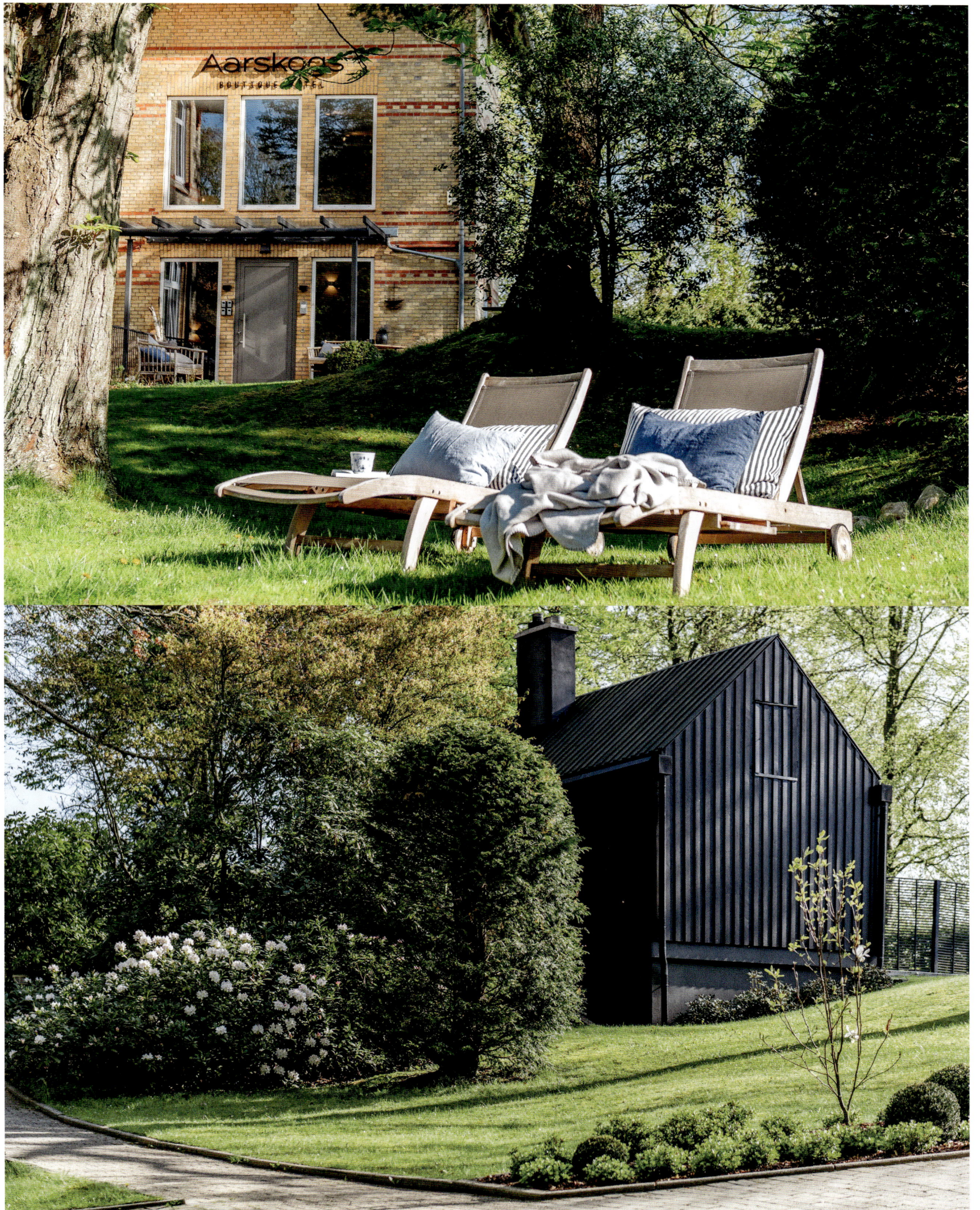

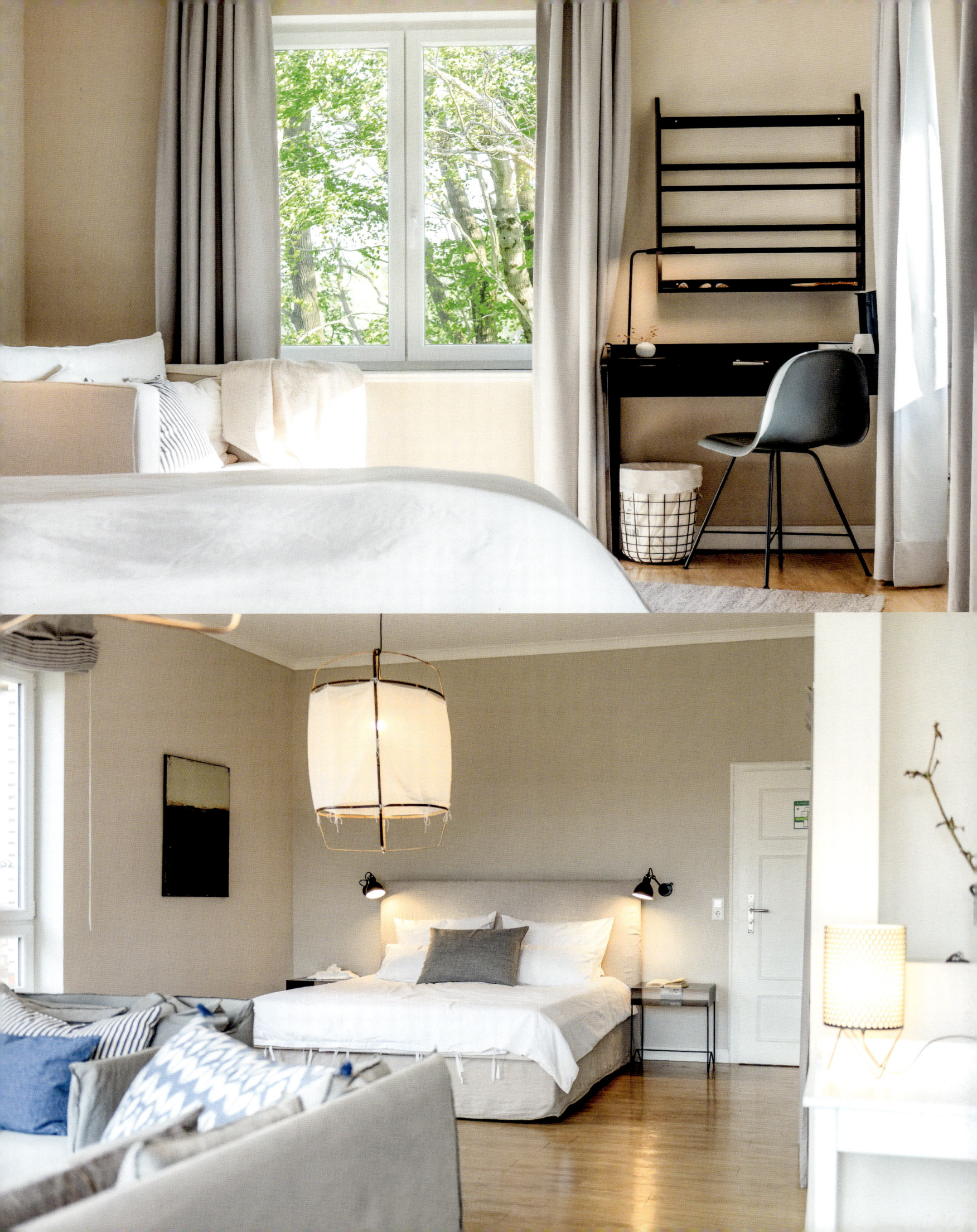

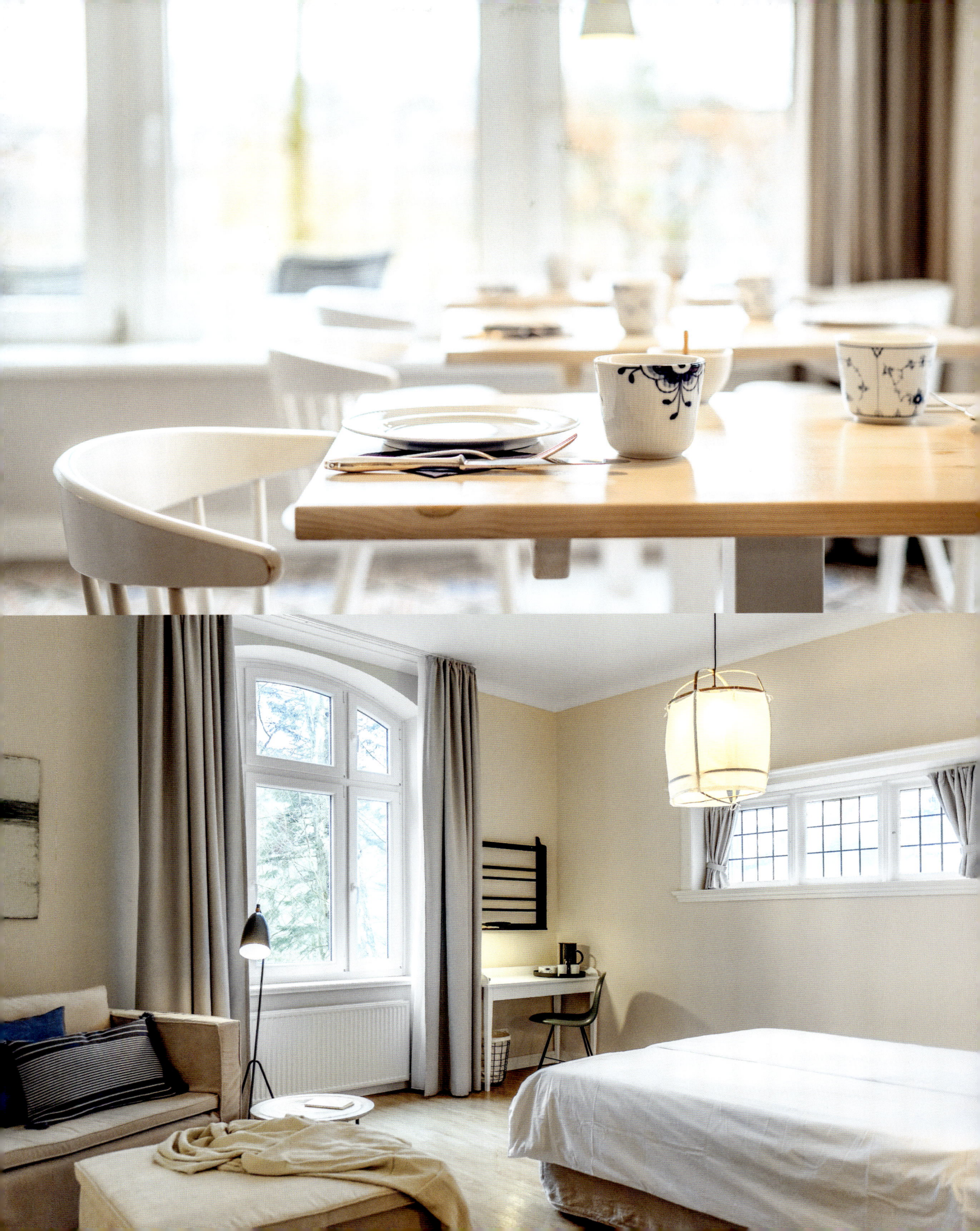

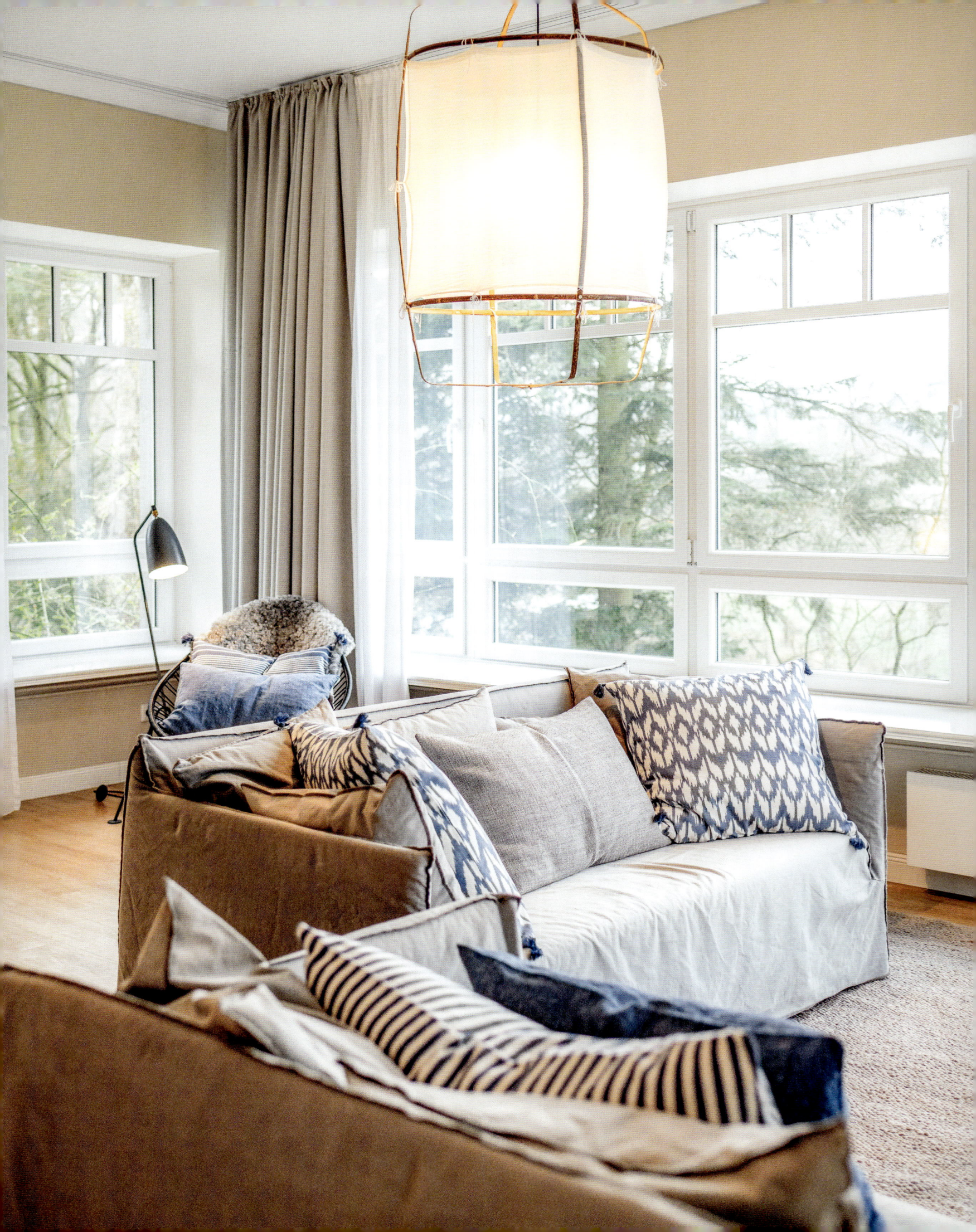

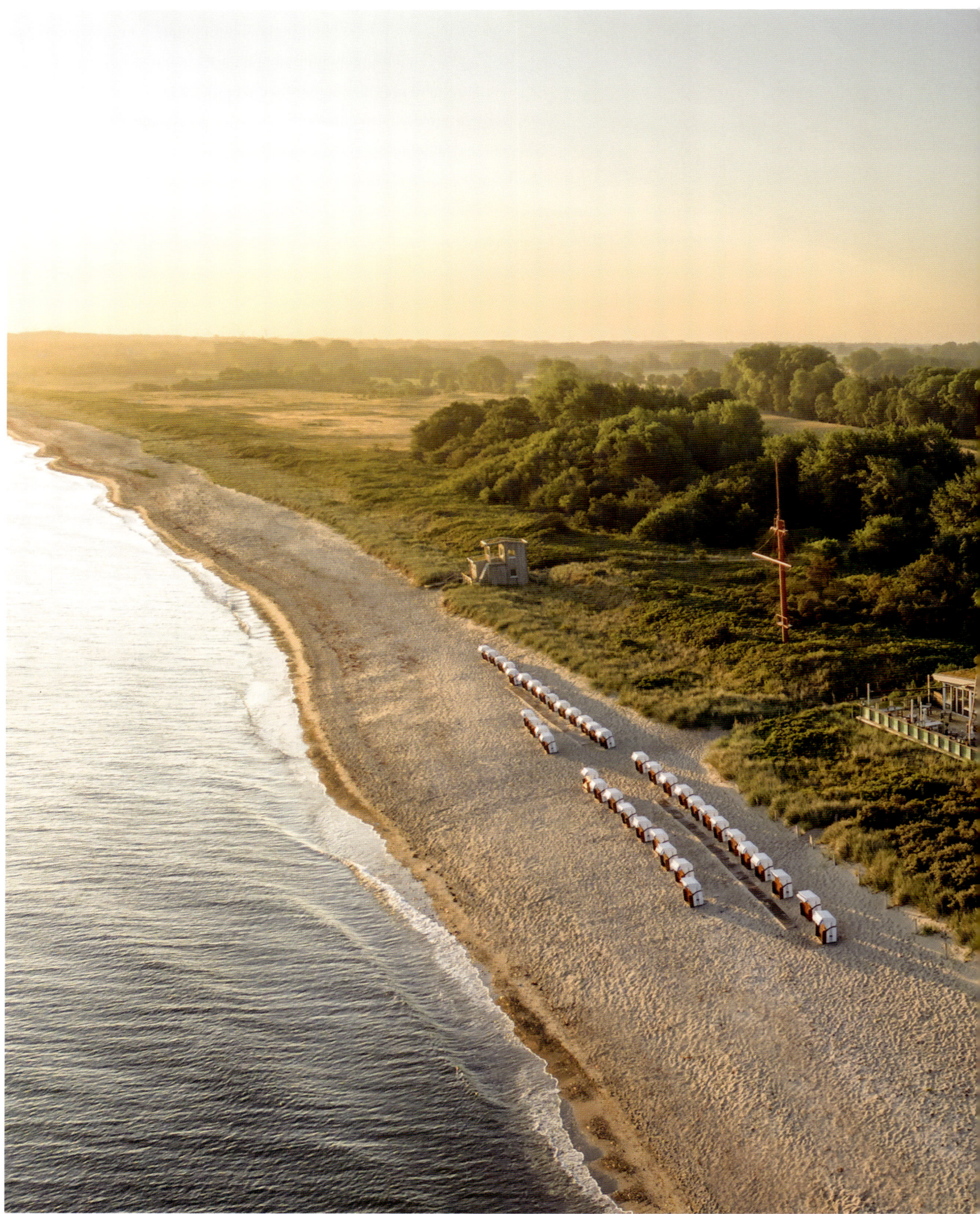

WEISSENHAUS PRIVATE NATURE LUXURY RESORT

WEISSENHAUS, OSTSEE

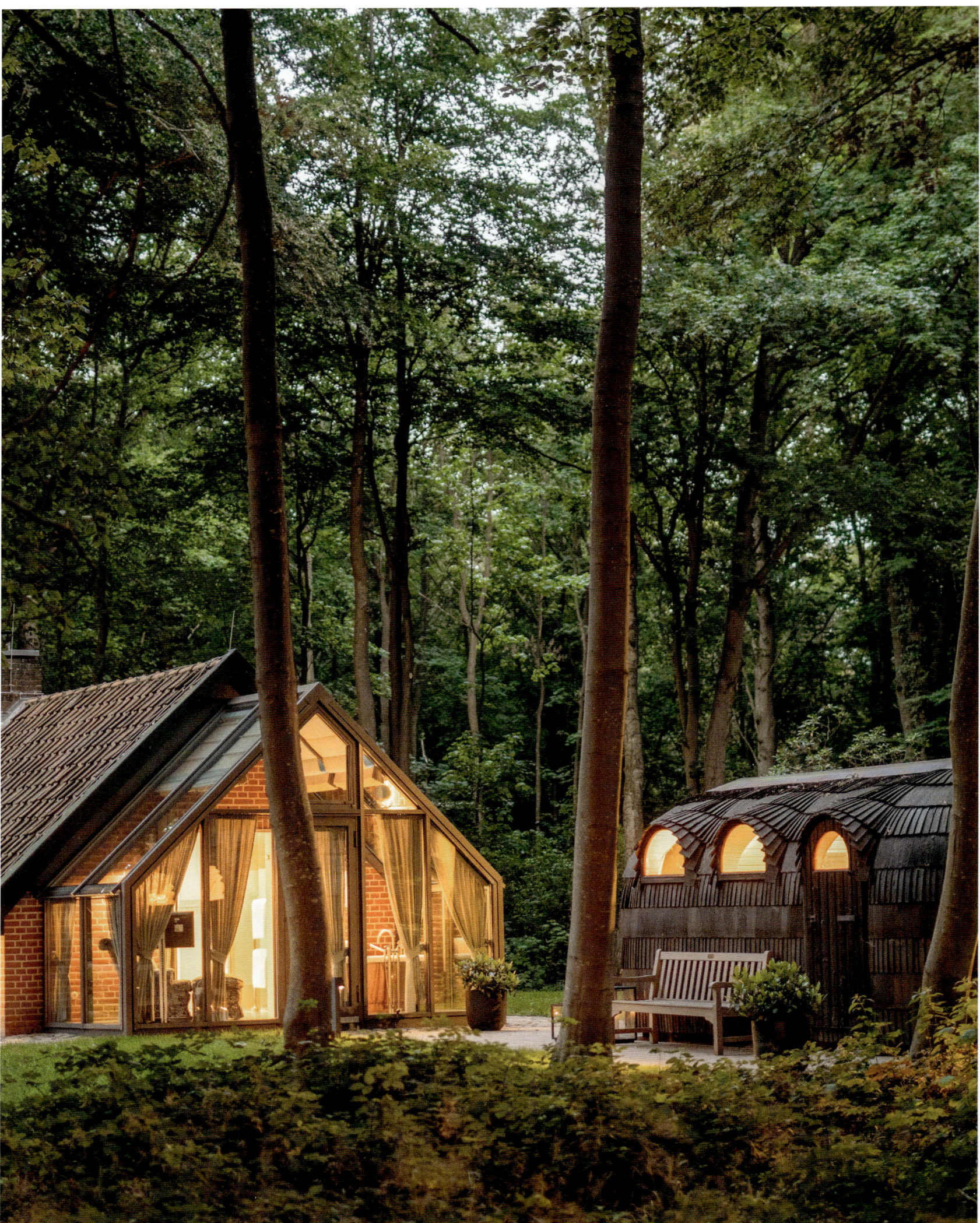

WEISSENHAUS PRIVATE NATURE LUXURY RESORT

Parkallee 1, 23758 Weißenhaus
Tel. +49 4382 92620 · info@weissenhaus.de
www.weissenhaus.de

A MANOR BY THE SEA

Following twelve years of intensive building work and careful restoration in accordance with conservation requirements, the imposing village ensemble Weissenhaus Private Nature Luxury Resort opened in 2014. Stunning park scenery embraces the varied historic buildings that serve to accommodate guests and have also hosted a G7 summit. On the resort-guest-only principle, a maximum of 120 guests enjoy an undisturbed idyll around the romantic manor lake, as well as the observatory and the chance to spot wild animals on the walk through the manor's own woods. For relaxation there are countless avenues, orchards, and sequestered clearings close to a natural beach with basket-chairs. The prize-winning spa covering 2,500 square meters, occupying three buildings, leaves no wish unfulfilled, from three pools to the lovingly designed sauna zone, and the restaurants are first-class. "Courtier" in the picture gallery of the mansion, which has two Michelin stars, pampers all of the senses with a perspective view through the park to the sea and French cuisine. ◆ Book to pack: "The German Lesson" by Siegfried Lenz

DIRECTIONS *On a 75-hectare/180-acre beach estate in Schleswig-Holstein, about 1.5 hours northeast of Hamburg and its international airport ·* **ROOMS** *60 rooms, suites and villas ·* **RATES** *€€€€ ·* **FOOD** *In addition to the gourmet restaurant "Courtier" and the "Asiabar," there is the breakfast restaurant "Kavaliershaus," as well as the main restaurant "Bootshaus" serving Mediterranean dishes by the beach ·* **HISTORY** *The whole village ensemble and its historic park around the neobaroque mansion have a history going back 400 years. The resort was opened in summer 2014 ·* **X-FACTOR** *Luxury down to the last detail in an authentic and idyllic feel-good atmosphere*

EIN SCHLOSSGUT DIREKT AM MEER

Nach zwölf Jahren intensiver Bauzeit und achtsamer, denkmalgerechter Restaurierung ist das imposante Dorfensemble Weissenhaus Private Nature Luxury Resort im Jahr 2014 eröffnet worden. Die traumhaft inszenierte 75 Hektar große Parkkulisse schmiegt sich um die vielfältigen, historischen Gebäude, die den Gästen als Unterkunft dienen und die bereits G7-Gastgeber waren. Dank des Resort-Guest-Only-Konzepts genießen die maximal 120 Gäste hier die ungestörte Idylle rund um den romantischen Schlossteich sowie die Sternwarte und Wildtierbeobachtungen auf der hauseigenen Spazierstrecke durch die Wälder. Unzählige Alleen und Obstgärten, verwunschene Waldlichtungen direkt am Naturstrand mit Strandkörben laden zur Erholung ein. Die vielfach prämierte 2500 Quadratmeter große Schlosstherme, die sich in drei Gebäuden inszeniert, lässt von drei Pools über die liebevoll gestaltete Saunalandschaft bis zum Yogapavillon keinen Wellnesswunsch offen, zudem sind die Restaurants erstklassig. Das mit zwei Michelin-Sternen ausgezeichnete „Courtier" im Bildersaal des Herrenhauses sorgt neben der Blickachse durch den Park bis zum Meer mit seiner französischen Cuisine für Genussmomente für alle Sinne. ◆ Buchtipp: „Das Wettangeln" von Siegfried Lenz

ANREISE *Auf einem 75 ha großen Strandgrundstück in Schleswig-Holstein gelegen, 1,5 Fahrtstunden nordöstlich von Hamburg und seinem internationalen Flughafen* · **PREISE** *€€€€* · **ZIMMER** *60 Zimmer, Suiten und Villen* · **KÜCHE** *Neben dem Gourmetrestaurant „Courtier" und der „Asiabar" im Schlossgewölbe gibt es noch das Frühstücksrestaurant „Kavaliershaus" und das Hauptrestaurant „Bootshaus" mit mediterranen Speisen in direkter Strandlage* · **GESCHICHTE** *Das gesamte Dorfensemble samt historischer Parkanlage rund um das neobarocke Herrenhaus blickt auf eine reiche 400-jährige Geschichte zurück. Eröffnet wurde das Resort im Sommer 2014* · **X-FAKTOR** *Bis ins Detail durchdachter Luxus in authentischer und idyllischer Wohlfühlatmosphäre*

UN DOMAINE À LA MER

Après douze années de travaux intensifs et de rénovation respectueuse de ce monument historique, l'imposant village du Weissenhaus Private Nature Luxury Resort a ouvert en 2014. Le parc de 75 hectares forme un écrin onirique autour des différents bâtiments anciens où les hôtes séjournent, et qui ont notamment accueilli un sommet du G7. Exclusivement réservé à ses clients, l'établissement n'en reçoit pas plus de 120 à la fois afin qu'ils profitent pleinement de la tranquillité idyllique des lieux, autour de l'étang romantique du château ou le long du parcours de promenade qui traverse la forêt, avec ses postes d'observation des étoiles et de la faune sauvage. Les innombrables allées et vergers, les clairières enchantées qui donnent sur la plage jalonnée des fameuses corbeilles, tout invite à la détente. L'espace spa de 2 500 mètres carrés, plusieurs fois primé, est réparti sur trois bâtiments. Il comprend trois piscines, des saunas aménagés avec soin et un pavillon de yoga. Quant aux restaurants, ils sont de première classe. Le « Courtier », récompensé par deux étoiles Michelin, se trouve dans la salle des tableaux de la maison de maîtres. Il offre une vue sur le parc et la mer et propose une cuisine française qui ravit les sens. ◆ À lire : « Une minute de silence » de Siegfried Lenz

ACCÈS *Situé sur un terrain de 75 hectares en bord de mer dans le Schleswig-Holstein, à 1,5 h au nord-est de Hambourg et de son aéroport* · **PRIX** *€€€€* · **CHAMBRES** *60 chambres, suites et villas* · **RESTAURATION** *Outre le gastronomique « Courtier » et l'« Asiabar », vous trouverez le « Kavaliershaus » dédié au petit-déjeuner et le « Bootshaus » avec son menu méditerranéen servi sur la plage* · **HISTOIRE** *Le parc historique, la maison de maître néobaroque et l'ensemble du domaine ont une riche histoire de 400 ans. L'établissement a ouvert ses portes à l'été 2014* · **LES « PLUS »** *Un luxe bien pensé, jusqu'aux moindres détails, dans une atmosphère de bien-être authentique et idyllique*

SCHLESWIG-HOLSTEIN 35

36 SCHLESWIG-HOLSTEIN

DIE REEDERIN

HANSESTADT LÜBECK

DIE REEDERIN

Große Altefähre 23, 23552 Lübeck
Tel. +49 451 3973 9966 · info@diereederin.de
www.diereederin.de

A HOTEL WITH A HISTORY

From 1868 to 2016 this pretty townhouse belonged to the forwarding and shipping company F. H. Bertling, which was based in Lübeck and had a famous employee: the former German chancellor Willy Brandt, who was an intern here as a young man. Many reminders of the previous owners remain: in the lobby is the "captain's washbasin" in which sailors had to wash their hands before they were allowed to enter the main office. The bedsteads were made by recycling the sliding doors of old file cupboards, and parts of shipping containers were built into the bathrooms. The seven guest rooms occupy the area that was once the typists' office, the cotton department, the book-keeping office, and the archive. The owner, Nina Dietze, has furnished them in a Hanseatic and Scandinavian style, and named each after a vessel that was once operated by the shipping line. Photographs of these ships adorn the walls, and in the honeymoon suite, called "Hilde," there is even a watercolor that the captain of the freighter painted on his voyages. Guests who want to immerse themselves more deeply in the maritime history of Lübeck can admire the famous historic sailing ships that have been meticulously restored in the nearby museum dock. These old boats are only a few minutes' walk from the hotel: Die Reederin – the name of the hotel means "woman shipowner" – has a first-class location on the picturesque Old Town island, which is surrounded by water and was the first entire city quarter in northern Europe to be given World Heritage status by Unesco. ◆ Book to pack and film to watch: "Buddenbrooks" by Thomas Mann (filmed in 2008 by Heinrich Breloer)

DIRECTIONS *A taxi from Lübeck train station takes 10 minutes. Those who come in their own car can stop to load and unload in front of the hotel and pay for a parking space nearby* · **ROOMS** *7 rooms and suites* · **RATES** *€€–€€€* · **FOOD** *In the restaurant with its small terrace, breakfast is served à la carte. For lunch and dinner there are many options within walking distance* · **HISTORY** *The building dates from 1790, the hotel was opened in May 2021* · **X-FACTOR** *A gem, a witness to the history of Lübeck*

EIN HAUS MIT GESCHICHTE

Dieses hübsche Stadthaus gehörte von 1868 bis 2016 der Spedition und Reederei F. H. Bertling, die in Lübeck lange ihren Sitz hatte und deren berühmtester Mitarbeiter Willy Brandt war – er absolvierte hier als junger Mann ein Volontariat. Vieles erinnert noch heute an die ehemaligen Besitzer: So blieb im Flur das „Kapitäns-Waschbecken" erhalten, an dem sich die Seemänner früher die Hände waschen mussten, ehe sie das Hauptkontor betreten durften. Für die Kopfteile der Betten recycelte man die Schiebetüren der alten Aktenschränke, und in den Badezimmern wurden Elemente ausrangierter Container verbaut. Die sieben Zimmer entstanden dort, wo einst Schreibmaschinensaal, Baumwollabteilung, Buchhaltung und Archiv untergebracht waren. Die Besitzerin Nina Dietze hat sie hanseatisch-skandinavisch eingerichtet und jedes nach einem ehemaligen Schiff der Reederei getauft. Fotos der Namensgeber schmücken die Wände, und in der Hochzeitssuite „Hilde" hängt sogar ein Aquarell, das der Kapitän des Frachters auf seinen Reisen gemalt hat. Wer noch tiefer in die Seefahrtsgeschichte von Lübeck eintauchen möchte, kann im nahen Museumshafen die berühmten, detailgetreu restaurierten Traditionssegler bewundern. Bis zu den „alten Pötten", wie sie flapsig-liebevoll auch genannt werden, läuft man vom Hotel aus nur ein paar Minuten: Die Reederin befindet sich in bester Lage auf der malerischen Altstadtinsel, die rundum von Wasser umgeben ist und das erste komplette Stadtviertel in Nordeuropa war, das zum Unesco-Welterbe ernannt wurde.
◆ Buch- und Filmtipp: „Buddenbrooks" von Thomas Mann (2008 von Heinrich Breloer verfilmt)

ANREISE *Vom Hauptbahnhof Lübeck benötigt man mit dem Taxi 10 Minuten. Wer mit dem eigenen Auto anreist, kann zum Ent- und Beladen vor dem Hotel halten und einen Parkplatz in der Nähe mieten* · **PREISE** *€€–€€€* · **ZIMMER** *7 Zimmer und Suiten* · **KÜCHE** *Im Restaurant mit kleiner Terrasse gibt es À-la-carte-Frühstück. Für Lunch und Dinner befinden sich in Gehweite zahlreiche Lokale* · **GESCHICHTE** *Das Haus anno 1790 wurde im Mai 2021 als Hotel eröffnet* · **X-FAKTOR** *Ein Schmuckstück, das Lübecker Geschichte erzählt*

UNE MAISON RICHE D'HISTOIRE

De 1868 à 2016, cette jolie maison de ville a appartenu à la société de transport et armateur F. H. Bertling, longtemps installée à Lübeck, et dont le collaborateur le plus célèbre fut l'ancien chancelier Willy Brandt – il y effectua un stage dans sa jeunesse. Les anciens propriétaires ont laissé ici de nombreux vestiges. Ainsi le « lavabo du capitaine », où les marins se lavaient autrefois les mains avant d'entrer dans le bureau de leur supérieur, a été conservé dans un couloir. Les portes coulissantes des anciennes armoires à dossiers ont été recyclées en têtes de lit et des éléments de conteneurs au rebut ont retrouvé une utilité dans les salles de bains. Chacune des sept chambres conçues dans ce qui était autrefois la salle des dactylos, le département coton, la comptabilité et les archives a été aménagée par la propriétaire Nina Dietze dans un style hanséatique et scandinave, et baptisée du nom d'un ancien navire de la compagnie Bertling. Des photos des femmes qui ont donné leur prénom à ces bateaux ornent les murs ; une aquarelle peinte par le capitaine du « Hilde » lors d'un de ses voyages est même accrochée dans la suite nuptiale éponyme. Ceux qui souhaitent approfondir leurs connaissances de l'histoire de Lübeck pourront admirer les voiliers anciens célèbres, restaurés dans les règles de l'art, qui sont exposés dans le tout proche musée du port. Les « vieux pots », comme sont affectueusement surnommés ces bateaux, se trouvent à quelques minutes à pied de l'hôtel. Die Reederin est idéalement situé sur l'île pittoresque que forme la vieille ville entièrement cernée d'eau, premier quartier entier d'Europe du Nord inscrit au patrimoine mondial de l'Unesco. ◆ À lire et à voir : « Les Buddenbrook » de Thomas Mann (adapté pour la télévision en 2008 par Heinrich Breloer)

ACCÈS *Située à 10 min en taxi de la gare centrale de Lübeck. Si vous arrivez en voiture, vous pourrez décharger vos bagages devant l'hôtel puis stationner sur un parking payant voisin* · **PRIX** *€€–€€€* · **CHAMBRES** *7 chambres et suites* · **RESTAURATION** *Le restaurant, doté d'une petite terrasse, propose un petit-déjeuner à la carte. De nombreux restaurants où bien déjeuner et dîner sont accessibles à pied* · **HISTOIRE** *La maison construite en 1790 a été convertie en hôtel en mai 2021* · **LES « PLUS »** *Un bijou, qui raconte l'histoire de Lübeck*

SCHLESWIG-HOLSTEIN 43

SEEHOTEL AM NEUKLOSTERSEE

NAKENSTORF

48 MECKLENBURG-VORPOMMERN

SEEHOTEL AM NEUKLOSTERSEE

Seestraße 1, 23992 Nakenstorf
Tel. +49 38422 4570 · seehotel@nalbach-architekten.de
www.seehotel-neuklostersee.de

ON THE SHORE OF THE LAKE

In the years of the German Democratic Republic, this hotel in the northwest of the province of Mecklenburg was a vacation home. After the reunification of Germany, the architects Johanne and Gernot Nalbach discovered the building, converted it into a hotel and lent it their own personal touch – as if it were the family's weekend home and they came from Berlin to the lake here every Friday, bringing a few good friends along with them. The rooms in modern country-house style are in the old brick-built farmhouse, in the 19th-century half-timbered "art barn," the new spa barn with its pool, and three holiday cottages that used to be dachas. On the peaceful lake, the Neuklostersee, the hotel has a sandy beach and two jetties where rowboats and sailboats can moor. Those who prefer to stay on dry land can explore the lake scenery by bike, or walk through the woods and past fields of wheat and flowering meadows, before eating some home-made cake on the restaurant terrace by the lake shore or relaxing with a massage in the spa. Children love the sheep and cats that live on the farm and some special spots such as the "bird's nest," a hiding place in the trees that can only be reached by climbing a rope ladder – a perfect place for reading or making up stories. And in the "children's hotel," a disused transformer building that the owners have repurposed as a playground, there are nest boxes for butterflies, May beetles and bats, a swing, and an ear trumpet for listening to birdsong. ◆ Book to pack: "Elective Affinities" by Johann Wolfgang von Goethe

DIRECTIONS *20 minutes' drive east of Wismar in the Sternberger Seenland nature reserve. Hamburg is 1.5 hours, Berlin 2.5 hours away by car ·* **RATES** *€€–€€€ ·* **ROOMS** *26 rooms and suites, plus 3 holiday cottages ·* **FOOD** *The restaurant with its terrace and conservatory serves breakfast and seasonal regional cooking according to the principles of the Slow Food movement. The hotel also has a bar with a cigar lounge ·* **HISTORY** *Opened in summer 1993 ·* **X-FACTOR** *Concerts, readings and drama productions are regularly held in the "art barn"*

DIREKT AM SEE

Zu DDR-Zeiten war diese Adresse im Nordwesten Mecklenburgs ein Ferienheim. Nach der Wende entdeckten die Architekten Johanne und Gernot Nalbach die Immobilie, wandelten sie in ein Hotel um und verliehen ihr dabei eine ganz persönliche Note – als wäre sie das Wochenendhaus der Familie, und man käme jeden Freitag aus Berlin hierher an den See, immer ein paar gute Freunde im Schlepptau. Die Zimmer im modernen Landhausstil befinden sich im alten Klinkerbauernhaus, in der historischen Fachwerk-Kunstscheune aus dem 19. Jahrhundert, der neuen Badescheune oder drei Ferienhäusern, die einst Datschen waren. Am friedlichen Neuklostersee hat das Hotel einen Sandstrand und zwei Stege, an denen Ruder- und Segelboote anlegen. Wer lieber auf festem Boden bleibt, kann die Seenlandschaft auf dem Fahrrad erkunden oder durch Wälder streifen, an Kornfeldern und Blumenwiesen vorbeispazieren und danach auf der Restaurantterrasse am Wasser hausgemachten Kuchen essen oder im Spa bei einer Massage entspannen. Kinder lieben die Schafe und Katzen, die auf dem Hof leben, und so besondere Orte wie das „Vogelnest", ein Versteck in den Bäumen, das nur über eine Strickleiter erreichbar ist – ein perfekter Platz zum Geschichtenlesen oder -erfinden. Und im „Kinderhotel", einem ausrangierten Trafohäuschen, das die Besitzer zum Spielplatz umfunktioniert haben, gibt es Nistkästen für Schmetterlinge, Maikäfer und Fledermäuse, eine Schaukel sowie einen Hörtrichter für Vogelstimmen. ◆ Buchtipp: „Die Wahlverwandtschaften" von Johann Wolfgang von Goethe

ANREISE *20 Fahrtminuten östlich von Wismar im Naturschutzgebiet Sternberger Seenland gelegen. Hamburg ist 1,5 und Berlin 2,5 Fahrtstunden entfernt* · **PREISE** *€€–€€€* · **ZIMMER** *26 Zimmer und Suiten, dazu 3 Ferienhäuser* · **KÜCHE** *Im Restaurant mit Terrasse und Wintergarten wird Frühstück serviert sowie saisonal-regionale Küche, die dem Slow-Food-Konzept folgt. Zudem besitzt das Hotel eine Bar mit Zigarrenlounge* · **GESCHICHTE** *Im Sommer 1993 eröffnet* · **X-FAKTOR** *Die Kunstscheune ist regelmäßig Bühne für Konzerte, Lesungen und Theateraufführungen*

SUR LE LAC

Au temps de la RDA, cette adresse au nord-ouest du Mecklembourg était celle d'un centre de vacances. Après la chute du Mur, les architectes Johanne et Gernot Nalbach ont découvert la propriété et l'ont transformée en hôtel, guidés par une vision très personnelle – celle d'une maison de famille où l'on viendrait de Berlin tous les vendredis pour passer le week-end au bord du lac avec quelques bons amis. Les chambres qui mêlent style campagnard et modernité ont été aménagées dans l'ancienne ferme en brique, dans la grange à colombages du XIXe siècle changée en lieu d'art, dans la nouvelle grange dédiée à la baignade et dans trois datchas converties en maisons de vacances. Posé sur une paisible rive du Neuklostersee, l'hôtel possède une plage de sable et deux pontons où sont amarrés bateaux à rames et à voile. Ceux qui préfèrent la terre ferme pourront explorer le paysage lacustre à vélo, se promener en forêt, entre champs de blé et prairies fleuries, puis déguster des gâteaux faits maison sur la terrasse du restaurant, au bord de l'eau, ou se détendre avec un massage au spa. Les enfants adorent les moutons et les chats qui vivent à la ferme et les nombreux recoins secrets du domaine, comme le « nid d'oiseau », une cachette dans les arbres accessible par une échelle de corde, parfaite pour lire ou inventer des histoires. Dans « l'hôtel des enfants », une sous-station électrique désaffectée que les propriétaires ont transformée en aire de jeu, ils découvriront des nichoirs pour papillons, hannetons et chauve-souris, une balançoire et un cornet acoustique pour écouter le chant des oiseaux. ◆ À lire : « Les Affinités électives » de Johann Wolfgang von Goethe

ACCÈS *Situé à 20 min de route à l'est de Wismar, dans la réserve naturelle du Sternberger Seenland. Hambourg est à 1,5 h de route et Berlin à 2,5 h* · **PRIX** *€€–€€€* · **CHAMBRES** *26 chambres et suites, 3 maisons de vacances* · **RESTAURATION** *Le restaurant avec terrasse et jardin d'hiver sert le petit-déjeuner et propose une cuisine locale et de saison élaborée selon le concept du «slow food». L'hôtel dispose aussi d'un bar et d'un salon pour les fumeurs de cigare* · **HISTOIRE** *Ouvert à l'été 1993* · **LES « PLUS »** *La grange dédiée à l'art accueille régulièrement concerts, lectures et représentations théâtrales*

MECKLENBURG-VORPOMMERN

MECKLENBURG-VORPOMMERN 53

GRAND HOTEL HEILIGENDAMM

BAD DOBERAN, OSTSEE

MECKLENBURG-VORPOMMERN

GRAND HOTEL HEILIGENDAMM

Prof.-Dr.-Vogel-Straße 6, 18209 Bad Doberan-Heiligendamm
Tel. +49 38203 7400 · info@grandhotel-heiligendamm.de
www.grandhotel-heiligendamm.de

SEASIDE SUMMER

In 1793 Friedrich Franz I, Grand Duke of Mecklenburg, heeding the advice of his personal doctor, took a break from his duties, and went to the Baltic Sea for a health cure. Here he bathed in the sea, breathed the salty air, and felt so good that he quickly decided to establish the first German seaside resort. The following years and decades saw the emergence of Heiligendamm, the "white town by the sea" with its neo-classical lodging houses, bathhouses and assembly rooms, and an atmosphere both elegant and fashionable. The European aristocracy made it their favorite destination: even Queen Luise of Prussia and Tsar Nicholas I spent their summer holidays here. Artists, too, were soon to arrive: in Heiligendamm Felix Mendelssohn Bartholdy found inspiration for his compositions, and Rainer Maria Rilke for his poetry. Today, this grand hotel brings the good old times back to life. Splendid buildings such as Burg Hohenzollern and Haus Mecklenburg, fully refurbished, accommodate the high-class rooms and suites (don't fail to book one with a sea view!), and the spa building with its columned façade houses no fewer than three restaurants. There is a dedicated children's villa, a de luxe playground, and a spa zone measuring 32,000 square feet. In the genuine seaside tradition, there is no lack of social life: guests stroll through the park, meet at classical and jazz concerts or for open-air film screenings by the pool, and take a ride in Molli, a heritage train that has been puffing and whistling since 1886 as it rumbles on its tracks to the neighboring seaside resorts of Kühlungsborn and Bad Doberan. ◆ Book to pack: "Selected Poems" by Rainer Maria Rilke, who loved the lake at Heiligendamm, where he wrote his poem "Hinter den schuldlosen Bäumen" ("Behind the Innocent Trees")

DIRECTIONS *Heiligendamm is northeast of Schwerin. The nearest major airports are Hamburg and Berlin (2.5–3 hours' drive)* · **RATES** *€€€–€€€€* · **ROOMS** *195 rooms and suites* · **FOOD** *Gourmet menus in "Friedrich Franz," which has a Michelin star, creative regional cuisine in the "Kurhaus Restaurant." In summer there is a beach bar and a food truck by the pool* · **HISTORY** *Opened in 2003 and modernized in 2024. In 2007 the G8 summit of world leaders was held here* · **X-FACTOR** *The dream beach with its pier and basket chairs*

SOMMERFRISCHE

1793 hörte Friedrich Franz I., Großherzog von Mecklenburg, auf seinen Leibarzt, ließ seine Verpflichtungen ruhen und fuhr zur Kur an die Ostsee. Dort badete er im Meer, atmete die salzhaltige Luft ein und fühlte sich so wohl, dass er kurz entschlossen das erste deutsche Seebad gründete. In den folgenden Jahren und Jahrzehnten entstand Heiligendamm, die „weiße Stadt am Meer" mit ihren klassizistischen Logier-, Bade- und Gesellschaftshäusern und ihrem eleganten sowie mondänen Flair. Europas Hochadel erkor sie zum Lieblingsziel; selbst Königin Luise von Preußen und Zar Nikolaus I. verbrachten hier ihre Sommerfrische. Auch Künstler ließen nicht auf sich warten: Felix Mendelssohn Bartholdy fand in Heiligendamm Inspiration für seine Kompositionen und Rainer Maria Rilke für seine Poesie. Heute lässt dieses Grandhotel die gute alte Zeit wieder aufleben. In rundum renovierten Prachtbauten wie der Burg Hohenzollern oder dem Haus Mecklenburg sind vornehme Zimmer und Suiten untergebracht (unbedingt Meerblick buchen!), und das Kurhaus mit seiner Säulenfassade beherbergt gleich drei Restaurants. Es gibt eine eigene Kindervilla, die ein Spielplatz de luxe ist, sowie ein 3000 Quadratmeter großes Spa. In echter Seebadtradition kommt auch das gesellschaftliche Leben nicht zu kurz: Man flaniert durch den Park, trifft sich bei Klassik- und Jazzkonzerten oder zum Freiluftkino am Pool und fährt mit der Nostalgiebahn Molli, die seit 1886 dampfend und pfeifend über die Schienen rattert, in die nahen Ostseebäder Kühlungsborn und Bad Doberan. ◆ Buchtipp: „Gesammelte Werke" von Rainer Maria Rilke, der den Spiegelsee von Heiligendamm liebte und hier das Gedicht „Hinter den schuldlosen Bäumen" schrieb

ANREISE *Heiligendamm liegt nordöstlich von Schwerin. Die nächsten großen Flughäfen sind Hamburg und Berlin (2,5–3 Fahrtstunden)* · **PREISE** *€€€–€€€€* · **ZIMMER** *195 Zimmer und Suiten* · **KÜCHE** *Gourmetmenüs im „Friedrich Franz" (ein Michelin-Stern), kreative Regionalküche im „Kurhaus Restaurant". Im Sommer gibt es eine Strandbar und einen Foodtruck am Pool* · **GESCHICHTE** *2003 eröffnet und zuletzt 2024 modernisiert. 2007 war der G8-Gipfel zu Gast* · **X-FAKTOR** *Der Bilderbuchstrand mit Steg und Strandkörben*

FRAÎCHEUR ESTIVALE

En 1793, Frédéric-François Iᵉʳ, grand-duc de Mecklembourg, abandonna les obligations de sa charge pour partir en cure au bord de la Baltique, sur ordre de son médecin personnel. Les bains de mer et les embruns lui firent un tel bien qu'il décida bientôt de fonder la première station balnéaire allemande. Heiligendamm, « la ville blanche en bord de mer », sortit de terre au cours des décennies suivantes : ses hôtels, ses établissements thermaux et ses diverses institutions bourgeoises aux façades d'une élégance classique ne tardèrent pas à attirer la bonne société mondaine. Elle devint la destination favorite de la haute noblesse européenne, et même la reine Louise de Prusse et le tsar Nicolas Iᵉʳ y passèrent l'été. Les artistes se joignirent au mouvement : Felix Mendelssohn Bartholdy y trouva l'inspiration pour ses compositions et Rainer Maria Rilke pour sa poésie. Un âge d'or que le grand hôtel fait aujourd'hui revivre. Les bâtiments qui constituent cet ensemble architectural sublime ont été entièrement rénovés : le château Hohenzollern et la maison Mecklembourg abritent des chambres et des suites au style raffiné (réservez impérativement une vue sur mer !) et la Kurhaus, avec sa façade à colonnade, accueille pas moins de trois restaurants. Une villa entière a été transformée en terrain de jeu de luxe pour les enfants et les adultes disposent d'un spa de 3 000 mètres carrés. Dans la plus pure tradition des stations balnéaires, la vie sociale n'est pas en reste : on flâne dans le parc, on se retrouve pour des concerts de musique classique ou de jazz, ou au cinéma en plein air au bord de la piscine, et on prend le petit train Molli, qui siffle depuis 1886 sur les rails menant aux stations voisines de Kühlungsborn et Bad Doberan. ◆ À lire : « Œuvres complètes » de Rainer Maria Rilke, qui aimait beaucoup le Spiegelsee de Heiligendamm, où il composa le poème « Derrière les arbres innocents »

ACCÈS *Situé au nord-est de Schwerin. Les grands aéroports les plus proches sont à Hambourg et Berlin (2,5–3 h de route)* · **PRIX** *€€€–€€€€* · **CHAMBRES** *195 chambres et suites* · **RESTAURATION** *Menus gastronomiques au « Friedrich Franz » (une étoile Michelin), cuisine régionale créative au « Kurhaus Restaurant ». Offre complétée l'été par un bar de plage et un food-truck à côté de la piscine* · **HISTOIRE** *Inauguré en 2003 et modernisé en 2024. Le sommet du G8 s'y est tenu en 2007* · **LES « PLUS »** *La plage de carte postale avec ponton et chaises de plage*

MECKLENBURG-VORPOMMERN 59

MECKLENBURG-VORPOMMERN 61

MECKLENBURG-VORPOMMERN

HOTEL NEPTUN

ROSTOCK-WARNEMÜNDE, OSTSEE

MECKLENBURG–VORPOMMERN

66 MECKLENBURG-VORPOMMERN

HOTEL NEPTUN

Seestraße 19, 18119 Rostock-Warnemünde
Tel. +49 381 7770 · info@hotel-neptun.de
www.hotel-neptun.de

EAST MEETS WEST

This hotel is a chapter in German history. A block of steel and concrete 210 feet high, it was built by a Swedish company on the beach at Warnemünde and inaugurated in 1970. It was conceived as luxury accommodation with western European standards – for vacationers from the West who would spend their hard currency behind the Iron Curtain. Up to 800 guests could be accommodated here, and all rooms had a sea view from the front or the side. The bar on the 19th floor provided a stunning panorama across the Baltic Sea, and the disco, one of the first in the German Democratic Republic, was legendary. Shortly after the opening, the GDR leader Erich Honecker allowed deserving members of the Free German Trade Union Federation to stay here for two weeks for a price of 310 marks per person, including full board. From that time onwards, guests from capitalist and communist countries, and from more than 120 nations, rubbed shoulders at the Neptun. Stars from the glittering world of show business and statesmen such as Fidel Castro and Helmut Schmidt came, and with so many opportunities for east-west contact, politicians and the secret police of the GDR were not far away. To prevent illegal exchange of money between the guests, the hotel even had its own currency at one stage. The hotel, the landmark of Warnemünde, successfully survived the fall of the East German socialist state, with a smaller number of beds but still with an ideal location on the beach, a thalasso spa and new restaurants. The best-loved places to eat and drink have stayed just as they were: the "Broiler" grill still serves its iconic chicken and fries, and the "Sky Bar" remains a popular location for watching ships. In fine weather the roof can be opened to the heavens as in the past – and today, it's not only the view of blue sky that is boundless. ◆ Book to pack: "Too Far Afield" by Günter Grass

DIRECTIONS *The drive to Rostock airport takes 40 minutes, to the airports in Hamburg and Berlin 2.5–3 hours ·* **RATES** *€€–€€€€ ·* **ROOMS** *338 rooms and suites on 14 of the 19 floors ·* **FOOD** *Four restaurants and three bars ·* **HISTORY** *Opened on 4 June 1971. Since 1996 the Neptun with its wellness zone covering 2,400 sq m/26,000 sq ft has been a spa hotel ·* **X-FACTOR** *The saltwater pool with a view of the Baltic Sea*

OST TRIFFT WEST

Dieses Hotel ist ein Stück deutsch-deutsche Geschichte. Der 64 Meter hohe Block aus Stahl und Beton wurde von einer schwedischen Firma am Strand von Warnemünde hochgezogen und Anfang der 1970er eingeweiht. Er war als Luxusherberge mit Westniveau konzipiert – für Westurlauber, die Devisen in den Osten bringen würden. Bis zu 800 Gäste konnten hier übernachten, alle Zimmer hatten mindestens seitliche Meersicht, die Bar in der 19. Etage bot ein grandioses Panorama über die Ostsee, und die Disco war eine der ersten in der DDR und legendär. Nur kurz nach dem Start öffnete Erich Honecker das Haus aber auch für verdiente Mitglieder des Freien Deutschen Gewerkschaftsbundes, die hier für 310 Mark pro Person inklusive Vollpension zwei Wochen Ferien machen konnten. Seither trafen sich im Neptun Gäste aus Sozialismus und Kapitalismus sowie aus mehr als 120 Ländern der Welt. Schillernde Showstars waren darunter und Staatsmänner wie Fidel Castro oder Helmut Schmidt, und bei so vielen möglichen Berührungspunkten von Ost und West waren auch Politik und Staatssicherheit der DDR nicht weit. Um illegalen Tauschhandel zwischen den Gästen einzudämmen, hatte das Hotel einst sogar seine eigene Währung. Die Wende hat das Hotel und Wahrzeichen von Warnemünde erfolgreich überstanden, mit etwas weniger Betten zwar, aber noch immer mit bester Strandlage, einem Thalasso-Spa und neuen Restaurants. Die beliebtesten Lokale jedoch sind die alten geblieben: Die „Grillstube Broiler", deren Hähnchen mit Pommes Kult sind, und die „Sky-Bar" als Lieblingsplatz zum Schiffeschauen. Bei schönem Wetter kann nach wie vor das Dach zum Himmel geöffnet werden – aber heute ist nicht nur der Blick ins Blaue grenzenlos. ◆ Buchtipp: „Ein weites Feld" von Günter Grass

ANREISE *Der Flughafen Rostock ist 40 Fahrtminuten entfernt, die Flughäfen von Hamburg und Berlin erreicht man in rund 2,5–3 Fahrtstunden* · **PREISE** *€€–€€€€* · **ZIMMER** *338 Zimmer und Suiten auf 14 der insgesamt 19 Etagen* · **KÜCHE** *Vier Restaurants und drei Bars* · **GESCHICHTE** *Am 4. Juni 1971 eröffnet. Mit dem 2400 qm großen Spa ist das Neptun seit 1996 ein Wellnesshotel* · **X-FAKTOR** *Das Meerwasser-Schwimmbad mit Blick auf die Ostsee*

L'EST RENCONTRE L'OUEST

Cet hôtel est un morceau d'histoire germano-allemande. Ce bloc d'acier et de béton de 64 mètres de haut a été érigé sur la plage de Warnemünde par une entreprise suédoise et inauguré au début des années 1970. L'hôtel a été conçu dans l'esprit d'une auberge de luxe selon les critères de l'Ouest, où les vacanciers de l'Ouest viendraient dépenser leurs devises. Il pouvait accueillir jusqu'à 800 clients par nuit, dans des chambres ayant toutes au moins une vue latérale sur la mer ; le bar du 19e étage offrait un panorama grandiose sur la Baltique, et la discothèque, une des premières de RDA, était légendaire. Peu après son inauguration, Erich Honecker l'ouvrit aux membres méritants de la Confédération des syndicats libres, qui allaient y passer deux semaines de vacances en pension complète pour 310 marks par personne. Depuis, adeptes du socialisme et du capitalisme et hôtes venus de 120 pays se sont croisés au Neptun, parmi lesquels des vedettes et des hommes d'État comme Fidel Castro et Helmut Schmidt. La porosité entre Ouest et Est y était telle que la police politique et les services de sécurité est-allemands n'étaient jamais bien loin non plus. Pour éviter le troc illégal entre les clients, l'hôtel avait même sa propre monnaie. Devenu le symbole de Warnemüde, il a survécu à la chute du Mur. Il propose moins de lits mais jouit toujours de son emplacement privilégié sur la plage, d'un spa thalasso et de nouveaux restaurants. Les plus populaires n'ont pas changé : le poulet-frites du « Grillstube Broiler » est culte et le « Sky Bar » reste l'endroit idéal pour admirer les bateaux. Par beau temps, le toit s'ouvre sur le ciel, comme avant – mais aujourd'hui cette vue sur le bleu n'est plus la seule à ne pas connaître de frontières. ◆ À lire : « Toute une histoire » de Günter Grass

ACCÈS *L'aéroport de Rostock se trouve à 40 min, ceux de Hambourg et Berlin sont à 2,5–3 h de route* · **PRIX** *€€–€€€€* · **CHAMBRES** *338 chambres et suites sur 14 des 19 étages* · **RESTAURATION** *Quatre restaurants et trois bars* · **HISTOIRE** *Ouvert le 4 juin 1971. Avec son spa de 2 400 m², le Neptun est classé « Hôtel bien-être » depuis 1996* · **LES « PLUS »** *La piscine d'eau de mer avec vue sur la Baltique*

MECKLENBURG-VORPOMMERN 69

KRANICH MUSEUM & HOTEL

HESSENBURG/SAAL

KRANICH MUSEUM & HOTEL

Dorfplatz 2–5, 18317 Hessenburg/Saal
Tel. +49 38223 669 900 · info@kranichhotel.de
www.kranichhotel.de

ON THE TRAIL OF THE CRANES

This bird is regarded as elegant, intelligent and alert, and in many cultures symbolizes love, loyalty and a long life. It is often seen as a bringer of good fortune, because it comes along with the spring: the crane. Flying from Spain to Sweden, this migratory bird makes a stopover in Mecklenburg-Western Pomerania. Twice a year, in spring and especially in autumn, visitors to this estate can see hundreds of cranes here. Its owner, an art historian, has conceived a special museum along with the New York artist and architect Alex Schweder and the architect Clemens Klein: as part of an artist-in-residence program, talented international artists spend some time on the estate, creating paintings, sculptures or installations inspired by the place and making them available to the in-house collection. In the park, which was laid out in the 19th century and restored between 2015 and 2020 by Ludivine Gragy, in the museum, and in the hotel rooms, guests can view the art dedicated to the cranes and their habitat. In the historic manor house dating from 1840, in the former ice house, and in what used to be the smithy, Schweder and Klein have designed extraordinary apartments. They combined rough brick walls and warm parquet floors, antiques and designer items. They adorned the rooms with cast-iron stoves and free-standing bathtubs, and rounded it all off with a skillful use of lighting. For self-catering, the vacation apartments have small kitchens – so that in principle guests do not need to leave the "crane cosmos," and can immerse themselves for a few days round the clock in this special world of its own. ◆ Book to pack: "Thousand Cranes" by Yasunari Kawabata

DIRECTIONS *The Hessenburg estate is in the north of Western Pomerania. The nearest regional airport is Rostock (1 hour's drive), the nearest international airport is Hamburg (2.5–3 hours by car)* · **RATES** *€–€€€* · **ROOMS** *6 rooms and 2 apartments in the main house, 2 apartments in the garden house, 1 apartment in the smithy* · **FOOD** *Breakfast is served in the room or the garden. From the end of March until the end of October, the estate's own café opens at weekends and on public holidays* · **HISTORY** *Bettina Klein, the hotel owner, bought the manor house at the end of 1998 and later acquired the rest of the 8-hectare/20-acre estate. The museum was opened in 2012, the hotel in stages from 2012* · **X-FACTOR** *With a little luck, you can also see storks nesting here*

AUF DEN SPUREN DER KRANICHE

Er gilt als elegant, klug und wachsam, ist in vielen Kulturen ein Symbol für Liebe, Treue und ein langes Leben und wird häufig als Glücksbote angesehen, da er den Frühling bringt: der Kranich. Auf seinem Weg zwischen Spanien und Schweden macht der Zugvogel auch in Mecklenburg-Vorpommern Station. Zweimal im Jahr, im Frühjahr und vor allem im Herbst, kann man hier Hunderte Kraniche beobachten und dabei auf diesem Gut wohnen. Seine Besitzerin, eine Kunsthistorikerin, hat mit dem New Yorker Künstler und Architekten Alex Schweder sowie dem Architekten Clemens Klein ein besonderes Museum konzipiert: Internationale Talente verbringen im Rahmen eines Artist-in-Residence-Programms einige Zeit auf dem Hof, schaffen vom Ort inspirierte Bilder, Skulpturen oder Installationen und stellen diese der hauseigenen Sammlung zur Verfügung. Die den Kranichen und ihrem Lebensraum gewidmete Kunst können die Gäste im Park, der im 19. Jahrhundert angelegt und 2015–2020 von Ludivine Gragy regeneriert wurde, im Museum und in den Hotelzimmern bestaunen. Im historischen Herrenhaus anno 1840, im ehemaligen Eishaus und in der einstigen Schmiede haben Schweder und Klein außergewöhnliche Apartments eingerichtet. Sie kombinierten rohe Backsteinwände und warme Parkettböden, Antiquitäten und Designerstücke, schmückten die Räume mit gusseisernen Öfen und frei stehenden Badewannen und rundeten das Ganze mit geschickt eingesetztem Licht ab. Für Selbstversorger haben die Ferienwohnungen kleine Küchen – so muss man den „Kosmos Kranich" im Prinzip nicht verlassen und darf diese ganz eigene Welt ein paar Tage lang rund um die Uhr erleben. ◆ Buchtipp: „Tausend Kraniche" von Yasunari Kawabata

ANREISE *Der Gutshof Hessenburg liegt im nördlichen Vorpommern. Nächster Regionalflughafen ist Rostock (1 Fahrtstunde), nächster internationaler Flughafen Hamburg (2,5–3 Fahrtstunden)* · **PREISE** *€–€€€* · **ZIMMER** *6 Zimmer und 2 Apartments im Haupthaus, 2 Apartments im Gartenhaus, 1 Apartment in der Schmiede* · **KÜCHE** *Frühstück gibt es im Zimmer oder Garten. Von Ende März bis Ende Oktober ist das hofeigene Café am Wochenende und an Feiertagen geöffnet* · **GESCHICHTE** *Eigentümerin Bettina Klein kaufte das Herrenhaus Ende 1998 und später die weiteren Grundstücke des 8 ha großen Guts. Das Museum eröffnete 2012, das Hotel sukzessive ab 2012* · **X-FAKTOR** *Mit viel Glück lassen sich hier auch Störche beim Nisten beobachten*

SUR LA PISTE DES GRUES

Élégante, intelligente, vigilante, elle symbolise l'amour, la fidélité et la longévité dans de nombreuses cultures, et parce qu'elle annonce le printemps, la grue est souvent considérée comme une messagère et un porte-bonheur. Sur son chemin migratoire entre l'Espagne et la Suède, elle fait halte dans le Land du Mecklembourg-Poméranie occidentale. Deux fois par an, au printemps et surtout à l'automne, il est ainsi possible d'observer depuis l'hôtel des centaines de ces beaux oiseaux blancs. La propriétaire des lieux, historienne d'art, a conçu avec l'artiste et architecte new-yorkais Alex Schweder et l'architecte Clemens Klein un musée très particulier : des artistes du monde entier passent quelque temps en résidence à la ferme et les toiles, les sculptures ou les installations que leur inspirent les lieux viennent enrichir la collection exposée. Les œuvres consacrées aux grues et à leur habitat sont mises en scène dans le parc créé au XIXe siècle et remanié entre 2015 et 2020 par Ludivine Gragy, dans le musée et dans les chambres de l'hôtel. Schweder et Klein ont aménagé des appartements d'exception dans le manoir historique bâti en 1840, dans l'ancienne glacière et dans l'ancienne forge. Ils y ont combiné murs en briques brutes et parquets chaleureux, antiquités et pièces de designers, poêles en fonte et baignoires îlot, le tout savamment éclairé. Les appartements sont équipés de petites cuisines pour ceux qui souhaitent préparer eux-mêmes leurs repas ; il est ainsi possible de ne pas quitter le « cosmos Kranich » afin d'y vivre en immersion totale 24 heures sur 24, pour un jour ou plusieurs. ◆ À lire : « Nuée d'oiseaux blancs » de Yasunari Kawabata

ACCÈS *Situé dans le Nord de la Poméranie occidentale. L'aéroport régional le plus proche est à Rostock (1 h de route), l'aéroport international le plus proche est celui de Hambourg (2,5–3 h de route)* · **PRIX** *€–€€€* · **CHAMBRES** *6 chambres et 2 appartements dans la maison principale, 2 appartements dans la « cabane » de jardin, 1 appartement dans la forge* · **RESTAURATION** *Le petit-déjeuner est pris en chambre ou dans le jardin. De fin mars à fin octobre, le café de la ferme est ouvert le week-end et les jours fériés* · **HISTOIRE** *La propriétaire Bettina Klein a acheté le manoir fin 1998, puis les autres parcelles du domaine de 8 hectares. Le musée a ouvert ses portes en 2012, et l'hôtel par étapes à partir de cette date* · **LES « PLUS »** *Avec beaucoup de chance, vous y observerez des cigognes en train de nicher*

MECKLENBURG-VORPOMMERN 75

MECKLENBURG-VORPOMMERN 77

GUT ÜSELITZ

POSERITZ, RÜGEN, OSTSEE

GUT ÜSELITZ

Üselitz 2, 18574 Poseritz
Tel. +49 170 555 7576 · info@ueselitz.de
www.ueselitz.de

DOUBLE GOOD FORTUNE

To live on an island is a stroke of luck in itself. But to live on an island that lies in turn on another island is twice as good – and on Rügen this is possible. There, in a sea inlet called Üselitzer Wiek, is a manor house surrounded by a heritage park and by water. When the owner, an architect, and his wife discovered this Renaissance building dating from the 16th century, it was a looted ruin with a collapsed roof. The couple sensitively restored the estate and reinterpreted its long history. Today it is an atmospheric, proud and somewhat defiant-looking moated castle, that combines historic and modern elements on the ground floor and harbors seven vacation apartments in a plain but elegant style. The apartments directly beneath the roof are especially fine, and even have their own terraces. Guests who bring along their extended family or a lot of friends can hire the house for exclusive use and feel like the lord of the manor for a while. A stroll through the enchanted park is like a journey back in time: here the foundation walls of barns have been uncovered, and apples, pears and plums grow on fruit trees that are over 100 years old. The watery landscape all around, which was drained in the 1920s but later flooded again and thus brought back to life, is home to greylag geese and ducks, cranes and cormorants – and displays a fascinating spectacle of light and color at all seasons of the year. ◆ Book to pack: "The Adventures of Elizabeth in Rügen" by Elizabeth von Arnim

DIRECTIONS *In the south of Rügen, just under 30 minutes' drive from Stralsund. The driving time by car to the regional airport in Rostock is 1.5 hours, to Hamburg and Berlin 3 hours ·* **RATES** *€–€€ ·* **ROOMS** *7 apartments ·* **FOOD** *The estate does not have its own restaurant, but kitchenettes have been installed in all of the apartments and guests can buy food in the nearby organic farm shop. The owners have also compiled a list of good places to eat on Rügen ·* **HISTORY** *The original house, built in about 1553, was one of the oldest on the island. The Welbergen family bought the estate in 1998 and completed restoration in early 2018 ·* **X-FACTOR** *The house and outbuildings can also be booked for weddings and other celebrations*

DOPPELTES GLÜCK

Auf einer Insel zu wohnen, ist schon ein Glück. Aber auf einer Insel zu wohnen, die wiederum auf einer Insel liegt, ist doppelt so schön – und auf Rügen möglich. Dort steht in der Meeresbucht Üselitzer Wiek dieses Gutshaus, das von einem denkmalgeschützten Park und von Wasser umgeben ist. Als der Besitzer, ein Architekt, und seine Frau das Renaissancegebäude aus dem 16. Jahrhundert entdeckten, war es eine geplünderte Ruine mit eingestürztem Dach. Mit viel Fingerspitzengefühl sanierte das Paar das Anwesen und interpretierte seine lange Geschichte neu. Heute ist es ein stimmungsvolles, stolzes und ein bisschen trutziges Wasserschloss, in dessen Erdgeschoss historische auf moderne Elemente treffen und das sieben schlicht-elegante Ferienwohnungen umfasst (besonders gelungen sind die Mansarden unterm Dach, die sogar eigene Terrassen haben). Wer mit der Großfamilie oder vielen Freunden kommen möchte, kann das Haus auch exklusiv mieten und sich dann wie ein Gutsherr auf Zeit fühlen. Ein Spaziergang durch den verwunschenen Park gleicht einer Reise in die Vergangenheit: Dort wurden die Grundmauern einstiger Scheunen freigelegt, und an mehr als 100 Jahre alten Obstbäumen wachsen Äpfel, Birnen und Pflaumen. Die Wasserlandschaft ringsum, die in den 1920ern trockengelegt, später aber wieder geflutet und damit neu belebt wurde, ist Heimat für Graugänse und Enten, Kraniche und Kormorane – und bietet zu jeder Jahreszeit ein faszinierendes Licht- und Farbenspiel.
◆ Buchtipp: „Elizabeth auf Rügen" von Elizabeth von Arnim

ANREISE *Im Süden von Rügen gelegen, knapp 30 Fahrtminuten von Stralsund entfernt. Zum nächsten Regionalflughafen in Rostock sind es 1,5 Fahrtstunden, nach Hamburg und Berlin je 3 Fahrtstunden* · **PREISE** *€-€€* · **ZIMMER** *7 Ferienwohnungen* · **KÜCHE** *Zum Gut gehört kein eigenes Restaurant, aber alle Apartments sind mit einer Küchenzeile ausgestattet (einkaufen kann man in nahen Hof- und Bioläden). Die Eigentümer haben zudem eine Liste mit guten Lokalen auf Rügen zusammengestellt* · **GESCHICHTE** *Das ursprüngliche Haus entstand um 1553 und war eines der ältesten der Insel. Die Familie Welbergen erwarb das Gut 1998 und schloss die Sanierung Anfang 2018 ab* · **X-FAKTOR** *Haus und Hof können auch für Hochzeiten und andere Feste gebucht werden*

DOUBLE CHANCE

Vivre sur une île est déjà une chance, mais vivre sur une île lovée dans une autre île, c'est deux fois plus beau – et c'est possible à Rügen. Là, dans la baie de l'Üselitzer Wiek, se niche un manoir entouré d'eau et doté d'un parc classé. Lorsque le propriétaire architecte et sa femme l'ont découvert, ce bâtiment Renaissance du XVIᵉ siècle n'était plus qu'une ruine pillée dont le toit s'était effondré. Le couple a réhabilité la propriété et réinterprété sa longue histoire avec goût et délicatesse. C'est aujourd'hui un château cerné d'eau, massif et majestueux, où règne une atmosphère unique ; il compte sept appartements sobres et élégants (mention spéciale aux suites mansardées dotées d'une terrasse indépendante, particulièrement réussies), et au rez-de-chaussée les détails historiques côtoient des éléments modernes. Ceux qui souhaitent y venir nombreux, en famille ou entre amis, peuvent louer la demeure entière et s'y sentir comme chez eux le temps de leur séjour. Une promenade dans le parc évoque un voyage dans le passé : les fondations d'anciennes granges ont été mises au jour et des arbres fruitiers plus que centenaires y donnent foison de pommes, de poires et de prunes. Le paysage aquatique qui l'entoure fut asséché dans les années 1920, puis remis en eau et si bien revitalisé qu'il accueille aujourd'hui des oies cendrées et des canards, des grues et des cormorans, et offre en toute saison un fascinant jeu de lumière et de couleurs. ◆ À lire : « Les aventures d'Elizabeth à Rügen » d'Elizabeth von Arnim

ACCÈS *Situé au sud de Rügen, à moins de 30 min en voiture de Stralsund. Il faut 1,5 h pour atteindre l'aéroport régional de Rostock et 3 h pour gagner ceux de Berlin et Hambourg* · **PRIX** *€-€€* · **CHAMBRES** *7 appartements de vacances* · **RESTAURATION** *L'établissement ne possède pas de restaurant, mais tous les appartements sont équipés d'une kitchenette et la clientèle peut faire ses courses dans les boutiques de la ferme et les magasins bio à proximité. Les propriétaires proposent aussi une liste des meilleurs restaurants de Rügen* · **HISTOIRE** *La maison d'origine, bâtie vers 1553, est une des plus anciennes de l'île. La famille Welbergen a acquis le domaine en 1998 et achevé sa rénovation début 2018* · **LES « PLUS »** *La maison et la ferme se réservent aussi pour des mariages et d'autres fêtes*

MECKLENBURG-VORPOMMERN

MECKLENBURG-VORPOMMERN 87

GUTSHAUS RENSOW

RENSOW

GUTSHAUS RENSOW

17168 Rensow (Prebberede)
Tel. +49 171 127 7050 · gutshaus-rensow@gmx.de
www.gutshaus-rensow.de

A PASSION FOR COLLECTING

When he was just a small boy, Knut traveled all around northern Germany with his father, an antiques dealer, rummaging around farmyards and manor houses in search of old furniture and porcelain. Later he even paid for part of his studies by selling what he found on flea markets. His Danish wife Christina was a fashion advisor who styled elite private clients such as Princess Diana in London before becoming a photo stylist and working as a decorator on the makeover of a grand hotel. So it's no wonder that this creative couple, who met in Copenhagen, pursue a shared passion: Knut and Christina save abandoned manor houses from ruin, restore the dilapidated fabric of the buildings with their own hands, and furnish them in the shabby chic manner – on a low budget but with lots of style, an eye for detail, and a touch of eccentricity. This is what happened with the manor house in Rensow, in the middle of nowhere in Mecklenburg, where they now live with their three children, pets, and farm animals. In their baroque mansion, almost every piece of furniture has its own history, and every accessory has a patina. Guests can stay in the former library with its Empire shelves, in the old pharmacy with exposed half-timbering, or in the Madonna Parlor, once a retreat for the lady of the house. A few steps away is the old village school, which the owners have furnished in a consciously rustic style, inspired by the wabi-sabi philosophy, which is based on the aesthetics of simplicity and imperfection. In the garden there is a quaint sauna, and guests also have use of the manor park. It was once landscaped in the English manner, but today has run a little bit wild and is home to a singing nightingale, lithe-limbed deer, and peacocks that fan their tails with nonchalance. At Rensow, even the animals are stylish. ◆ Book to pack: "A Landowner's Morning" by Leo N. Tolstoi

DIRECTIONS *Rensow is situated to the southeast of Rostock, about 2.5 hours by car from the airports of Berlin Brandenburg and Hamburg* · **RATES** *€–€€* · **ROOMS** *4 apartments and 3 double rooms in the manor house (maximum 21 guests), 2 apartments and 1 double room in the old school (maximum 10 guests). For group bookings, the rooms can be added to the apartments* · **FOOD** *For self-catering, all apartments have either a kitchen or facilities for making hot drinks* · **HISTORY** *The manor house was built in 1690 on the site of a 9th-century fort of the Slavic Wend people. Knut and Christina discovered it in 2002* · **X-FACTOR** *There is nothing boring about a country stay here: the hosts have lots of tips for outings in the region*

SAMMELLEIDENSCHAFT

Schon als kleiner Junge fuhr Knut mit seinem Vater, der einen Antikhandel betrieb, kreuz und quer durch Norddeutschland und stöberte auf Bauernhöfen und Landsitzen nach alten Möbeln und Porzellan. Später finanzierte er sogar einen Teil seines Studiums mit dem Verkauf von Flohmarktfundstücken. Seine dänische Frau Christina war Modeberaterin und stylte in London noble Privatkundinnen wie Prinzessin Diana, ehe sie als Fotostylistin tätig war und als Dekorateurin ein Grandhotel in Szene setzte. Kein Wunder also, dass das kreative Paar, das sich in Kopenhagen kennenlernte, einer gemeinsamen Leidenschaft folgt: Knut und Christina retten verlassene Gutshäuser vor dem Verfall, restaurieren die maroden Gemäuer eigenhändig und richten sie im Shabby Chic her – mit wenig Geld, aber viel Stil, einem Auge für Details und einer Prise Exzentrik. So auch das Haus in Rensow mitten im Nirgendwo von Mecklenburg, wo sie inzwischen mit drei Kindern, Haus- und Hoftieren leben. In ihrem barocken Gutsgebäude hat fast jedes Möbelstück eine Geschichte und jedes Accessoire Patina. Man kann in der ehemaligen Bibliothek mit Empireregalen wohnen, in der einstigen Apotheke mit freigelegtem Fachwerk und Kaminofen oder in der Madonnenstube, in die sich früher die Dame des Hauses zurückzog. Ein paar Schritte entfernt steht die alte Schule des Dorfs; diese haben die Besitzer bewusst rustikal eingerichtet und ließen sich dabei vom Wabi-Sabi-Konzept inspirieren, das auf der Ästhetik des Einfachen und Unvollkommenen basiert. Im Garten gibt es eine urige Sauna, und die Gäste dürfen zudem den Gutspark nutzen. Einst war er wie ein englischer Landschaftsgarten gestaltet, heute ist er leicht verwildert und Heimat einer singenden Nachtigall, zartgliedriger Rehe und von Pfauen, die nonchalant ihre Räder schlagen. Auf Rensow haben eben sogar die Tiere Stil. ◆ Buchtipp: „Der Morgen eines Gutsbesitzers" von Leo N. Tolstoi

ANREISE *Rensow liegt südöstlich von Rostock, von den Flughäfen Berlin Brandenburg und Hamburg sind es rund 2,5 Fahrtstunden* · **PREISE** *€–€€* · **ZIMMER** *4 Apartments und 3 Doppelzimmer im Gutshaus (maximal 21 Gäste), 2 Apartments und 1 Doppelzimmer in der alten Schule (maximal 10 Gäste). Die Zimmer ergänzen die Apartments bei Gruppenbuchungen* · **KÜCHE** *Alle Wohnungen haben Küchen oder Teeküchen für Selbstversorger* · **GESCHICHTE** *Das Gutshaus entstand 1690 an der Stelle einer wendischen Festung aus dem 9. Jahrhundert. Knut und Christina entdeckten es 2002* · **X-FAKTOR** *Langeweile auf dem Land gibt es hier nicht; die Gastgeber haben jede Menge Tipps für Ausflüge in die Umgebung*

COLLECTIONNITE

Tout petit déjà, Knut parcourait le Nord de l'Allemagne avec son père antiquaire, qui fouillait les fermes et les manoirs en quête de vaisselle et de meubles anciens. Il a ensuite financé une partie de ses études en vendant des objets trouvés dans les marchés aux puces. Sa femme danoise Christina, un temps conseillère de mode pour la noblesse londonienne et qui a compté parmi ses prestigieuses clientes la princesse Diana, a ensuite été styliste photo, avant de mettre en scène un grand hôtel en tant que décoratrice. Il n'est donc pas étonnant que ce couple de créatifs, qui s'est rencontré à Copenhague, s'engage dans une passion commune : Knut et Christina sauvent de la ruine des manoirs abandonnés, restaurent de leurs propres mains les murs délabrés et aménagent l'intérieur dans un style « shabby chic » bien dosé, avec peu de moyens mais beaucoup de style, un coup d'œil pour les détails et un brin d'excentricité. C'est ce qu'ils ont fait à Rensow, posé au milieu de nulle part dans le Mecklembourg, où ils vivent aujourd'hui avec leurs trois enfants et des animaux domestiques et de ferme. Dans leur manoir baroque, presque chaque meuble a une histoire et chaque accessoire, une patine. On peut séjourner dans l'ancienne bibliothèque aux rayonnages Empire, dans l'ancienne pharmacie avec ses colombages mis à nu et son poêle, ou dans le salon de la Madone, où se retirait autrefois la maîtresse de maison. L'ancienne école du village, à quelques pas de là, a été aménagée de manière volontairement rustique. Les propriétaires se sont inspirés du « wabi-sabi », concept fondé sur l'esthétique de la simplicité et de l'imperfection. Le jardin abrite un sauna et les hôtes peuvent aussi profiter du vaste parc. Jadis aménagé comme un jardin à l'anglaise, il est aujourd'hui laissé partiellement en friche fleurie et accueille un rossignol chanteur, des chevreuils aux pattes délicates et des paons nonchalants qui ne rechignent pas à faire la roue. À Rensow, même les animaux ont du style. ◆ À lire : « La Matinée d'un seigneur » de Léon Tolstoï

ACCÈS *Situé au sud-est de Rostock, à environ 2,5 h de route des aéroports de Berlin Brandenburg et de Hambourg* · **PRIX** *€–€€* · **CHAMBRES** *4 appartements et 3 chambres doubles dans le manoir (pour un total maximal de 21 hôtes); 2 appartements et 1 chambre double dans l'ancienne école (10 hôtes maximum). Les chambres complètent les appartements en cas de réservations de groupe* · **RESTAURATION** *Tous les appartements disposent d'une cuisine ou d'une kitchenette pour préparer soi-même ses repas* · **HISTOIRE** *Le manoir a été construit en 1690 à l'emplacement d'une forteresse slave du IXe siècle. Knut et Christina l'ont découvert en 2002* · **LES « PLUS »** *Impossible de s'ennuyer à la campagne; les propriétaires dispensent de nombreux conseils pour découvrir la région*

MECKLENBURG-VORPOMMERN 95

96 MECKLENBURG-VORPOMMERN

GLAMPING IM GUTSPARK

MALCHIN, MECKLENBURGISCHE SEENPLATTE

GLAMPING IM GUTSPARK

Scharpzower Dorfstraße 19, 17139 Malchin
Tel. +49 173 257 3343 · gutshausscharpzow@gmail.com
www.glampingimgutspark.de

CAMPING AS IN BYGONE TIMES

The owners of this glamping accommodation took their inspiration from the luxurious tents of the 19th century – from the age when wealthy travelers set up great camps for festivals and celebrations, giving them magnificent furnishings and opulent decoration. In the highly romantic manor park of Scharpzow in the lake district of Mecklenburg, they have erected four bell tents, made according to historic models and fitted out with facilities reminiscent of bygone days: proper beds and bedlinen are taken for granted here, as well as antique writing desks and rocking chairs, valet stands and old paintings. For hot days there is a fan, for cold weather a wood-burning stove – and as a small concession to the present day, the tents even have a power supply. Each has its own patio with a firepit, from where guests gaze into the pretty landscape garden with its gnarled trees and enchanted clearings. There are so many birds here that locals tell a story of how the writer Hoffmann von Fallersleben wrote his famous children's song "Alle Vögel sind schon da" ("All the birds are already here") after paying a visit. By a pond stands the garden pavilion, where guests meet for barbecues and chilling out – and in the elegant style of this manor estate, tablecloths and candles are laid out for a fine evening meal, as well as picnic baskets for excursions in the surroundings. One wonderful place for an outing is the lake in the neighboring village, where swimmers can leap into the water from wooden jetties, then dry out in the sunlight and the fresh air. At a nearby lake, the Kummerower See, a yacht rocks gently on the water – it is used by the owners of the manor, who like to take their guests for a sail at sunset. ◆ Book to pack: "As It Was: Pleasures, Landscapes and Justice" by Sybille Bedford

DIRECTIONS *The estate is between the villages of Malchin and Stavenhagen. The drive to the airports of Berlin and Hamburg takes 2.5–3 hours* · **RATES** *€–€€* · **ROOMS** *4 tents (22–40 sq m/240–430 sq ft, for up to 2 adults and 2 children). All guests share the warm-water outdoor shower and toilets* · **FOOD** *On request, breakfast with organic products and homemade bread is provided; Flammkuchen (crispy dough with a topping, like a pizza) is served on three evenings a week* · **HISTORY** *The manor house dates from 1896. It is the home of the hosts, who have been restoring the estate since 2019* · **X-FACTOR** *The outdoor sauna with a view of the pond and park*

ZELTEN WIE ANNO DAZUMAL

Von den luxuriösen Zeltlagern des 19. Jahrhunderts ließen sich die Besitzer dieser Glamping-Unterkünfte inspirieren – von der Epoche, als wohlhabende Reisende bei Festen und Feierlichkeiten große Zeltstätten errichteten, diese prachtvoll möblierten und opulent dekorierten. Im wildromantischen Gutspark von Scharpzow auf der Mecklenburgischen Seenplatte haben sie vier Glockenzelte aufgestellt, die nach historischen Vorlagen konstruiert und mit nostalgisch anmutenden Annehmlichkeiten ausgestattet wurden: Richtige Betten und Leinenwäsche gehören selbstverständlich mit dazu, außerdem antike Sekretäre und Schaukelstühle, stumme Diener und alte Gemälde. Für heiße Tage gibt es einen Ventilator und für kalte einen Holzofen – und als kleines Zugeständnis an die Gegenwart haben die Zelte sogar Strom. Von der eigenen Terrasse mit Feuerschale schaut man in den malerischen Landschaftspark mit seinen knorrigen Bäumen und verwunschenen Lichtungen. Hier leben seit jeher so viele Vögel, dass in der Gegend die Sage umgeht, Hoffmann von Fallersleben hätte nach einem Besuch seinerzeit das berühmte Kinderlied „Alle Vögel sind schon da" geschrieben. An einem Teich steht der Gartenpavillon, wo sich die Gäste zum Grillen und Chillen treffen – ganz im eleganten Gutsstil liegen hier auch Tischdecken und Kerzen für eine schöne Abendtafel bereit sowie Picknickkörbe für Ausflüge in die Umgebung. Ein wunderbares Ziel ist der Badesee des Nachbardorfs, wo man von Holzstegen aus ins Wasser springt und sich später von Licht und Luft trocknen lässt. Und am nahen Kummerower See dümpelt die Segeljacht, auf der die Gutsleute ihre Besucher gerne zu einem Sonnenuntergangstörn mitnehmen.
◆ Buchtipp: „Am liebsten nach Süden" von Sybille Bedford

ANREISE *Das Gut liegt zwischen den Ortschaften Malchin und Stavenhagen. Von den Flughäfen Berlin und Hamburg fährt man 2,5–3 Stunden* · **PREISE** *€–€€* · **ZIMMER** *4 Zelte (22–40 qm, für maximal 2 Erwachsene und 2 Kinder). Alle Gäste teilen sich die Außendusche mit warmem Wasser und die Toiletten* · **KÜCHE** *Auf Wunsch gibt es Frühstück mit Bioprodukten und selbst gebackenem Brot; an drei Abenden pro Woche gibt es Flammkuchen* · **GESCHICHTE** *Das Gutshaus ist von 1896. Dort wohnen die Gastgeber, die das Anwesen seit 2019 restaurieren* · **X-FAKTOR** *Die Außensauna mit Teich- und Parkblick*

CAMPER COMME DANS LE TEMPS

Les propriétaires de ces hébergements de glamping se sont inspirés des luxueux campements du XIXe siècle, que les voyageurs fortunés érigeaient puis meublaient et décoraient somptueusement pour divers rassemblements festifs. Dans le parc romantique et sauvage du domaine de Scharpzow, en pleine région des lacs du Mecklembourg, ils ont installé quatre tentes en cloche, conçues d'après les modèles historiques, avec des commodités qui fleurent bon la nostalgie : de vrais lits et du linge de maison en lin, des secrétaires anciens et des fauteuils à bascule, des valets de nuit et des tableaux classiques, un poêle à bois s'il fait froid et un ventilateur pour les journées chaudes, car oui, petite concession au temps présent, les tentes ont l'électricité ! La terrasse privée, équipée d'un brasero, offre une vue imprenable sur le parc paysager, ses arbres noueux et ses clairières enchantées. Tant d'oiseaux vivent ici, depuis si longtemps, qu'une légende circule selon laquelle Hoffmann von Fallersleben aurait composé sa célèbre chanson pour enfants « Alle Vögel sind schon da » (« Tous les oiseaux sont déjà là ») après avoir séjourné dans la région. Au bord d'un étang, le pavillon de jardin accueille les hôtes pour un barbecue ou un moment de détente – en accord avec l'esprit élégant du domaine, des nappes et des bougies sont à disposition pour dresser une belle table le soir, ainsi que des paniers de pique-nique pour les excursions. Le lac de baignade du village voisin est une destination merveilleuse où l'on saute à l'eau depuis des pontons en bois pour ensuite sécher au soleil, et les propriétaires aiment emmener leurs visiteurs pour une croisière au crépuscule à bord de leur voilier, sur le lac Kummerow tout proche.
◆ À lire : « Un héritage » de Sybille Bedford

ACCÈS *Situé entre les communes de Malchin et Stavenhagen. Les aéroports de Berlin et Hambourg sont à 2,5–3 h de route* · **PRIX** *€–€€* · **CHAMBRES** *4 tentes (22–40 m², pour 2 adultes et 2 enfants au maximum). Tous les hôtes partagent la douche extérieure avec eau chaude et les toilettes* · **RESTAURATION** *Sur demande, petit-déjeuner avec des produits bio et du pain maison ; trois soirs par semaine, tartes flambées* · **HISTOIRE** *L'établissement date de 1896. Les propriétaires vivent sur place et restaurent le domaine depuis 2019* · **LES « PLUS »** *Le sauna extérieur avec vue sur l'étang et le parc*

MECKLENBURG-VORPOMMERN 103

MECKLENBURG-VORPOMMERN

108 MECKLENBURG-VORPOMMERN

ST. OBERHOLZ RETREAT

LEIZEN, MECKLENBURGISCHE SEENPLATTE

ST. OBERHOLZ RETREAT

Walower Straße 30, 17209 Leizen
Tel. +49 30 5557 8594 · woldzegarten@sanktoberholz.de
www.sanktoberholz-retreat.de

I'M ON WORKATION

Ansgar Oberholz and his partner Koulla Louca made a name for themselves when they opened the first co-working café in Berlin and all of Germany on Rosenthaler Platz in 2005. Thanks to good coffee, a fast Internet connection, and like-minded customers, St. Oberholz was the meeting place for the crowd known as Berlin's digital Bohemia at that time and for start-up founders, many of whom turned their creative ideas into lots of money at the bar counter. Over the years, the project has grown and grown. More cafés in Berlin were added, then a consultancy that explained the transformation of the working world to companies, and finally the first workation hotel, the St. Oberholz Retreat. On an old farm in Mecklenburg-Western Pomerania it is now possible to combine work and vacation, the city and the country, and also design and nature. There are shared living areas with a sofa and corner seating, an open fireplace, a co-working space, and telephone kiosks for having an undisturbed conversation. Teams confer in separate workshop spaces and do yoga together after the meeting. For relaxation there is also a large garden, a lake for swimming and a spa with a pool and sauna. The restaurant is furnished with chairs by Bruno Rey, and has plenty of vegan and vegetarian dishes on the menu. The rooms and apartments in the farmhouse and the converted sheep stall are a treat for the eyes: they have wonderful monochrome color schemes and bed platforms almost as high as the windows, designed specially for the hotel by the architect Sigurd Larsen. Days when you have a view of the natural surroundings as soon as you wake up are usually extremely good days.

◆ Book to pack: "The Perfections" by Vincenzo Latronico

DIRECTIONS *Woldzegarten is situated 1.5–2 hours' drive north of Berlin and 2–2.5 hours east of Hamburg* · **RATES** *€€–€€€* · **ROOMS** *18 rooms and 8 apartments* · **FOOD** *A delicious breakfast and creative dishes made from regional organic products* · **HISTORY** *The farm dates back to the 18th century, and the retreat started up in January 2023* · **X-FACTOR** *Where work is vacation*

I'M ON WORKATION

Bekannt wurden Ansgar Oberholz und seine Partnerin Koulla Louca, als sie 2005 am Rosenthaler Platz in Berlin das erste Coworking-Café der Stadt und des Landes eröffneten. Guter Kaffee, schnelles Internet und gleichgesinnte Gäste: Im St. Oberholz trafen sich die, die man damals Berlins digitale Boheme nannte, und Start-up-Gründer, die vom Tresen aus ihre kreativen Ideen oft zu viel Geld machten. Im Lauf der Jahre ist das Projekt kontinuierlich gewachsen. Weitere Cafés in Berlin kamen hinzu, eine Beratungsfirma, die Unternehmen den Wandel der Arbeitswelt erklärt, und schließlich das erste Workation-Hotel, das St. Oberholz Retreat. Auf einem alten Gutshof in Mecklenburg-Vorpommern lassen sich seither Arbeit und Urlaub, Stadt und Land sowie Design und Natur verbinden. Es gibt gemeinsam genutzte Wohnflächen mit Sofa und Sitzecken, offenem Kamin, Coworking-Bereich und Telefonzellen für ungestörte Gespräche. Teams diskutieren in separaten Workshop-Räumen und machen nach dem Meeting zusammen Yoga. Zur Entspannung gibt es außerdem einen großen Garten, einen Badesee sowie ein Spa mit Schwimmbad und Sauna. Im Restaurant stehen Stühle von Bruno Rey und auf der Speisekarte zahlreiche vegane und vegetarische Gerichte. Eine besondere Augenweide sind die Zimmer und Apartments im Gutshaus und ehemaligen Schafstall: Sie haben wunderbare monochrome Farbkonzepte und Bettpodeste, die der Architekt Sigurd Larsen speziell für das Hotel entworfen hat und die nahezu Fensterhöhe erreichen. Tage, an denen man schon beim Aufwachen direkt in die Natur schaut, werden meistens gute Tage.
◆ Buchtipp: „Die Perfektionen" von Vincenzo Latronico

ANREISE *Woldzegarten liegt 1,5–2 Fahrtstunden nördlich von Berlin und 2–2,5 Fahrtstunden östlich von Hamburg* · **PREISE** €€–€€€ · **ZIMMER** *18 Zimmer und 8 Apartments* · **KÜCHE** *Leckeres Frühstück und kreative Gerichte aus regionalen Bioprodukten* · **GESCHICHTE** *Der Gutshof datiert bis ins 18. Jahrhundert zurück. Das Retreat besteht seit Januar 2023* · **X-FAKTOR** *Wo Arbeit Urlaub wird*

BUREAU AVEC VUE

Ansgar Oberholz et sa partenaire Koulla Louca se sont fait connaître en 2005 en ouvrant à Berlin le premier café de coworking de la ville et d'Allemagne, sur la Rosenthaler Platz. Du bon café, une connexion Internet à haut débit et une clientèle réunie autour d'idées communes – ce qu'on appelle alors la bohème numérique berlinoise aime à se retrouver au St. Oberholz, où nombre de fondateurs de start-ups ont monnayé leurs idées créatives au comptoir. Au fil des années, le projet ne cesse de croître. D'autres cafés s'ajoutent à celui de Berlin, puis une société de conseil dédiée aux changements subis par le monde du travail. Enfin, les deux associés ouvrent le premier hôtel workation, le St. Oberholz Retreat – un lieu où se mêlent travail et loisirs, ville et campagne, design et nature, dans une ancienne ferme du Mecklembourg-Poméranie occidentale. On y trouve des espaces communs avec canapés et coins salon, une cheminée ouverte, un espace de coworking et des cabines téléphoniques pour les discussions confidentielles. Les équipes disposent de salles de travail séparées et peuvent enchaîner réunion et séance de yoga collective. Pour la détente, la clientèle dispose d'un grand jardin, d'un lac de baignade et d'un spa avec piscine et sauna. Le restaurant est équipé de chaises de Bruno Rey et la carte propose de nombreux plats végétariens et vegans. Les chambres et les appartements du manoir et de l'ancienne bergerie sont un régal pour les yeux, avec leurs camaïeux de couleurs admirablement choisies et leurs estrades spécialement conçues pour l'hôtel par l'architecte Sigurd Larsen, afin de surélever les lits à hauteur de fenêtre. Contempler la nature dès le réveil présage en général d'une bonne journée. ◆ À lire : « Les Perfections » de Vincenzo Latronico

ACCÈS *Woldzegarten se trouve à environ 1,5–2 h de route au nord de Berlin et à 2–2,5 h de route à l'est de Hambourg* · **PRIX** €€–€€€ · **CHAMBRES** *18 chambres et 8 appartements* · **RESTAURATION** *Un petit-déjeuner délicieux et des plats créatifs à base de produits bio et locaux* · **HISTOIRE** *Le domaine date du XVIIIe siècle. Le refuge existe depuis janvier 2023* · **LES « PLUS »** *Quand le travail ressemble à des vacances*

116 MECKLENBURG-VORPOMMERN

MECKLENBURG-VORPOMMERN 117

ST. OAK

KYRITZ

ST. OAK

Marktplatz 2B, 16866 Kyritz
Tel. +49 172 326 2282 · hello@st-oak.com
www.st-oak.com

A DREAM HOUSE

This charming little town is also known in Brandenburg as "Kyritz an der Knatter," meaning "on the Rattle." It does not owe this jokey nickname to any river, but to the loud rattling of the mill wheels that once turned here: Kyritz was once an important place for artisans and merchants, and even became a member of the Hanseatic League, an association of trading cities. Visitors who would like to trace this history can stay in fine style in the historic town center. In a magnificent building, a protected monument directly on the marketplace, Laura Muthesius and Nora Eisermann have fitted out three fantastic vacation apartments. The staircase leading up to them with its blue wall tiles and original Art Nouveau windows is a sight for sore eyes immediately on entering! The two owners are the authors of a successful food and design blog (Our Food Stories), posting opulently arranged photos that are almost as lovely as Old Masters. Their sense of beauty and aesthetics is evident in very detail of the three exquisite apartments. In the loft apartment measuring 1,725 square feet, the olive-green Devol kitchen combines English country-house style with Moroccan tiles and Carrara marble, the living room is furnished with perfectly formed Danish designer items, art books add a personal touch, and brass fittings gleam in the bathroom. Oak parquet flooring and walls in natural-colored limewash frame these gems, and there is even a pretty south-facing balcony with a view of the town hall and the peace oak that was planted in 1814 after the defeat of Napoleon at the Battle of the Nations. ◆ Book to pack: "Before the Feast" by Saša Stanišić

DIRECTIONS *Kyritz is about 1.5 hours' drive northwest of Berlin* · **RATES** *€–€€* · **ROOMS** *1 apartment for up to 4 persons, 2 others with 3 and 2 rooms respectively* · **FOOD** *Self-caterers buy produce in the nearby health-food shop or on the market that is held right outside the door on Tuesdays and Fridays. In summer guests can use the little garden in the back yard with its outdoor stove and barbecue* · **HISTORY** *Constructed for a bank in 1912, the building has housed holiday apartments since 2024* · **X-FACTOR** *Four bikes are available to guests for trips to swim in the nearby lakes and to an idyllic rose garden, the Kyritzer Stadtpark*

BRANDENBURG

TRAUMHAUS

Dieses charmante Städtchen ist in Brandenburg auch als „Kyritz an der Knatter" bekannt. Den etwas flapsigen Beinamen verdankt es keinem Fluss, sondern den laut knatternden Mühlenrädern, die sich hier früher drehten – Kyritz war einst ein bedeutender Standort für Handwerker und Händler und sogar Mitglied der Hanse. Wer den Spuren der Geschichte folgen möchte, kann im historischen Zentrum ausgesprochen stilvoll wohnen: In einem denkmalgeschützten Prachtbau direkt am Marktplatz haben Laura Muthesius und Nora Eisermann drei fantastische Ferienwohnungen eingerichtet. Schon der Aufstieg durchs Treppenhaus mit seinen blauen Wandfliesen und originalen Jugendstilfenstern ist ein Augenschmaus! Die beiden Besitzerinnen betreiben einen erfolgreichen Food- und Designblog (Our Food Stories), dessen opulent inszenierte Fotos beinahe so malerisch sind wie alte Meister. Ihr Gespür für Schönheit und Ästhetik zeigt sich in jedem Detail der drei exquisiten Apartments. So wurde in dem 160 Quadratmeter großen Loft Apartment die olivgrüne Devol-Küche im englischen Landhausstil mit marokkanischen Kacheln und Carrara-Marmor kombiniert, im Wohnzimmer stehen formschöne dänische Designermöbel, Kunstbücher sorgen für eine persönliche Note, und im Bad glänzen Messingarmaturen. Eichenparkett und in Naturtönen gekalkte Wände rahmen die Schmuckstücke ein, und es gibt sogar einen lauschigen Südbalkon mit Blick auf das Rathaus sowie die Friedenseiche, die 1814 nach dem Sieg über Napoleon in der Völkerschlacht gepflanzt wurde.
◆ Buchtipp: „Vor dem Fest" von Saša Stanišić

ANREISE *Kyritz liegt rund 1,5 Fahrtstunden nordwestlich von Berlin* · **PREISE** *€–€€* · **ZIMMER** *1 Apartment für bis zu 4 Personen, 2 weitere Wohnungen mit 3 bzw. 2 Zimmern* · **KÜCHE** *Selbstversorger kaufen im nahen Bioladen oder auf dem Wochenmarkt ein, der dienstags und freitags vor der Tür stattfindet. Im Sommer kann man das Hinterhofgärtchen mit Außenküche und Grill nutzen* · **GESCHICHTE** *Das Haus wurde 1912 von einer Bank gebaut. Seit 2024 werden hier Ferienapartments vermietet* · **X-FAKTOR** *Für Gäste stehen vier Fahrräder bereit, um Ausflüge zu den nahen Badeseen und dem idyllischen Rosengarten, dem Kyritzer Stadtpark, zu machen*

MAISON DE RÊVE

Cette charmante bourgade du Brandebourg est surnommée « Kyritz sur le Knatter », en référence non à un cours d'eau qui la traverserait, mais au bruit des roues de moulin qui y tournaient autrefois (« knattern » signifie « claquer »), à l'époque où Kyritz était un carrefour important, membre de la Hanse. Si vous souhaitez remonter le fil de l'histoire, une adresse de la vieille ville conjugue patrimoine et style : Laura Muthesius et Nora Eisermann ont aménagé trois fantastiques appartements de vacances dans un magnifique bâtiment classé monument historique, situé directement sur la place du marché. La cage d'escalier, avec ses carreaux muraux bleus et ses fenêtres Art nouveau d'origine, est déjà un plaisir pour les yeux ! Les deux propriétaires tiennent un blog très suivi sur l'alimentation et le design (Our Food Stories) dont les photos, mises en scène avec opulence, sont presque aussi pittoresques que les natures mortes des maîtres anciens. Leur sens de l'esthétique et leur coup d'œil pour la beauté se manifestent dans chaque détail des trois appartements. Dans le loft de 160 mètres carrés, par exemple, la cuisine Devol vert olive de style cottage anglais se marie avec des carreaux marocains et du marbre de Carrare, des meubles design danois aux formes élégantes ont été installés dans le salon, des livres d'art apportent une touche personnelle et des robinets en laiton brillent dans la salle de bains. Le parquet en chêne et les murs passés à la chaux dans des tons naturels servent d'écrin à ces détails précieux. Il y a même un charmant balcon plein sud avec vue sur l'hôtel de ville et le chêne de la paix, planté en 1814 après la victoire sur Napoléon lors de la bataille des Nations. ◆ À lire : « Avant la fête » de Saša Stanišić

ACCÈS *Situé à environ 1,5 h de route au nord-ouest de Berlin* · **PRIX** *€–€€* · **CHAMBRES** *1 appartement accueillant jusqu'à 4 personnes, 2 autres logements avec 2 ou 3 chambres* · **RESTAURATION** *Ceux qui souhaitent faire leurs courses en toute autonomie peuvent se fournir au magasin bio tout proche ou au marché qui se tient sur le pas de la porte les mardis et vendredis. En été, on peut utiliser le petit jardin de l'arrière-cour avec cuisine extérieure et barbecue* · **HISTOIRE** *La maison a été bâtie en 1912 pour une banque. Depuis 2024, on y loue des appartements de vacances* · **LES « PLUS »** *Quatre vélos sont à la disposition des hôtes pour faire des excursions vers les lacs de baignade voisins et l'idyllique Rosengarten, le parc municipal de Kyritz*

BRANDENBURG 123

STIMBEKHOF

BISPINGEN, LÜNEBURGER HEIDE

STIMBEKHOF

Oberhaverbeck 2, 29646 Bispingen
Tel. +49 5198 981 090 · moin@stimbekhof.de
www.stimbekhof.de

A HAPPY PLACE

According to an old rule of thumb, the heather on the Lüneburg Heath flowers between 8 August and 9 September. In this season, a purple carpet covers the land, and on perfect days when ground mist floats over the earth and the setting sun turns the sky orange, pink and red, the heath rivals even Provence with its fields of lavender. So late summer is the best time to come, and the finest place to stay then is the Stimbekhof, which is a picture postcard motif, just like the natural world around it. The farm and its thatched half-timbered buildings date from 1920. It was a guesthouse for horse riding and a conference hotel until it became the pet project of three young hoteliers. Björn, Sabrina and Jovitha first leased then bought the ensemble, and transformed it into snug accommodation. The rooms have lattice windows, quietly creaking floorboards and modern country-house furnishings. There are both charming little chambers and extensive suites with a terrace, and the coziest rooms are directly beneath the slope of the roof and have massive ceiling beams. Guests can sleep late in perfect peace, later do some yoga in green surroundings, read a book beneath ancient trees, and sweat out the last traces of stress in the sauna. A truly relaxed way to explore the area is to hire a horse-drawn coach – and for more active exercise, guests cycle or hike along the so-called Heidschnuck Way, named after the local breed of sheep. To round off the evening in fitting style, they can drink a heather-flower cocktail in this enchanting scenery on an estate that brings happiness to its visitors. ◆ Book to pack: "Dark Mirrors" by Arno Schmidt (who lived one hour away in Bargfeld, where his house can be visited)

DIRECTIONS *In Oberhaverbeck in the state of Lower Saxony, close to picturesque Bispingen. 1 hour by car south of Hamburg, 1.5 hours by car to Hamburg airport* · **RATES** *€€–€€€* · **ROOMS** *27 rooms and suites, plus from May to October 1 glamping tent for 2 persons* · **FOOD** *The farm kitchen and café serve breakfast, bakery treats (Sabrina's apple waffles are delightful) and small dishes. As many ingredients as possible are locally produced* · **HISTORY** *Opened in summer 2020* · **X-FACTOR** *Yoga and fasting retreats are held regularly*

EIN GLÜCKSGRIFF

Nach einer alten Faustregel blüht die Lüneburger Heide zwischen dem 8. August und 9. September – dann liegt eine lilafarbene Decke über dem Land, und wenn an perfekten Tagen morgens Nebel über dem Boden schwebt und abends die untergehende Sonne den Himmel orange, rosa und rot färbt, macht die Heide selbst der Provence mit ihren Lavendelfeldern Konkurrenz. Am besten kommt man also im Spätsommer hierher, und am schönsten wohnt man dann im Stimbekhof, der wie die Natur ringsum einem Bilderbuchmotiv gleicht. Entstanden ist der Hof mit seinen reetgedeckten Fachwerkhäusern 1920. Er diente als Pferdepension sowie Tagungshotel, ehe er zum Herzensprojekt dreier junger Hoteliers wurde. Björn, Sabrina und Jovitha haben das Ensemble zunächst gepachtet und dann gekauft und in ein lauschiges Gut verwandelt. Die Zimmer haben Sprossenfenster, leicht knarzende Dielen und modernes Landhausmobiliar. Es gibt charmante Stübchen ebenso wie weitläufige Suiten mit Terrasse, wobei die gemütlichsten Räume direkt unter Dachschrägen und dicken Deckenbalken liegen. Gäste können in vollkommener Ruhe ausschlafen, später Yoga im Grünen praktizieren, unter uralten Bäumen ein Buch lesen und das letzte bisschen Stress in der Sauna ausschwitzen. Ganz entspannt lässt sich die Umgebung dann per Pferdekutsche entdecken – wer aktiver sein will, fährt Rad oder wandert entlang des Heidschnuckenwegs, der nach der hiesigen Schafrasse benannt ist. Stilgetreu beschließt abends ein Heideblütencocktail den Tag in dieser zauberhaften Landschaft und auf einem Gut, das glücklich macht. ◆ Buchtipp: „Schwarze Spiegel" von Arno Schmidt (er lebte im eine Stunde entfernten Bargfeld, wo sein ehemaliges Haus besichtigt werden kann)

ANREISE *Im niedersächsischen Oberhaverbeck gelegen, nahe des pittoresken Orts Bispingen. 1 Fahrtstunde südlich von Hamburg, der Flughafen Hamburg liegt 1,5 Fahrtstunden entfernt* · **PREISE** €€–€€€ · **ZIMMER** *27 Zimmer und Suiten, dazu von Mai bis Oktober 1 Glamping-Zelt für 2 Personen* · **KÜCHE** *Hofküche und -café servieren Frühstück, Gebäck (Sabrinas Apfelwaffeln sind ein Gedicht!) und kleine Gerichte. So viele Zutaten wie möglich kommen aus der Gegend* · **GESCHICHTE** *Im Sommer 2020 eröffnet* · **X-FAKTOR** *Regelmäßig finden Yoga- und Fasten-Retreats statt*

UN COUP DE CHANCE

Selon une règle empirique ancestrale, la lande de Lunebourg fleurit entre le 8 août et le 9 septembre ; une couverture mauve s'étend alors sur la région et quand le brouillard matinal flotte au-dessus du sol, que le soleil couchant teinte le ciel d'orange, de rose et de rouge, la lande rivalise même avec la Provence et ses champs de lavande. L'été indien est donc la meilleure période où séjourner au Stimbekhof pour profiter pleinement des beautés de la nature environnante, comme sorties d'un livre d'images. La ferme, avec ses chaumières à colombages, a vu le jour en 1920 et a servi de pension pour chevaux et d'hôtel de congrès avant de devenir le projet passion de trois jeunes hôteliers. Björn, Sabrina et Jovitha ont d'abord loué puis acheté l'ensemble et l'ont transformé en un domaine intime. Les chambres ont des fenêtres à croisillons, des planchers qui grincent juste ce qu'il faut et des meubles à la fois rustiques et modernes. Des petits salons charmants jouxtent de vastes suites avec terrasse, et les chambres les plus confortables ont été aménagées dans les combles aux poutres épaisses. Les hôtes peuvent s'accorder de longues grasses matinées, faire du yoga dans la verdure, lire un livre sous les arbres centenaires et évacuer au sauna le peu de stress restant. Ils découvrent les environs en calèche, ou à vélo pour les plus actifs, ou partent en randonnée sur le Heidschnuckenweg, ainsi nommé en référence à la race de moutons locale. Le soir, un cocktail aux fleurs de bruyère apportera une conclusion parfaite à une journée enchanteresse dans un écrin qui rend heureux. ◆ À lire : « Miroirs noirs » d'Arno Schmidt (il vécut à une heure de là, à Bargfeld, où son ancienne maison se visite)

ACCÈS *Situé à Oberhaverbeck, en Basse-Saxe, près du joli village de Bispingen. À 1 h de route au sud de Hambourg et à 1,5 h de l'aéroport de Hambourg* · **PRIX** €€–€€€ · **CHAMBRES** *27 chambres et suites, ainsi qu'une tente de glamping pour 2 personnes de mai à octobre* · **RESTAURATION** *La cuisine et le café de la ferme servent le petit-déjeuner, des pâtisseries (les gaufres aux pommes de Sabrina sont un poème !) et de délicieux petits plats. Autant que possible, les ingrédients sont locaux* · **HISTOIRE** *Ouvert à l'été 2020* · **LES « PLUS »** *Des retraites de yoga et de jeûne sont régulièrement organisées*

132 NIEDERSACHSEN

NIEDERSACHSEN 133

RESORT BAUMGEFLÜSTER

BAD ZWISCHENAHN

RESORT BAUMGEFLÜSTER

Brannenweg 22 (office), 26160 Bad Zwischenahn
Tel. +49 179 739 2658 · info@baumgefluester.de
www.baumgefluester.de

WELL HIDDEN

To sleep in a tree house once in your life: this is a dream that many have in childhood, but not everyone makes it come true. Some people have no garden, or lack a suitable tree, or find no one in the family with a talent for carpentry, and others cannot summon the courage after all to spend a night in a tree house with all its unaccustomed and slightly spooky sounds. What a blessing, therefore, is this resort in the Ammerland region of Lower Saxony, where guests can stay in green surroundings in safety in extremely comfortable tree houses! The owner reveals the exact location of the well-hidden spot in the forest to her guests only when they arrive. In a clearing they then find four luxurious wooden houses, standing proudly on posts 13 feet high among oak and beech trees. The rooms are designed according to Le Corbusier's proportions with their walls of solid, untreated larch wood that is windproof, rainproof, and smells wonderful. On an area of almost 430 square feet, each house has a living room with kitchenette, a bedroom, and a bathroom, and is supplied with warm water, electricity, and even underfloor heating – only television and radio are, purposely, absent. To make up for this, guests have a direct view of the natural world from large windows and the terrace for spotting squirrels, rabbits, pheasants, and sometimes a young deer or a rare goldcrest by day. As there are no sources of artificial light round about, on cloudless nights a myriad stars twinkle above the tree tops, and the forest rustles and whispers round the clock – which is how the resort got its name, meaning "tree whispers." Guests almost feel reluctant to leave behind the rustling and take a trip around the region. Those who manage to do this can visit nearby Bad Zwischenahn, where rhododendrons flower in the parks in May and June, or the Zwischenahner Meer – the name suggests the sea, but actually it is a lake – and of course a real sea too, the North Sea. ◆ Book to pack: "Walden; or, Life in the Woods" by Henry David Thoreau

DIRECTIONS *Near Bad Zwischenahn, just under 1 hour by car from the regional airport in Bremen and 2.5 hours from Hamburg airport* · **RATES** *€€–€€€* · **ROOMS** *4 tree houses, each with a terrace of about 16 sq m/ 170 sq ft, for up to 4 persons. Another, larger house is planned for 2025* · **FOOD** *All tree houses have a pantry. If desired, a breakfast basket with rolls, home-made jam and herb dip is placed by the door. Very close by in the spa town are some wonderful restaurants, one of them Michelin-starred* · **HISTORY** *Designed by Andreas Wenning, a tree-house architect from Bremen, and opened in 2011* · **X-FACTOR** *Glamping with all five senses*

GUT VERSTECKT

Einmal im Baumhaus schlafen: Diesen Traum haben als Kind viele, doch nicht allen wird er erfüllt. Mal fehlt der eigene Garten, mal der passende Baum. Manchmal findet sich in der Familie kein talentierter Handwerker, und manchmal reicht am Ende der Mut dann doch nicht aus für eine Baumhausnacht mit all ihren ungewohnten und ein bisschen unheimlichen Geräuschen. Wie schön, dass es dieses Resort im niedersächsischen Ammerland gibt, wo man mitten im Grünen in äußerst komfortablen Baumhäusern und in Sicherheit wohnen kann. Die genaue Lage der gut versteckten Stelle im Wald verrät die Besitzerin ihren Gästen erst bei der Anreise. Auf einer Lichtung findet man schließlich vier luxuriöse Holzhäuser, die auf vier Meter hohen Stelzen zwischen Eichen und Buchen thronen. Die Räume orientieren sich an Le Corbusiers Raummaß, ihre Wände sind aus massivem, unbehandeltem Lärchenholz, das wind- und wetterfest ist und herrlich duftet. Auf knapp 40 Quadratmetern bietet jedes Haus einen Wohnraum mit Küchenzeile, ein Schlafzimmer und ein Bad. Warmes Wasser, Strom und sogar Fußbodenheizung gibt es, nur auf Fernseher und Radio wird bewusst verzichtet. Dafür schaut man aus großen Fenstern und von der Terrasse aus direkt in die Natur und erhascht tagsüber Eichhörnchen, Hasen, Fasane und vielleicht sogar ein Rehkitz oder das seltene Goldhähnchen. Da es ringsum keine künstlichen Lichtquellen gibt, funkeln in klaren Nächten unzählige Sterne über den Baumkronen, und rund um die Uhr raschelt und wispert es im Wald – so kam das Resort auch zu seinem Namen. Es fällt einem fast schwer, das Baumgeflüster für einen Ausflug durch die Region zu verlassen. Wer es schafft, besucht in der Nähe Bad Zwischenahn, in dessen Parks im Mai und Juni die Rhododendren blühen, das Zwischenahner Meer, das eigentlich ein See ist, und natürlich das „echte" Meer, die Nordsee. ◆ Buchtipp: „Wo und wofür ich lebte" von Henry David Thoreau

ANREISE *Bei Bad Zwischenahn gelegen, knapp 1 Fahrtstunde vom Regionalflughafen Bremen und 2,5 Fahrtstunden vom Flughafen Hamburg entfernt* · **PREISE** *€€–€€€* · **ZIMMER** *4 Baumhäuser, jedes mit ca. 16 qm großer Terrasse und für bis zu 4 Personen. Ein weiteres und noch größeres Haus soll 2025 entstehen* · **KÜCHE** *Die Häuser haben alle eine Pantry. Auf Wunsch wird ein Frühstückskorb mit Brötchen, hausgemachter Konfitüre und Kräuterdip vor die Tür gestellt. In unmittelbarer Nähe befinden sich im Kurort herrliche Restaurants, darunter sogar eine Sterneküche* · **GESCHICHTE** *Vom Bremer Baumhausarchitekten Andreas Wenning entworfen und 2011 eingeweiht* · **X-FAKTOR** *Glamping mit allen Sinnen*

BIEN CACHÉ

Passer une nuit dans une cabane perchée : c'est le rêve de beaucoup d'enfants, mais que peu ont réalisé. Il manque le jardin, le bricoleur de talent dans la famille ou l'arbre qui sera assez solide, ou parfois le courage d'aller dormir si haut, parmi les branches et les bruits insolites, un peu inquiétants. Par bonheur, il existe dans l'Ammerland, en Basse-Saxe, un endroit où vivre en pleine nature, dans des cabanes perchées extrêmement confortables et parfaitement sécurisées. La propriétaire ne révèle à ses hôtes l'emplacement exact de ce lieu si bien caché dans la forêt qu'au moment de leur arrivée. Ils atteignent alors la clairière autour de laquelle quatre luxueuses maisons se dressent sur des pilotis de quatre mètres de haut parmi les chênes et les hêtres. Les pièces ont été conçues selon les règles architecturales de Le Corbusier, avec des murs en mélèze massif non traité, résistant au vent et aux intempéries et délicieusement parfumé. Sur près de 40 mètres carrés, chaque cabane est constituée d'un salon avec coin cuisine, d'une chambre et d'une salle de bains. Elles ont toutes l'eau chaude, l'électricité et même un système de chauffage par le sol, mais la télévision et la radio ont été volontairement oubliées. Les grandes fenêtres et la terrasse ouvertes sur la nature offrent un poste d'observation idéal d'où apercevoir écureuils, lièvres, faisans, chevreuils et même le rare roitelet. Vierge de toute pollution lumineuse, le ciel nocturne s'emplit d'étoiles par temps clair, et la forêt bruisse et murmure à toute heure – c'est d'ailleurs pourquoi le domaine se nomme « Au murmure des arbres ». Il est presque difficile de quitter ce havre de paix pour une excursion dans la région, mais Bad Zwischenahn vaut une visite avec ses parcs dont les rhododendrons fleurissent en mai et juin, son lac, et bien sûr la mer du Nord toute proche. ◆ À lire : « Walden, ou la vie dans les bois » d'Henry David Thoreau

ACCÈS *Situé près de Bad Zwischenahn, à moins de 1 h de route de l'aéroport régional de Brême et à 2,5 h de l'aéroport de Hambourg* · **PRIX** *€€–€€€* · **CHAMBRES** *4 cabanes dans les arbres pouvant accueillir jusqu'à 4 personnes ; chacune est dotée d'une terrasse d'environ 16 m². Une maison plus grande doit ouvrir en 2025* · **RESTAURATION** *Les maisons sont toutes équipées d'une kitchenette. Sur demande, un panier de petit-déjeuner avec petits pains, confiture maison et crème aux herbes est déposé devant la porte. Tout près, la station thermale propose de magnifiques adresses, dont un restaurant étoilé* · **HISTOIRE** *Conçu par l'architecte de Brême spécialisé dans les maisons perchées Andreas Wenning et inauguré en 2011* · **LES « PLUS »** *Du glamping qui met tous les sens en éveil*

NIEDERSACHSEN 139

BAUHAUS DESSAU ATELIERHAUS

DESSAU-ROSSLAU

BAUHAUS DESSAU ATELIERHAUS

Gropiusallee 38, 06846 Dessau-Roßlau
Tel. +49 340 650 8250 · unterkunft@bauhaus-dessau.de
www.bauhaus-dessau.de

THE BEST OF BAUHAUS

No school had a greater influence on 20th-century architecture than the Bauhaus. When Walter Gropius founded it in 1919 in Weimar, he wanted to combine art and crafts as well as theory and practice with equal standing, and to create a "Gesamtkunstwerk," an all-round work of art, the "building of the future." The Bauhaus was avant-garde and aesthetic, sober and clear, rational and functional. In 1925 it moved to Dessau, where it flourished. Mies van der Rohe was involved here, Marcel Breuer designed his celebrated steel-tube chairs, and Marianne Brandt created her beautiful lamps. Walter Gropius himself designed the Bauhaus building, the school of concrete, steel and glass. The Atelierhaus, the studio building, was part of this. The students and young masters lived and worked in its five stories – and today the rooms, faithfully restored, are unique accommodation for lovers of architecture. The rooms, furnished only with a bed, table and chairs, shelves and cupboards, and each measuring about 260 square feet, have been kept as plain and simple as in the past. Guests will look in vain for an Internet connection, television or even a minibar. There is a washbasin, but the bathroom and toilet are in the corridor, shared with other guests. The most sought-after rooms have small balconies that look a little bit like springboards. It is said that the residents once used them to climb from one party to another. The canteen, too, still exists, serving Bauhaus classics such as bread with buttermilk, which suited every student's budget, in the original surroundings. Those who can't get enough Bauhaus may visit the Meisterhäuser, the nearby houses of the masters, and of course the Bauhaus Museum, designed in 2015 by the addenda architects office. ◆ Book to pack: "The Bauhaus Group" by Nicholas Fox Weber

DIRECTIONS *Dessau is between Berlin and Leipzig, just under 2 hours by car from Berlin Brandenburg airport* · **RATES** *€* · **ROOMS** *23 of the 28 studio rooms can be booked* · **FOOD** *Facilities for making hot drinks are available on every floor. There is the "café-bistro" in the Bauhaus, and a coffee bar in the museum. Near the masters' houses is the "Trinkhalle," a reinterpretation of the original design by Mies van der Rohe* · **HISTORY** *The Atelierhaus (also known as the Prellerhaus) was built in 1926 and is now part of Unesco World Heritage* · **X-FACTOR** *The Bauhaus Dessau Foundation runs an artist-in-residence program. The artists live and work in the Muche/Schlemmer master's house*

DAS BESTE VOM BAUHAUS

Das Bauhaus hat die Architektur des 20. Jahrhunderts wie keine andere Schule beeinflusst. Als Walter Gropius es 1919 in Weimar gründete, wollte er Kunst und Handwerk sowie Theorie und Praxis gleichwertig verbinden und ein Gesamtkunstwerk, den „Bau der Zukunft", schaffen. Das Bauhaus war avantgardistisch und ästhetisch, kühl und klar, rational und funktional. 1925 zog es nach Dessau um und erlebte dort seine Blütezeit. Mies van der Rohe war hier tätig, Marcel Breuer entwarf seine gefeierten Stahlrohrstühle und Marianne Brandt formschöne Leuchten. Von Walter Gropius selbst stammt das Bauhausgebäude, die Schule aus Beton, Stahl und Glas, zu der auch das Atelierhaus gehört. Auf seinen fünf Etagen lebten und arbeiteten die Studenten und Jungmeister – heute sind die stilgetreu restaurierten Zimmer einzigartige Unterkünfte für Architekturliebhaber. Nur mit Bett, Tisch und Stühlen, Regalen und Schränken sind die je rund 24 Quadratmeter großen Räume noch genauso reduziert und einfach gehalten wie damals. Internet, Fernseher oder gar Minibar sucht man vergebens – ein Waschbecken gibt es, doch Bad und Toilette liegen auf dem Flur und werden mit anderen Gästen geteilt. Die begehrtesten Zimmer haben kleine Balkone, die ein bisschen wie Sprungbretter aussehen und über die die Bewohner einst von Party zu Party geklettert sein sollen. Auch die Kantine besteht noch und bietet nach wie vor im Originalambiente den Bauhausklassiker „Brot mit Buttermilch" an, der damals in jedes studentische Budget passte. Wer noch nicht genug vom Bauhaus hat, kann in der Nähe die Meisterhäuser besichtigen und natürlich das Bauhaus Museum, das 2015 vom Architekturbüro addenda architects entworfen wurde. ◆ Buchtipp: „Die Bauhaus-Bande" von Nicholas Fox Weber

ANREISE *Dessau liegt zwischen Berlin und Leipzig, knapp 2 Fahrtstunden vom Flughafen Berlin Brandenburg entfernt* · **PREISE** *€* · **ZIMMER** *Von den 28 Atelierräumen können 23 gemietet werden* · **KÜCHE** *Auf jeder Etage gibt es eine Teeküche. Im Bauhaus gibt es das „café-bistro" und im Museum eine Kaffeebar. Bei den Meisterhäusern steht zudem die „Trinkhalle", die den ursprünglichen Entwurf Mies van der Rohes neu interpretiert* · **GESCHICHTE** *Das Atelierhaus (auch „Prellerhaus" genannt) entstand 1926 und gehört heute zum Unesco-Welterbe* · **X-FAKTOR** *Für Künstler bietet die Stiftung Bauhaus Dessau ein Artist-in-Residence-Programm an, bei dem sie im Meisterhaus Muche/Schlemmer wohnen und arbeiten dürfen*

LE MEILLEUR DU BAUHAUS

Le Bauhaus a influencé l'architecture du XXe siècle comme aucune autre école. Lorsque Walter Gropius l'a fondée en 1919 à Weimar, c'était avec l'ambition de mettre sur un pied d'égalité l'art et l'artisanat, la théorie et la pratique, afin de créer une œuvre d'art totale, le « bâtiment du futur ». Le Bauhaus était avant-gardiste et esthétique, froid et clair, rationnel et fonctionnel. En 1925, l'école déménagea à Dessau, où elle connut son apogée. Mies van de Rohe y travailla, Marcel Breuer y conçut ses fameuses chaises en acier tubulaire, et Marianne Brandt des luminaires à l'élégance minimaliste. La bâtisse en béton, acier et verre qui accueillait l'école et dont fait partie la maison-atelier est aussi une création de Gropius en personne. Les étudiants et les jeunes maîtres se partageaient les cinq étages, où ils vivaient et travaillaient. Aujourd'hui, leurs chambres ont été restaurées dans les règles de l'art et constituent des logements uniques pour les amoureux d'architecture. Meublées d'un lit, d'une table et de chaises, d'une étagère et d'une armoire, les pièces d'environ 24 mètres carrés sont aussi sobres qu'à l'époque, presque monastiques. Inutile de chercher réseau Internet, télévision ou minibar. Quand à la salle de bains et aux toilettes, elles se trouvent dans le couloir et se partagent avec d'autres hôtes. Les chambres sont dotées d'un simple lavabo. Les plus convoitées ont des petits balcons aux airs de tremplins, que les habitants auraient jadis escaladés pour passer de fête en fête. La cantine aussi a été conservée et propose toujours, dans son ambiance d'origine, le classique « pain au babeurre » que les étudiants pouvaient alors se permettre. Si vous n'êtes pas encore lassés du Bauhaus, il est possible de visiter les maisons des maîtres ainsi que le musée, conçu en 2015 par l'agence d'architecture addenda architects. ◆ À lire : « La Bande du Bauhaus » de Nicholas Fox Weber

ACCÈS *Dessau est situé entre Berlin et Leipzig, à moins de 2 h de route de l'aéroport de Berlin Brandenburg* · **PRIX** *€* · **CHAMBRES** *23 des 28 chambres aménagées dans l'atelier sont disponibles* · **RESTAURATION** *Chaque étage dispose d'une kitchenette. Le Bauhaus possède un « café-bistro » et d'un café au musée. Une « Trinkhalle » se dresse aussi près des maisons de maîtres en une belle réinterprétation du projet imaginé par Mies van der Rohe* · **HISTOIRE** *La maison-atelier (également appelée Prellerhaus) date de 1926; elle est classée au patrimoine mondial de l'Unesco* · **LES « PLUS »** *La fondation Bauhaus Dessau accueille des artistes en résidence dans la maison de maître Muche/Schlemmer*

HOTEL VILLA SORGENFREI

RADEBEUL

HOTEL VILLA SORGENFREI

Augustusweg 48, 01445 Radebeul
Tel. +49 351 795 6660 · info@hotel-villa-sorgenfrei.de
www.hotel-villa-sorgenfrei.de

CAREFREE!

Radebeul, part of the city of Dresden, lies in green surroundings between the River Elbe and vineyards where grapes for wine have been grown for more than 850 years, nowadays mainly varieties for white wine such as Müller-Thurgau, Riesling or Pinot Blanc. On one of the loveliest wine estates of the region, the Dresden banker Christian Friedrich von Gregory built this mansion in the late 18th century. It was designed in a style known as the Dresden Zopfstil, something between Rococo and Neoclassical, and has the appearance of a miniature palace with its belvedere turret, a magnificently ornate clock, and a gilded griffin as a weather vane. In the hotel rooms, old floors and ceiling beams have been preserved, and the historic murals and mirror paintings uncovered. The most beautiful room is for the pleasure of all guests: once the banquet and garden room, it now houses the restaurant and is atmospherically illuminated by candles and a crystal chandelier that is around 200 years old. In summer, guests can sit on the terrace, gaze into the perfectly maintained park, and listen to the twittering of birds – and then the villa lives up to its name, meaning "carefree," which is exactly how the guests feel. It is worth paying a relaxed visit to the neighboring wine estates of Radebeul, for example the picturesque Schloss Wackerbarth, where not only still wine is made, but also sparkling wine by the champagne method. Meissen, site of the first porcelain manufacture in Europe, is also close by, and Dresden with its world-famous showcase architecture and numerous museums is of course a classic destination. ◆ Book to pack: "In the Realm of the Silver Lion" by Karl May, whose grave is in Radebeul

DIRECTIONS *Radebeul is a suburb of Dresden with fine villas. Dresden airport is 15 minutes away by car* · **RATES** *€€–€€€* · **ROOMS** *14 rooms and 2 suites. One further room is currently being built* · **FOOD** *The "Restaurant Atelier Sanssouci," serving modern French gourmet cuisine, has a Michelin star* · **HISTORY** *The estate, built between 1783 and 1789, is a protected site. Since 2015 it has been run by the Dresden restaurateur Stefan Hermann* · **X-FACTOR** *A sister establishment is situated in the high-class Dresden district of Loschwitz: a villa apartment for up to 5 guests in a superb old building with antique and modern furnishings*

KEINE SORGE!

Der Dresdner Stadtteil Radebeul liegt ganz im Grünen, zwischen der Elbe und den Weinbergen, an denen schon seit über 850 Jahren Wein angebaut wird, heute vor allem weiße Rebsorten wie Müller-Thurgau, Riesling oder Weißburgunder. Auf einem der schönsten Güter der Region ließ der Dresdner Bankier Christian Friedrich von Gregory Ende des 18. Jahrhunderts diesen Herrensitz erbauen. Er wurde im Dresdner Zopfstil gestaltet, der zwischen Rokoko und Klassizismus angesiedelt ist, und gleicht mit seinem Dachreiter, der prachtvoll verzierten Uhr, dem Belvedere-Türmchen und dem vergoldeten Greif als Wetterfahne einem Schlösschen. In den Hotelzimmern wurden alte Fußböden und Deckenbalken erhalten und historische Wand- und Spiegelmalereien freigelegt. Der schönste Raum ist für alle Gäste da: der ehemalige Fest- und Gartensaal, in dem sich das Restaurant befindet und der von Kerzen sowie einem rund 200 Jahre alten Kristalllüster stimmungsvoll beleuchtet wird. Im Sommer kann man auch auf der Terrasse sitzen, in den makellos gepflegten Park schauen und den Vögeln beim Zwitschern zuhören – dann wird der Name der Villa Programm und das Leben wahrlich sorgenfrei. Eine entspannte Stippvisite lohnt sich zu den benachbarten Weingütern Radebeuls, wie dem malerischen Schloss Wackerbarth, in dem neben Wein auch Sekt nach der Champagnermethode gekeltert wird. Meißen mit der ersten Porzellanmanufaktur Europas ist ebenfalls in der Nähe, und Dresden mit seinen weltberühmten Prachtbauten und vielen Museen gilt sowieso als Klassiker. ◆ Buchtipp: „Erzgebirgische Dorfgeschichten" von Karl May, der in Radebeul begraben ist

ANREISE *Radebeul ist ein Villenvorort von Dresden. Der Dresdner Flughafen liegt 15 Fahrtminuten entfernt* · **PREISE** *€€–€€€* · **ZIMMER** *14 Zimmer und 2 Suiten. Ein weiteres Zimmer entsteht derzeit* · **KÜCHE** *Das „Restaurant Atelier Sanssouci" mit moderner französischer Feinschmeckerküche hat einen Michelin-Stern* · **GESCHICHTE** *Das denkmalgeschützte Anwesen entstand zwischen 1783 und 1789. Seit 2015 betreibt der Dresdner Gastronom Stefan Hermann das Hotel* · **X-FAKTOR** *Im noblen Dresdner Viertel Loschwitz gibt es eine Dependance: eine Villenwohnung für bis zu 5 Gäste in einem prächtigen Altbau mit antiken und modernen Möbeln*

AUCUN SOUCI !

À Dresde, le quartier de Radebeul se niche dans un écrin de verdure, entre l'Elbe et les vignobles cultivés depuis plus de 850 ans qui produisent aujourd'hui principalement des cépages blancs, comme le müller-thurgau, le riesling ou le pinot blanc. C'est sur un des plus beaux domaines de la région que le banquier dresdois Christian Friedrich von Gregory fit construire ce manoir à la fin du XVIIIe siècle. Conçu dans le style « Zopfstil » typique de Dresde, entre rococo et classicisme, il évoque un castelet avec son lanternon de croisée, son petit belvédère, son horloge finement ouvragée et son griffon doré en guise de girouette. Dans les chambres de l'hôtel, les planchers et les poutres d'époque ont été conservés et les peintures murales et miroirs anciens, restaurés. La plus belle pièce profite à tous les hôtes : l'ancien salon de réception et son jardin d'hiver accueillent aujourd'hui le restaurant, éclairé à la bougie et par un lustre en cristal d'environ 200 ans. En été, on peut s'installer sur la terrasse, face au parc impeccablement entretenu, pour écouter le gazouillis des oiseaux. Le nom de l'hôtel (« le sans souci ») devient alors tout un programme. Une petite visite des domaines viticoles voisins de Radebeul s'impose, comme le pittoresque château Wackerbarth, qui vend son vin mais aussi un mousseux élaboré selon la méthode champenoise et qui vaut le détour ! La première manufacture de porcelaine d'Europe se trouve à Meissen, tout près, et Dresde elle-même, avec son architecture mondialement connue et ses nombreux musées, demeure un classique. ◆ À lire : « Kaltenburg » de Marcel Beyer

ACCÈS *Radebeul est une banlieue résidentielle de Dresde. L'aéroport de la ville se trouve à 15 min de route* · **PRIX** *€€–€€€* · **CHAMBRES** *14 chambres et 2 suites. Une autre chambre est en cours de construction* · **RESTAURATION** *Le « Restaurant Atelier Sorgenfrei » sert une cuisine française moderne pour gourmets, récompensée d'une étoile au Michelin* · **HISTOIRE** *La propriété, classée monument historique, a été construite entre 1783 et 1789. Elle est exploitée depuis 2015 par le restaurateur dresdois Stefan Hermann* · **LES « PLUS »** *L'établissement propose une dépendance dans le quartier chic de Loschwitz, à Dresde : un appartement pouvant accueillir jusqu'à 5 personnes dans un bâtiment historique magnifique, avec meubles anciens et modernes*

SACHSEN 153

SACHSEN 155

SACHSEN 157

BURGKELLER MEISSEN

MEISSEN

BURGKELLER MEISSEN

Domplatz 11, 01662 Meißen
Tel. +49 3521 41400 · info@hotel-burgkeller-meissen.de
www.hotel-burgkeller-meissen.de

AT THE FOOT OF THE CASTLE

It is regarded as the first German palace and a masterpiece of Gothic architecture: the Albrechtsburg in Meissen, which was built in the late 15th and early 16th century on a rock high above the River Elbe, in the place where Emperor Henry I built a wooden fortress as long ago as the year 929. The neighboring hotel, Burgkeller Meissen, is linked to both buildings through its long history. It was the residence of the burgraves of Meissen, accommodated the financial administration, and was used by the porcelain manufactory of Meissen before becoming the royal Saxon Burgkeller, or castle vaults, in 1881. The Kerstinghaus, which by that time was part of the complex, was originally the residence of priests, and made history in 1762 when Frederick the Great negotiated the end of the Seven Years' War there. So there is no finer location for a stay in Meissen, as it enjoys a sensational view of the city and the river, and the honeymoon suite with its four-poster bed is one of the most romantic rooms far and wide. A spa has been installed in the ancient cellar vaults, and the restaurants serve Saxon specialties – on Meissen porcelain, it goes without saying. August the Strong, Prince Elector of Saxony, was so obsessed by this "white gold," which originally came from China, that he diagnosed himself as suffering from the "maladie de porcelaine" (the porcelain disease), and set his alchemists to work to find their own formula for its production. Successfully: since 1708, delicate porcelain has been made in Meissen – and for more than 150 years, the Albrechtsburg itself was a porcelain factory, and has now become a porcelain museum that is well worth a visit. ◆ Book to pack: "Meissen Porcelain" by John Sandon

DIRECTIONS *Meissen is northwest of Dresden, a drive of about 40 minutes from the airport. The hotel is situated in the center, near the cathedral and Albrechtsburg* · **RATES** *€€–€€€* · **ROOMS** *26 rooms and suites (including 1 apartment)* · **FOOD** *The "Böttgerstube" and the café "Pavillon" have a view of the city and the Elbe Valley, while the "Burggrafenstube" lies beneath a painted vault. In summer, guests sit on the "Domplatzterrasse" or the panorama terrace, which is known as Meissen's balcony. The hotel also has a ballroom and a bar* · **HISTORY** *The main building was first mentioned in documents in 1150, the Kerstinghaus was built in about 1440, and the hotel was opened in 2000* · **X-FACTOR** *In the show workshop of the porcelain museum in Meissen, visitors can watch porcelain being made and painted by hand*

AM FUSS DER BURG

Sie gilt als erstes deutsches Schloss und als Meisterwerk der Gotik: die Albrechtsburg in Meißen, die im späten 15. und frühen 16. Jahrhundert auf einem Felsen hoch über der Elbe entstand, dort, wo Heinrich I. schon im Jahr 929 eine hölzerne Wehranlage hatte errichten lassen. Das benachbarte Hotel Burgkeller Meißen verbindet mit beiden Bauten eine lange Geschichte: Es war die Residenz der Meißner Burggrafen, diente als Schösserei (Finanzverwaltung) und wurde von der Porzellanmanufaktur Meissen genutzt, ehe es 1881 zum königlich-sächsischen Burgkeller wurde. Das Kerstinghaus, das inzwischen ebenfalls zum Komplex gehört, war ursprünglich eine Priesterwohnung und schrieb 1762 Geschichte, als Friedrich der Große dort das Ende des Siebenjährigen Krieges verhandelte. In besserer Lage kann man also in Meißen kaum wohnen, der Blick auf Stadt und Fluss ist sensationell und die Hochzeitssuite mit Himmelbett eines der romantischsten Zimmer weit und breit. Im uralten Kellergewölbe wurde das Spa eingerichtet, und die Restaurants servieren sächsische Spezialitäten selbstverständlich auf Meissner Porzellan. Auf das „weiße Gold", das ursprünglich aus China kam, war Sachsens Kurfürst August der Starke einst so versessen, dass er sich selbst die „maladie de porcelaine" (Porzellankrankheit) attestierte und seine Alchemisten auf eine eigene Produktionsformel ansetzen ließ. Mit Erfolg: Seit 1708 wird in Meißen filigranes Porzellan gefertigt – mehr als 150 Jahre lang war die Albrechtsburg selbst Porzellanfabrik und ist inzwischen ein sehenswertes Porzellanmuseum. ◆ Buchtipp: „Der Porzellaner" von Annick Klug

ANREISE *Meißen liegt nordwestlich von Dresden, zum Flughafen sind es ca. 40 Fahrtminuten. Das Hotel liegt im Zentrum neben dem Dom und der Albrechtsburg* · **PREISE** *€€–€€€* · **ZIMMER** *26 Zimmer und Suiten (inklusive 1 Apartment)* · **KÜCHE** *Die „Böttgerstube" und das Café „Pavillon" blicken über Stadt und Elbtal, die „Burggrafenstube" liegt unter bemaltem Gewölbe. Im Sommer sitzt man auf der „Domplatzterrasse" oder der Panoramaterrasse, die auch „Balkon von Meißen" genannt wird. Das Hotel hat zudem einen Ballsaal und eine Bar* · **GESCHICHTE** *Das Haupthaus wurde um 1150 erstmals urkundlich erwähnt, das Kerstinghaus um 1440 erbaut. Das Hotel entstand im Jahr 2000* · **X-FAKTOR** *In der Schauwerkstatt des Porzellanmuseums Meissen sehen Besucher live, wie Porzellan von Hand gefertigt und bemalt wird*

AU PIED DU CHÂTEAU

Considéré comme le premier château allemand et chef-d'œuvre de l'art gothique, l'Albrechtsburg de Meissen a été bâti entre la fin du XVe et le début du XVIe siècle sur un promontoire rocheux surplombant l'Elbe, là où Heinrich Ier avait déjà fait construire une fortification en bois en 929. L'hôtel Burgkeller Meissen partage une longue histoire avec ces illustres voisins : il fut la résidence des burgraves de Meissen puis le siège de l'administration financière, fut ensuite utilisé par la manufacture de porcelaine de Meissen, et abrita les caves de la cour royale de Saxe à partir de 1881. La maison Kersting, aujourd'hui intégrée à cet ensemble, était à l'origine un presbytère, où Frédéric le Grand négocia la fin de la guerre de Sept Ans. La vue sur la ville et le fleuve est sensationnelle et la suite nuptiale, avec son lit à baldaquin, est une des chambres les plus romantiques de la région. Le spa a été aménagé dans les très anciennes caves voûtées et les restaurants servent des spécialités saxonnes, évidemment dans une vaisselle en porcelaine locale. Le prince-électeur de Saxe Auguste le Fort aimait tant cet « or blanc » venu de Chine qu'il se décréta atteint de la « maladie de la porcelaine » et exigea de ses alchimistes qu'ils mettent au point leur propre méthode de production. Et ils y parvinrent : depuis 1708, la manufacture de Meissen fabrique une porcelaine raffinée. Pendant plus de 150 ans, l'Albrechtsburg a d'ailleurs été lui-même une usine de porcelaine, avant d'être transformé en un musée qui vaut une visite. ◆ À lire : « L'Alchimiste de Meissen : l'extraordinaire histoire de l'invention de la porcelaine en Europe » de Janet Gleeson

ACCÈS *Meissen se trouve au nord-ouest de Dresde, à environ 40 min de route de son aéroport. L'hôtel est situé dans le centre, près de la cathédrale et du château d'Albrechtsburg* · **PRIX** *€€–€€€* · **CHAMBRES** *26 chambres et suites (dont un appartement)* · **RESTAURATION** *La « Böttgerstube » et le pavillon-café donnent sur la ville et la vallée de l'Elbe, la « Burggrafenstube » se trouve sous des voûtes peintes. En été, on s'installe en « Domplatzterrasse » sur la place de la cathédrale ou sur l'esplanade panoramique surnommée le « balcon de Meissen ». L'hôtel dispose aussi d'une salle de bal et d'un bar* · **HISTOIRE** *Le bâtiment principal est mentionné pour la première fois vers 1150 et la maison Kersting a été bâtie vers 1440. L'hôtel date de 2000* · **LES « PLUS »** *Dans l'atelier du musée de la porcelaine de Meissen, les visiteurs peuvent observer comment la porcelaine est fabriquée et peinte à la main*

SACHSEN 165

166 SACHSEN

168 SACHSEN

SCHLOSS PROSSEN

BAD SCHANDAU, SÄCHSISCHE SCHWEIZ

SCHLOSS PROSSEN

Gründelweg 15, 01814 Bad Schandau
Tel. +49 35022 548 355 · urlaub@schloss-prossen.de
www.schloss-prossen.de

A MANSION IN SAXON SWITZERLAND

When the present owners bought Schloss Prossen in 2014, it was in a state of decay. The seat of a knight once stood here, and later a noble family moved in. The publisher Friedrich Brockhaus also lived here for a few years, and later the estate became a brewery for a short period, circus animals were kept in its stalls, and school pupils were taught in its rooms. This illustrious history had taken its toll on the building, so Jutta and Torsten Wiesner spent two years undertaking a complete restoration of the mansion. They replaced almost all of the roof beams, exposed the plaster ceilings, murals and historic floors, and combined the old building fabric with modern design. In collaboration with schoper.schoper, an architects' practice in Dresden, they fitted out the suites and apartments in loft style with high-class kitchen islands, selected furnishings, and plain industrial lamps. The vaults of the old mansion kitchens became a sauna, and visitors who would like some company can chat to other guests in the garden or in the elegant room with an open fireplace on the piano nobile. The River Elbe flows right behind the house and its courtyard, and all around is the national park called Sächsische Schweiz (Saxon Switzerland), where hikers, climbers, and cyclists are in their element. It is well worth making excursions to the fortresses of Königstein, Hohnstein, and Stolpen with their breathtaking views, and guests who walk along part of the Malerweg (Painters' Way) can admire the famous rock formations of the Elbsandsteingebirge, the sandstone range that once inspired artists such as Caspar David Friedrich and Ludwig Richter. ◆ Book to pack: "Shadow Pictures of a Journey to the Harz, Swiss Saxony, etc. etc. in the Summer of 1831" by Hans Christian Andersen

DIRECTIONS *Prossen is a district of Bad Schandau, 1 hour by car southeast of Dresden airport. It is even possible to arrive by boat, as Prossen has its own landing jetty* · **RATES** €–€€ · **ROOMS** *2 suites and 8 apartments* · **FOOD** *All apartments have a kitchen for self-catering. If requested, a breakfast basket with bread rolls can be delivered in the morning* · **HISTORY** *There may have been a manor house here as early as 1120. The estate is first mentioned in documents in 1412. It opened as a vacation residence in summer 2019* · **X-FACTOR** *A refuge, wonderfully restored and in beautiful surroundings*

EIN SCHLOSS IN DER SÄCHSISCHEN SCHWEIZ

Als die heutigen Besitzer Schloss Prossen 2014 kauften, war es verfallen. Einst hatte an seiner Stelle ein Rittersitz gestanden, später zog eine Adelsfamilie ein. Auch der Verleger Friedrich Brockhaus wohnte hier einige Jahre, ehe das Gut kurz als Bierbrauerei diente, in seinen Ställen Zirkustiere einquartiert und in seinen Sälen Schulkinder unterrichtet wurden. Die illustre Geschichte hinterließ ihre Spuren, und so investierten Jutta und Torsten Wiesner zwei Jahre in eine komplette Schlosssanierung. Sie tauschten so gut wie jeden Dachbalken aus, ließen Stuckdecken, Wandmalereien und historische Böden freilegen und verbanden die alte Bausubstanz mit modernem Design. Gemeinsam mit dem Dresdner Architekturbüro schoper.schoper richteten sie Suiten und Apartments im Loftstil mit hochwertigen Kücheninseln, ausgesuchten Möbeln und schlichten Industrieleuchten ein. Im Gewölbe der ehemaligen Schlossküche entstand eine Sauna, und wem nach Gesellschaft ist, der kann im Garten oder im eleganten Kaminsaal auf der Beletage mit anderen Gästen plaudern. Gleich hinter Haus und Hof verläuft die Elbe, und ringsum erstreckt sich der Nationalpark der Sächsischen Schweiz, in dem Wanderer, Kletterer und Radfahrer in ihrem Element sind. Ein Ausflug lohnt sich zu den Festungen von Königstein, Hohnstein und Stolpen mit ihren atemberaubenden Aussichten, und wer den Malerweg ein Stück entlanggeht, kann die berühmten Felsformationen des Elbsandsteingebirges bestaunen, die einst Künstler wie Caspar David Friedrich oder Ludwig Richter inspirierten. ◆ Buchtipp: „Schattenbilder. Von einer Reise in den Harz, die Sächsische Schweiz etc. etc. im Sommer 1831" von Hans Christian Andersen

ANREISE *Prossen ist ein Ortsteil von Bad Schandau und liegt 1 Fahrtstunde südöstlich des Flughafens Dresden. Man kann sogar per Schiff anreisen, Prossen besitzt eine eigene Anlegestelle* · **PREISE** *€–€€* · **ZIMMER** *2 Suiten und 8 Apartments* · **KÜCHE** *Alle Wohnungen verfügen über eine Küche für Selbstversorger. Auf Wunsch werden morgens Brötchen und ein Frühstückskorb geliefert* · **GESCHICHTE** *Eventuell gab es hier schon um 1120 ein Rittergut. Urkundlich erwähnt ist das Anwesen erstmals 1412. Als Ferienresidenz eröffnete es im Sommer 2019* · **X-FAKTOR** *Ein Refugium, wunderschön saniert und in wunderschöner Umgebung*

UN CHÂTEAU EN SUISSE SAXONNE

Quand les propriétaires actuels ont acheté le château de Prossen, en 2014, il était en ruine. Demeure d'un chevalier puis d'une famille de la noblesse, le domaine fut occupé pendant quelques années par l'éditeur Friedrich Brockhaus puis servit brièvement de brasserie avant qu'on ne loge des animaux de cirque dans ses écuries et des écoliers dans ses nombreuses pièces. Cette histoire aussi ancienne que rocambolesque a laissé des marques sur la bâtisse ; c'est pourquoi Jutta et Torsten Wiesner ont passé deux années à rénover l'ensemble du château. Ils ont remplacé presque toute la charpente et mis au jour les plafonds en stuc, les peintures murales et les sols anciens, qu'ils ont combinés avec des éléments de design modernes. En collaboration avec le cabinet d'architecture dresdois schoper.schoper, ils ont imaginé des suites et des appartements de style loft avec des îlots de cuisine raffinés, des meubles méticuleusement choisis et des luminaires industriels sobres. Un sauna a été aménagé sous la voûte des anciennes cuisines du château. Les hôtes en quête de compagnie pourront discuter dans le jardin ou dans l'élégant salon avec cheminée, à l'étage noble. L'Elbe passe juste derrière la bâtisse et sa cour, et tout autour s'étend le parc national de la Suisse saxonne, où les randonneurs, les grimpeurs et les cyclistes sont dans leur élément. Les forteresses de Königstein, Hohnstein et Stolpen et les vues époustouflantes qu'ils offrent méritent une excursion, et si vous suivez un peu le Malerweg (le chemin des peintres), vous pourrez admirer les célèbres formations rocheuses de l'Elbsandsteingebirge, qui ont autrefois inspiré des artistes comme Caspar David Friedrich et Ludwig Richter. ◆ À lire : « Voyages » de Hans Christian Andersen, qui se rendit en Suisse saxonne à l'été 1831

ACCÈS *Prossen est un quartier de Bad Schandau, à 1 h de route au sud-est de l'aéroport de Dresde. On peut même s'y rendre en bateau, puisque le château possède son propre embarcadère* · **PRIX** *€–€€* · **CHAMBRES** *2 suites et 8 appartements* · **RESTAURATION** *Tous les appartements disposent d'une cuisine où préparer ses repas soi-même. Sur demande, des petits pains et un panier de petit-déjeuner peuvent être livrés le matin* · **HISTOIRE** *Le domaine existerait depuis 1120 environ, mais il est officiellement mentionné pour la première fois en 1412. Reconverti en résidence de vacances, il a rouvert ses portes à l'été 2019* · **LES « PLUS »** *Un refuge magnifiquement rénové, dans un cadre somptueux*

SACHSEN

176 SACHSEN

HOTEL STADTHAUS ARNSTADT

ARNSTADT

182 THÜRINGEN

HOTEL STADTHAUS ARNSTADT

Pfarrhof 1, 99310 Arnstadt
Tel. +49 3628 586 9991 · info@stadthaus-arnstadt.de
www.stadthaus-arnstadt.de

A HARMONIOUS COMPOSITION

Thuringia is Bach country, and Arnstadt is Bach town – nowhere else have so many original places survived where this famous family of musicians was active. Long before the time of Johann Sebastian Bach, who had his first position as an organist here, his ancestors worked as town pipers and court musicians in Arnstadt. For 51 years his great uncle Heinrich Bach played the organ in a church, the Oberkirche, which was part of a 13th-century Franciscan monastery before the Reformation. The picturesque hotel stands directly opposite the church. Its impressive cellar vaults dating from 1450 were probably part of a building that belonged to the monastery and was destroyed in the town's great fire of 1581. Among the people who lived and worked in the Renaissance building that was newly constructed on the site, were a countess and Superintendent Christoph Olearius, who in Johann Sebastian Bach's time was the preacher at their shared place of work, the Neue Kirche (New Church). From 1870 the half-timbered structure was used as a glove factory, to which a new production building was added in 1903. The present owners, Judith Rüber and Jan Kobel, have restored the building, which stood empty for 15 years, with a great deal of expertise and the use of historic materials, for which they have received several conservation awards. Architectural elements from the Renaissance, the Baroque period, and the early 20th century have been combined harmoniously. The attractive rooms demonstrate a sure stylistic touch, mixing historic ceilings and wooden floors with furniture from various periods, often complemented by small libraries and contemporary art. The ensemble also includes a coffee roastery with an espresso bar and a garden. The coffee is also served at breakfast in the snug parlor with its wooden floorboards or in the Schwarzküchengewölbe vaults. ◆ Book to pack: "Bach" by John Eliot Gardiner

DIRECTIONS *Arnstadt is 30 minutes' drive south of Erfurt, a hub of the high-speed ICE trains. The next major airport is Leipzig (1.5 hours' drive)* · **RATES** *€–€€* · **ROOMS** *6 rooms and 2 holiday apartments* · **FOOD** *An excellent breakfast with regional and/or organic products and home-made jams. On some days, by arrangement, three or four-course dinner menus are served* · **HISTORY** *The half-timbered building dates from 1582, the factory from 1903. The hotel was opened in 2013 after an eight-year restoration* · **X-FACTOR** *The 200-sq-m/2,152 sq-ft apartment in the old sewing room of the factory building with ceilings 4 m/13 ft high*

EINE GELUNGENE KOMPOSITION

Thüringen ist Bachland, und Arnstadt ist Bachstadt – nirgendwo sonst sind so viele Originalschauplätze erhalten geblieben, an denen die berühmte Musikerfamilie einst gewirkt hat. Schon lange vor Johann Sebastian Bach, der hier seine erste Organistenstelle antrat, waren seine Vorfahren als Stadtpfeifer und Hofmusiker in Arnstadt tätig. Sein Großonkel Heinrich spielte 51 Jahre Orgel in der Oberkirche, die vor der Reformation Teil eines Franziskanerklosters aus dem 13. Jahrhundert war. Das pittoreske Hotel steht direkt gegenüber. Sein imposanter Gewölbekeller von 1450 war wahrscheinlich Teil eines zum Kloster gehörenden Wirtschaftsgebäudes, das 1581 einem großen Stadtbrand zum Opfer fiel. In dem dann neu errichteten Renaissancegebäude lebten und arbeiteten unter anderem ein Kalkschneider, eine Gräfin und der Superintendent Christoph Olearius, der zu Zeiten von Johann Sebastian Bach Prediger am gemeinsamen Arbeitsplatz, der Neuen Kirche, war. Ab 1870 wurde das Fachwerkgebäude als Handschuhmanufaktur genutzt und 1903 um einen Fabrikneubau ergänzt. Die jetzigen Besitzer, Judith Rüber und Jan Kobel, haben die Gebäude nach 15 Jahren Leerstand mit viel Sachverstand sowie historischen Materialien saniert und dafür mehrere Denkmalschutzpreise bekommen. Architektonische Elemente aus Renaissance, Barock und dem frühen 20. Jahrhundert verbinden sich harmonisch. Auch in den schönen Zimmern findet sich ein stilsicherer Mix aus historischen Decken und Holzböden sowie Möbeln unterschiedlicher Epochen, oft ergänzt durch kleine Bibliotheken sowie zeitgenössische Kunst. Zum Ensemble gehört eine Kaffeerösterei mit Espressobar und Garten. Den Kaffee gibt es auch zum Frühstück in der behaglichen Bohlenstube oder dem Schwarzküchengewölbe. ◆ Buchtipp: „Bachs Welt. Die Familiengeschichte eines Genies" von Volker Hagedorn

ANREISE *Arnstadt liegt 30 Fahrtminuten südlich vom ICE-Knoten Erfurt. Nächster größerer Flughafen ist Leipzig (1,5 Fahrtstunden)* · **PREISE** *€–€€* · **ZIMMER** *6 Zimmer und 2 Ferienwohnungen* · **KÜCHE** *Feines Frühstück, regionale und/oder Bioprodukte sowie hausgemachte Marmeladen. An ausgewählten Tagen und nach Absprache abends Drei- und Vier-Gänge-Menüs* · **GESCHICHTE** *Das Fachwerkhaus stammt von 1582, die Fabrik von 1903. Das Hotel wurde nach achtjähriger Sanierung 2013 eröffnet* · **X-FAKTOR** *Die 200 qm große Ferienwohnung im ehemaligen Nähsaal des Fabrikgebäudes mit 4 m hohen Decken und einem Steinway-Flügel*

UNE COMPOSITION RÉUSSIE

La Thuringe est le pays natal des Bach et Arnstadt est leur ville – on ne trouve nulle part ailleurs autant de lieux originaux où travailla la célèbre famille de musiciens. Bien avant que Jean-Sébastien y prenne son premier poste d'organiste, ses ancêtres avaient occupé à Arnstadt les postes de fifres municipaux et de musiciens de cour. Son grand-oncle Heinrich a joué de l'orgue pendant 51 ans dans l'Oberkirche, église qui dépendit jusqu'à la Réforme d'un monastère franciscain du XIIIe siècle. Le pittoresque hôtel se trouve juste en face. Son imposante cave voûtée de 1450 faisait sans doute partie d'un bâtiment d'exploitation appartenant au monastère, ravagé par un incendie en 1581. Un tailleur de pierre, une comtesse et le surintendant Christoph Olearius, prédicateur à la Neue Kirche à l'époque où J.-S. Bach y fut organiste, ont ensuite vécu et travaillé dans le bâtiment Renaissance nouvellement bâti. À partir de 1870, la bâtisse à colombages a abrité une manufacture de gants, complétée par une nouvelle usine en 1903. Les propriétaires actuels, Judith Rüber et Jan Kobel, ont rénové l'ensemble, resté inoccupé pendant 15 ans, avec beaucoup de savoir-faire et des matériaux historiques, ce qui leur a valu plusieurs prix patrimoniaux. Des éléments architecturaux de la Renaissance, du Baroque et du début du XXe siècle se combinent harmonieusement. Dans les chambres aussi, les styles se mêlent avec assurance : des planchers et plafonds lambrissés anciens, des meubles de différentes époques, souvent complétés par de petites bibliothèques et des pièces d'art contemporain. L'établissement comprend une brûlerie de café avec un bar à expresso et un jardin. Le café est également servi au petit-déjeuner dans l'agréable salle boisée ou sous les voûtes de la Schwarzküchengewölbe. ◆ À lire : « Musique au château du ciel. Un portrait de J.-S. Bach » de John Eliot Gardiner

ACCÈS *Situé à 30 min de route au sud de la gare d'Erfurt. Le grand aéroport le plus proche est à Leipzig (1,5 h de route)* · **PRIX** *€–€€* · **CHAMBRES** *6 chambres et 2 appartements de vacances* · **RESTAURATION** *Bon petit-déjeuner, produits locaux et/ou bio et confitures maison. Le soir, certains jours et sur commande, menus à trois ou quatre plats* · **HISTOIRE** *La maison à colombages date de 1582, l'usine de 1903. L'hôtel a ouvert en 2013, après huit ans de rénovation* · **LES « PLUS »** *L'appartement de 200 m² aménagé dans l'ancienne salle de couture de l'usine, avec ses 4 m de hauteur sous plafond*

THÜRINGEN 187

WALDHAUS OHLENBACH

SCHMALLENBERG-OHLENBACH, SAUERLAND

WALDHAUS OHLENBACH

Ohlenbach 10, 57392 Schmallenberg-Ohlenbach
Tel. +49 297 5840 · info@waldhaus-ohlenbach.de
www.waldhaus-ohlenbach.de

SURROUNDED BY NATURE

The Sauerland is sometimes called "the land of 1,000 mountains." Here in the south of Westphalia, the mountains are not very high (the highest, the Langenberg, rises to no more than 2,765 feet), but this lovely landscape with its hills, meadows, forests, and lakes is well worth a visit. There are moors and heaths, where everybody can pick blueberries and lingonberries in summer. In the Glindfeld woods, walkers can admire gigantic Douglas firs that are more than 120 years old and grow to heights of up to 205 feet, and the Sauerland is also the source of the River Ruhr, which flows into the Rhine. Most of those who grew up in the Ruhr region have known the Sauerland since their childhood as a weekend and vacation destination – and they may also know this hotel, as it has been the favorite of many regular guests since the 1960s. In a very quiet location, without any neighbors, on the south slopes of the Kahler Asten mountain, it has cozy rooms that all face south or west. During the day, there is a far-ranging view across the countryside, and on clear nights guests look up to the twinkling stars. From the indoor and outdoor pool, too, there is a panoramic view, and in the restaurant the owner himself stands at the stove to cook outstanding dishes with regional products. The service with a family feeling at the Waldhaus includes tips for a hike or a tour by bike or on skis – and so guests are sure to explore the land of 1,000 mountains by the finest routes. ◆ Book to pack: "Wanderlust, a History of Walking" by Rebecca Solnit

DIRECTIONS *In the High Sauerland near to Westfeld, a town of half-timbered buildings, about 1.5 hours by car southeast of Dortmund. The drive to Cologne airport takes almost 2 hours* · **RATES** €€€–€€€€ · **ROOMS** *46 rooms and suites* · **FOOD** *In the restaurant, where the menu changes daily, all guests have their own place for the duration of their stay* · **HISTORY** *The present owner's parents opened the Waldhaus in 1962* · **X-FACTOR** *Time out from the daily routine*

SO VIEL NATUR

„Land der 1000 Berge" wird das Sauerland auch genannt. Sehr hoch sind die Berge hier in Südwestfalen zwar nicht (der höchste, der Langenberg, misst gerade einmal 843 Meter), einen Besuch wert ist die schöne Landschaft mit ihren Hügeln, Wiesen, Wäldern und Seen aber allemal. Es gibt Moore und die Heide, in der im Sommer jeder Heidel- und Preiselbeeren pflücken darf, im Glindfelder Wald können Wanderer gigantische Douglasien bestaunen, die mehr als 120 Jahre alt sind und bis zu 63 Meter in den Himmel ragen, und im Sauerland entspringt sogar die Ruhr, die später in den Rhein mündet. Wer im Ruhrgebiet aufgewachsen ist, kennt das Sauerland wahrscheinlich seit Kindertagen als Wochenend- und Ferienziel – und vielleicht sogar dieses Hotel, denn es ist schon seit den 1960ern die Lieblingsadresse vieler Stammgäste. Ganz ruhig und ganz ohne Nachbarn am Südhang des Kahlen Astens gelegen, bietet es gemütliche Zimmer, die alle nach Süden oder Westen gerichtet sind. So geht der Blick tagsüber weit über die umliegende Landschaft und in klaren Nächten hinauf zu den funkelnden Sternen. Auch vom Innen- und Außenpool eröffnet sich ein Panoramablick, und im Restaurant steht der Besitzer selbst am Herd und kocht hervorragende Gerichte mit regionalen Produkten. Zum familiären Service des Waldhauses gehört der ein oder andere Tipp für die nächste Wanderung, Rad- oder Skitour – so entdeckt man das Land der 1000 Berge garantiert auf den schönsten Wegen. ◆ Buchtipp: „Wanderlust" von Rebecca Solnit

ANREISE *Im Hochsauerland nahe des Fachwerkorts Westfeld und rund 1,5 Fahrtstunden südöstlich von Dortmund gelegen. Der Flughafen Köln ist knapp 2 Fahrtstunden entfernt* · **PREISE** €€€–€€€€ · **ZIMMER** *46 Zimmer und Suiten* · **KÜCHE** *Im Restaurant, dessen Menükarte täglich wechselt, hat jeder Gast seinen festen Platz für die Dauer des Urlaubs* · **GESCHICHTE** *Die Eltern des heutigen Inhabers eröffneten das Waldhaus 1962* · **X-FAKTOR** *Eine Auszeit vom Alltag*

AU CŒUR DE LA NATURE

Le Sauerland est aussi appelé « le pays aux 1 000 montagnes ». Elles ne sont pas bien hautes ici, dans le Sud de la Westphalie (le plus haut sommet, le Langenberg, culmine à 843 m), mais le paysage où alternent collines et prairies, forêts et lacs, marais et lande, vaut vraiment la peine d'être parcouru. En été, la cueillette des airelles et des myrtilles est permise, et dans la forêt de Glindfeld, on marche parmi les immenses pins Douglas, dont certains ont plus de 120 ans et mesurent jusqu'à 63 mètres de haut. C'est aussi dans le Sauerland que la Ruhr prend sa source avant de se jeter dans le Rhin. Pour ceux qui ont grandi dans la région à laquelle la rivière donne son nom, le Sauerland est une destination familière de week-end et de vacances – et peut-être même cet hôtel aussi, puisqu'il accueille de nombreux habitués depuis les années 1960. Situé au calme, très loin du premier voisin, sur le versant sud du Kahler Asten, il propose des chambres confortables, toutes orientées au sud ou à l'ouest. Ainsi, la vue s'étend sur le paysage environnant pendant la journée et s'élève vers les étoiles scintillantes par temps clair une fois la nuit tombée. La piscine intérieure et extérieure offre aussi une vue panoramique, et au restaurant, le propriétaire se met lui-même aux fourneaux pour préparer d'excellents plats avec des produits locaux. Le service familial qu'offre le Waldhaus comprend moult conseils sur les meilleures randonnées à pied, à vélo ou à ski, afin que chaque hôte découvre le pays des 1 000 montagnes par les plus beaux chemins. ◆ À lire : « L'Art de marcher » de Rebecca Solnit

ACCÈS *Situé dans le Haut-Sauerland, près du village à colombages de Westfeld et à environ 1,5 h de route au sud-est de Dortmund. L'aéroport de Cologne est à 2 h de route* · **PRIX** €€€–€€€€ · **CHAMBRES** *46 chambres et suites* · **RESTAURATION** *Au restaurant, dont la carte change tous les jours, chaque client a sa place attitrée pour la durée de son séjour* · **HISTOIRE** *Les parents du propriétaire actuel ont ouvert la « maison forestière » en 1962* · **LES « PLUS »** *Une parenthèse dans le quotidien*

NORDRHEIN-WESTFALEN 195

PURS

ANDERNACH AM RHEIN

PURS

Steinweg 28, 56626 Andernach
+49 2632 958 6750 · info@purs.com
www.purs.com

SETTING THE SCENE

Andernach is one of the oldest towns in Germany. It has a pretty center with a town wall, an impressive round fortified tower that was built in the Middle Ages and in 1689 even withstood an attempt by the French to blow it up, and a Romanesque church that is well worth a visit – yet it is overshadowed a little by its neighbors on the Rhine: Koblenz on one side, Bonn and Cologne on the other. The owners of this boutique hotel wanted to change this situation. They bought an old chancellery that the archbishop of Cologne built in 1677 for the council members and the town chronicler, and commissioned Axel Vervoordt to furnish the historic building. The famous Belgian did this in his accustomed aesthetic style, combining cultures and continents in the rooms. The Flemish floorboards are as old as the building itself, and set the scene for hand-picked antiques from Vervoordt's collection in Antwerp: a French 19th-century pharmacy serves as the reception, and the rooms are fitted with individual items from an antique rustic wardrobe to an English writing desk. Next to these the designer placed his own creations, for example occasional tables made from slate that seem to float, armchairs covered with an upturned tapestry, or chairs that were once used as high-school benches in New Jersey. Vervoordt's signature subdued wall paints are the stage set for presenting this luxury – as is the carefully curated art from Europe and Asia. To match this conception, the restaurant serves fusion cuisine from north Japan, pleasing gourmets as much as lovers of architecture. ◆ Book to pack: "A Small Town in Germany" by John Le Carré

DIRECTIONS *Andernach is on the River Rhine, about 1 hour's drive south of Cologne airport* · **RATES** *€€€–€€€€* · **ROOMS** *11 rooms and suites* · **FOOD** *The innovative restaurant has a Michelin star. There is also a bar and a cigar lounge* · **HISTORY** *Opened in 2018* · **X-FACTOR** *For nature lovers too, Andernach is an interesting destination. Here you can marvel at the world's highest cold-water geyser, which shoots a fountain 60 m/195 ft into the air*

IN SZENE GESETZT

Andernach ist eine der ältesten Städte Deutschlands. Es besitzt ein malerisches Zentrum mit Wehrmauer, einen beeindruckenden runden Wehrturm, der im Mittelalter entstand und 1689 sogar einem Sprengversuch der Franzosen standhielt, sowie einen sehenswerten romanischen Dom – und doch steht es immer ein bisschen im Schatten seiner Nachbarn am Rhein, Koblenz auf der einen, Bonn und Köln auf der anderen Seite. Das wollten die Besitzer dieses Boutiquehotels ändern. Sie kauften eine alte Kanzlei, die der Erzbischof von Köln im Jahr 1677 als Ratsherren- und Geschichtsschreiberhaus in Auftrag gegeben hatte, und ließen das historische Gebäude von Axel Vervoordt ausstatten. Der berühmte Belgier tat das gewohnt ästhetisch, wobei er in den Räumen Kulturen und Kontinente verband. Die flämischen Dielenböden sind so alt wie das Haus selbst und Bühne für handverlesene Antiquitäten aus Vervoordts Antwerpener Sammlung: Eine französische Apotheke aus dem 19. Jahrhundert dient als Rezeption, und die Zimmer zieren Einzelstücke vom antiken Bauernschrank bis zum englischen Sekretär. Daneben platzierte der Designer eigene Entwürfe wie Beistelltischchen aus Schiefer, die zu schweben scheinen, Sessel, denen ein umgedrehter Gobelin übergestülpt wurde, oder Tische, die früher Highschool-Bänke in New Jersey waren. Vervoordts gedeckte Signatur-Wandfarben setzen den Luxus in Szene – ebenso wie die sorgfältig kuratierte Kunst aus Europa und Asien. Zum Gesamtkonzept passt selbst das Restaurant mit nordisch-japanischer Fusionsküche und macht neben Architekturliebhabern auch Gourmets glücklich. ◆ Buchtipp: „Der Schlafwandler" von Hugo Claus

ANREISE *Andernach liegt am Rhein, rund 1 Fahrtstunde südlich des Flughafens Köln* · **PREISE** *€€€–€€€€* · **ZIMMER** *11 Zimmer und Suiten* · **KÜCHE** *Das innovative Restaurant hat einen Michelin-Stern. Es gibt außerdem eine Bar und eine Zigarrenlounge* · **GESCHICHTE** *2018 eröffnet* · **X-FAKTOR** *Auch für Naturliebhaber ist Andernach ein spannendes Ziel. Sie können hier den höchsten Kaltwassergeysir der Welt bestaunen, dessen Fontäne bis zu 60 m hochschießt*

MISE EN SCÈNE

Andernach est une des plus anciennes villes d'Allemagne. Malgré son centre pittoresque, son enceinte fortifiée, son impressionnante tour de défense ronde érigée au Moyen Âge qui a résisté à l'assaut des Français en 1689, ainsi que sa cathédrale romane remarquable, elle reste un peu dans l'ombre de ses voisines rhénanes, Coblence d'un côté, Bonn et Cologne de l'autre. Les propriétaires de ce boutique-hôtel comptent bien y remédier. Ils ont acquis une ancienne chancellerie, dont l'archevêque de Cologne avait ordonné la construction en 1677 pour accueillir conseillers et historiens, et fait aménager ce bâtiment historique par Axel Vervoordt. Le célèbre Belge y a déployé son esthétique particulière, et les cultures et les continents se rencontrent dans chaque pièce. Les planchers flamands, aussi vieux que la maison, constituent une scène idéale pour les antiquités sélectionnées dans la collection anversoise de Vervoordt : un comptoir de pharmacie français du XIXe siècle tient lieu de réception et les chambres sont décorées de pièces uniques allant de l'armoire de ferme ancienne au secrétaire anglais. En contrepoint, le designer a placé ses propres créations : des guéridons en ardoise qui semblent en lévitation, des fauteuils couverts d'une tapisserie retournée ou d'anciens bancs d'un lycée du New Jersey convertis en tables. Les couleurs mattes qui font la marque de Vervoordt apportent une touche de luxe aux murs, tout comme l'art européen et asiatique qui s'y expose. Même le restaurant, qui propose une cuisine fusion nordique et japonaise, s'inscrit harmonieusement dans ce concept global et fait le bonheur des amateurs d'architecture comme des gourmets. ◆ À lire : « Le Dernier Lit et autres récits » de Hugo Claus

ACCÈS *Situé au bord du Rhin, à environ 1 h de route au sud de l'aéroport de Cologne* · **PRIX** *€€€–€€€€* · **CHAMBRES** *11 chambres et suites* · **RESTAURATION** *Le restaurant novateur possède une étoile Michelin. On y trouve aussi un bar et un fumoir pour les amateurs de cigares* · **HISTOIRE** *Ouvert en 2018* · **LES « PLUS »** *Andernach est aussi une destination passionnante pour les amoureux de la nature. Vous y admirerez le plus haut geyser d'eau froide au monde, qui jaillit jusqu'à 60 m de haut*

RHEINLAND-PFALZ 203

WEINKULTURGUT LONGEN-SCHLÖDER

LONGUICH AN DER MOSEL

206 RHEINLAND-PFALZ

WEINKULTURGUT LONGEN-SCHLÖDER

Kirchenweg 9, 54340 Longuich
Tel. +49 6502 8345 · info@longen-schloeder.de
www.longen-schloeder.de

STAYING WITH THE WINE GROWERS

The Moselle river is Germany's oldest wine region: the Romans grew grapes here to supply wine to their soldiers and the inhabitants of Augusta Treverorum, now the city of Trier, which grew to be the largest Roman settlement north of the Alps. The steep-sloping vineyards of the region are spectacular – along the Moselle are the steepest vineyards in the world, with slopes at an angle of up to 68 degrees. The most widely cultivated grape here is the renowned Riesling, which was once sold to the royal courts of Europe at prices higher than top French wines, and has been given a new, innovative image by young wine makers in recent years. The owners of this estate are equally creative as wine growers and as hoteliers: they succeeded in bringing the architect Matteo Thun from South Tyrol to the Moselle, where he designed out-of-the-ordinary accommodation for guests of the vineyard. In an idyllic site on orchard meadows, the cottages took their cue from the typical wine farmers' houses of the area, and were built from local materials such as slate and oak wood. On each doorstep is a garden with a patio, a lovely place to eat breakfast. Inside, guests need little more than a bed and bathroom, a table and chairs – all of it simple and in bright colors, with a few spots of wine red. The cottages do not have kitchens, as residents eat in the estate restaurant and wash down the meal with wines from the house cellar. Don't fail to try the semi-dry 2020-vintage Riesling, which the owners' son made, his first wine – and the artistic label on the bottle was designed by Matteo Thun. ◆ Book to pack: "The Wines of Germany" by Anne Krebiehl

DIRECTIONS *The Longen-Schlöder vineyard is 15 minutes by car to the northeast of Trier. The nearest major airports are Luxembourg (1 hour) and Frankfurt (2 hours' drive)* · **RATES** *€–€€* · **ROOMS** *20 cottages* · **FOOD** *In the "Vineria & Vinothek" with its terrace, hearty wine-grower's dishes are served. Wine tastings, wine events, and exhibitions are organized* · **HISTORY** *The farm has been owned by the family for generations. The vineyard cottages have been here since 2013* · **X-FACTOR** *A meeting of wine and design, nature and culture*

WOHNEN BEIM WINZER

Die Mosel ist die älteste Weinregion Deutschlands: Schon die Römer kultivierten hier Rebstöcke, um ihre Truppen und die Einwohner von Augusta Treverorum (das heutige Trier) mit Wein zu versorgen (Trier wuchs damals zur größten römischen Stadt nördlich der Alpen an). Spektakulär sind die Steillagen der Region – an der Mosel liegt sogar einer der steilsten Weinberge der Welt, dessen Hang sich bis zu 68 Grad neigt. Angebaut wird in der Gegend vor allem der renommierte Riesling, der an Europas Königshöfen einst teurer als französischer Spitzenwein gehandelt wurde und dem junge Winzer in den letzten Jahren ein neues, innovatives Image verpasst haben. So kreativ wie als Weinbauern sind die Besitzer dieses Guts auch als Hoteliers: Es gelang ihnen, den Architekten Matteo Thun von Südtirol an die Mosel zu holen, wo er für die Gäste des Anwesens ganz besondere Unterkünfte gestaltete. Idyllisch auf den Streuobstwiesen gelegen, sind sie den typischen Winzerhäuschen der Gegend nachempfunden und aus heimischen Materialien wie Schiefer und Eichenholz konstruiert. Vor der Tür liegt ein Gärtchen mit Terrasse, wo es sich herrlich frühstücken lässt. Drinnen braucht man nicht viel mehr als Bett und Bad, Tisch und Stuhl – alles ist in hellen Tönen einfach gehalten und mit wenigen Akzenten in Weinrot betont. Küchen haben die Häuschen keine, ihre Bewohner essen im Gutsrestaurant und trinken dazu Weine aus dem gutseigenen Keller. Unbedingt verkosten: den halbtrockenen Riesling aus dem Jahr 2020, den der Sohn des Hauses als ersten eigenen Wein gekeltert hat – das kunstvolle Etikett auf der Flasche entwarf Matteo Thun. ◆ Buchtipp: „Kurt Tucholsky und die Mosel", das der Autor unter seinem Pseudonym Ignaz Wrobel schrieb

ANREISE *Das Gut Longen-Schlöder liegt 15 Fahrtminuten nordöstlich von Trier. Die nächsten großen Flughäfen sind Luxemburg (1 Fahrtstunde) und Frankfurt (2 Fahrtstunden)* · **PREISE** *€–€€* · **ZIMMER** *20 Häuser* · **KÜCHE** *In der „Vineria & Vinothek" mit Terrasse gibt es deftige Winzerküche. Auch Weinverkostungen und -events sowie Ausstellungen werden organisiert* · **GESCHICHTE** *Das Gut ist seit Generationen im Familienbesitz. Die Winzerhäuschen bestehen seit 2013* · **X-FAKTOR** *Hier treffen Wein und Design, Natur und Kultur zusammen*

LOGER CHEZ LE VIGNERON

La Moselle est la plus ancienne région viticole d'Allemagne : les Romains y cultivaient déjà la vigne pour approvisionner en vin leurs troupes et les habitants d'Augusta Treverorum (l'actuelle Trèves, à l'époque la plus grande cité romaine au nord des Alpes). Ses coteaux sont spectaculaires : la région compte en effet un des vignobles les plus abrupts au monde, dont la pente atteint 68 degrés. La Moselle produit principalement le célèbre riesling, qui se négociait autrefois plus cher que les grands vins français dans les cours royales d'Europe, et auquel de jeunes viticulteurs ont donné ces dernières années une nouvelle image et un nouvel élan. Les propriétaires de cet établissement s'inscrivent dans cette veine et se montrent aussi créatifs dans le vin que dans l'hôtellerie. Ils ont convaincu l'architecte Matteo Thun de venir du Tyrol du Sud jusqu'à ces rives de la Moselle, où il a conçu des hébergements très particuliers pour les hôtes du domaine. Dans le cadre idyllique des vergers, ils s'inspirent des maisonnettes de vignerons traditionnelles de la région, en bois de chêne et ardoise. Chaque logement est doté d'une terrasse où prendre son petit-déjeuner et donne sur un jardinet. À l'intérieur, un lit, une salle de bains, une table et une chaise, guère plus – tout est simple, dans des tons clairs soulignés par quelques touches bordeaux. Les cabanes n'ont pas de cuisine car les hôtes mangent au restaurant de l'établissement et boivent les vins montés de la cave. À déguster absolument : le riesling demi-sec de 2020, le premier millésime vinifié par le fils de la maison. L'étiquette de la bouteille a été dessinée par Matteo Thun. ◆ À lire : « Leurs enfants après eux » de Nicolas Mathieu

ACCÈS *Situé à 15 min de route au nord-est de Trèves. Les aéroports internationaux les plus proches sont à Luxembourg et Francfort (à respectivement 1 h et 2 h de route)* · **PRIX** *€–€€* · **CHAMBRES** *20 maisonnettes* · **RESTAURATION** *La « Vineria & Vinothek », avec terrasse, propose une cuisine vigneronne consistante. Des dégustations de vin, des événements et des expositions sont également organisés* · **HISTOIRE** *L'établissement est une affaire de famille depuis plusieurs générations. Les cabanes de vignerons existent depuis 2013* · **LES « PLUS »** *Un lieu où se rencontrent vin et design, nature et culture*

RHEINLAND-PFALZ 209

GUT CANTZHEIM

KANZEM AN DER SAAR

GUT CANTZHEIM

Weinstraße 4, 54441 Kanzem an der Saar
Tel. +49 6501 607 6635 · reservierung@cantzheim.de
www.cantzheim.de

EXCELLENT TASTE

Anna Reimann, a German, discovered her love of wine in Chile when she was an intern on the well-known Santa Rita estate. Later she studied wine-making in France, helped with the grape harvest in Burgundy, and then traveled to New Zealand, where she made her own wine for the first time. Today, with her husband Stephan, also a wine maker, she runs this small vineyard on the River Saar. It is not an old-established family winery: Anna and Stephan have been growing vines with the mentality of a start-up only since 2016, but they are already earning high praise from connoisseurs for their fine, elegant Riesling. The Cantzheim estate is well known to fans of architecture as well as to wine lovers thanks to its exceptional, prize-winning restoration by the Swiss architect Max Dudler. Commissioned by Anna's father, Georg F. Thoma, in exemplary fashion he has restored the beauty of the late Baroque manor house, which stands majestically right in front of the vineyard – leaving untouched only the former chapel, now part of the private quarters of the house. The chapel is still illuminated from above through historic light wells, and exudes a very special atmosphere. Dudler has placed two contrasting modern buildings next to the age-old main house: the coach house was constructed from tamped concrete in layers that take their cue from the earthy colors of the hills, while the orangery with its delicate structure of steel and glass is intended as a reference to the silhouette of the vines. The five guest rooms in the house and the coach house, named after the local vineyards, were furnished in puristic style and the walls adorned with exquisite art. The whole ensemble including the vinotheque is regularly used for concerts, readings, tastings and cookery courses. ◆ Book to pack: "The Initiates" by Étienne Davodeau

DIRECTIONS *Kanzem lies on the Wiltinger Saarbogen, a bend in the River Saar, a little under 20 minutes' drive southwest of Trier. There is a train station right next to the estate, and the nearest sizeable airport Luxembourg (almost 40 minutes by car)* · **RATES** *€€–€€€* · **ROOMS** *5 rooms. Since 2022 the owners have also rented out 3 holiday apartments and 1 house in the village* · **FOOD** *Breakfast is taken in the garden, salon or vinotheque, where snacks, coffee and cake, and of course the estate's own wines, are also served. A four-course menu is served in the evenings* · **HISTORY** *The main building dates back to 1740, when it belonged to the wine estate of a monastery. It opened as a hotel in 2017* · **X-FACTOR** *The location in the beautiful and culturally diverse area where three countries meet: Germany, Luxembourg, and France*

AUSGEZEICHNETER GESCHMACK

Ihre Liebe zum Wein entdeckte die Deutsche Anna Reimann in Chile, als sie auf dem bekannten Gut Santa Rita ein Praktikum machte. Später studierte sie Önologie in Frankreich, half im Burgund bei der Lese und reiste dann bis nach Neuseeland, wo sie ihren ersten eigenen Wein herstellte. Heute leitet sie mit ihrem Mann Stephan, der ebenfalls vom Fach ist, dieses kleine Weingut an der Saar. Es ist kein alter Familienbesitz – erst seit 2016 bauen Anna und Stephan Reimann hier in Start-up-Mentalität Wein an und werden für ihren feinen, eleganten Riesling von Kennern bereits hochgelobt. Dass das Gut Cantzheim neben Weinliebhabern auch Architekturfans ein Begriff ist, liegt an seiner außergewöhnlichen und preisgekrönten Restaurierung durch den Schweizer Architekten Max Dudler. Im Auftrag von Annas Vater, Georg F. Thoma, wurde das spätbarocke Herrenhaus, das eindrucksvoll direkt vor dem Weinberg thront, bilderbuchartig saniert. Unangetastet blieb dabei nur die einstige Kapelle, die heute im Privatbereich des Hauses liegt, noch immer über historische Lichtschächte senkrecht beleuchtet wird und eine ganz besondere Atmosphäre ausstrahlt. Dem geschichtsträchtigen Haupthaus hat Dudler als Kontraste zwei moderne Neubauten zur Seite gestellt: Die Remise entstand aus Stampfbeton, dessen Schichten die Erdtöne der Hügel aufgreifen, und die Orangerie mit ihrer filigranen Struktur aus Stahl und Glas soll an die Silhouetten der Rebstöcke erinnern. Die fünf Gästezimmer im Haus und in der Remise, die nach hiesigen Weinlagen benannt sind, wurden puristisch eingerichtet und ihre Wände mit exquisiter Kunst dekoriert. Das gesamte Ensemble samt Vinothek wird regelmäßig für Konzerte, Lesungen, Verkostungen und Kochkurse genutzt. ◆ Buchtipp: „Die Ignoranten" von Étienne Davodeau

ANREISE *Kanzem liegt am Wiltinger Saarbogen, knapp 20 Fahrtminuten südwestlich von Trier. Gleich neben dem Gut ist der Bahnhof, nächster größerer Flughafen ist Luxemburg (knapp 40 Fahrtminuten)* · **PREISE** *€€–€€€* · **ZIMMER** *5 Zimmer. Seit 2022 bieten die Eigentümer auch 3 Ferienwohnungen und 1 Ferienhaus im Dorf an* · **KÜCHE** *Frühstück wird im Garten, Salon oder in der Vinothek serviert. Dort bekommt man zudem Snacks, Kaffee und Kuchen und natürlich hauseigene Weine. Abends gibt es ein Vier-Gänge-Menü* · **GESCHICHTE** *Das Haupthaus stammt aus dem Jahr 1740 und gehörte damals zum Weingut eines Klosters. Als Hotel eröffnete es 2017* · **X-FAKTOR** *Die Lage im wunderschönen und kulturell vielfältigen Dreiländereck Deutschland-Luxemburg-Frankreich*

UN GOÛT EXCEPTIONNEL

L'Allemande Anna Reimann a découvert son amour du vin au Chili, alors qu'elle effectuait un stage dans le célèbre domaine de Santa Rita. Elle a ensuite étudié l'œnologie en France et fait les vendanges en Bourgogne, puis s'est installée en Nouvelle-Zélande, où elle a produit son premier vin. Elle dirige aujourd'hui ce petit domaine viticole de la Sarre avec son mari Stephan, également du métier. Nous ne sommes pas ici dans une vieille maison de famille. Anna et Stephan n'y cultivent la vigne que depuis 2016, mais leur esprit d'entreprise a porté ses fruits puisque leur riesling, élégant et raffiné, est déjà très apprécié des connaisseurs. Le domaine de Cantzheim est connu des amateurs de vin mais aussi des fans d'architecture pour la restauration exceptionnelle, primée plusieurs fois, qu'y a menée l'architecte suisse Max Dudler. À la demande du père d'Anna, Georg F. Thoma, il a rénové la maison de maîtres de style baroque tardif qui trône au pied des coteaux, comme sortie d'un livre d'images. L'ancienne chapelle, qui fait partie du domaine privé, est restée intacte ; éclairée par des puits de lumière d'origine, elle dégage une atmosphère très particulière. Dudler a ajouté deux bâtiments dont la modernité contraste avec les vieilles pierres de la maison principale. La remise a été bâtie en béton estampé dont les strates reprennent les tons telluriques des collines environnantes, et l'orangerie, avec sa structure en verre et acier, évoque la silhouette des ceps de vigne. Les cinq chambres aménagées dans la maison et la remise, qui portent le nom de vignobles locaux, sont épurées et décorées d'œuvres d'art exquises. L'ensemble, complété par une vinothèque, accueille régulièrement des concerts, des conférences, des dégustations et des cours de cuisine. ◆ À lire : « Les Ignorants » d'Étienne Davodeau

ACCÈS *Kanzem est situé dans le Wiltinger Saarbogen, à moins de 20 min de route au sud-ouest de Trèves. La gare se trouve juste à côté du domaine et l'aéroport le proche est celui de Luxembourg (à 40 min de route)* · **PRIX** *€€–€€€* · **CHAMBRES** *5 chambres. Depuis 2022, les propriétaires proposent également 3 appartements et 1 maison de vacances dans le village* · **RESTAURATION** *Le petit-déjeuner est servi dans le jardin, au salon ou dans la vinothèque. Vous trouverez aussi des snacks, du café et des gâteaux, et bien sûr des vins de la maison. Un repas de quatre plats est servi le soir* · **HISTOIRE** *La maison principale date de 1740 et faisait alors partie du domaine viticole d'un monastère. Elle a ouvert ses portes en tant qu'hôtel en 2017* · **LES « PLUS »** *Sa situation, au delta entre Allemagne, Luxembourg et France, riche de beautés et de cultures diverses*

RHEINLAND-PFALZ

LE ROSSIGNOL

BLANSINGEN, EFRINGEN-KIRCHEN

LE ROSSIGNOL

Alemannenstraße 40/1, 79588 Efringen-Kirchen (Ortsteil Blansingen)
Tel. +49 7628 950 2190 · bonjour@lerossignol.de
www.lerossignol.de

THE FRENCH WAY

Sometimes the south of France is nearer than you think – and a bit of Gallic atmosphere surrounds this wine village in the Markgräflerland region, south of Freiburg. Here a 200-year-old farmyard has been turned into a picturesque guesthouse in the "chambres d'hôtes" style. Around a yard with cobblestones and Mediterranean plants stand a barn, storehouses and a wine farmer's house that have been converted into remarkably beautiful apartments. For its careful restoration, a sure stylistic touch and the natural way in which old and new have been blended here, the guesthouse has received an architectural award. The barn, now named "Le Logis," houses maisonette apartments in which rubblestone, steel and oak wood have been combined to great effect, and on the ground floor "Le Patio" has a direct view of the yard through a large, glazed, round-arched gateway. "La Remise" is the apartment in the former woodshed, whose modern slatted construction echoes the old wooden façade. With its blue tiled stove and antique kitchen tiles, "La Maison" is a little gem, while "L'Atelier" exudes an artistic atmosphere beneath massive beams. Following the example of their French colleagues, the hosts gather visitors in the salon for the weekly aperitif, hold wine tastings in the cellar, and invite chefs from around the region to cook menus that are eaten at the long communal table. Guests who acquire a taste for French ways at Le Rossignol, and want to intensify their feeling of savoir-vivre, only have to drive a few miles before they are really in France. Not in the south, admittedly, but in the east, and that is a good start. Bon voyage! ◆ Book to pack: "Hotel Pastis" by Peter Mayle

DIRECTIONS *Blansingen is in the far southwest of Germany, close to France and Switzerland. Basel-Mulhouse-Freiburg airport is about 30 minutes away by car* · **RATES** *€€* · **ROOMS** *5 apartments and 3 guest houses* · **FOOD** *All apartments have a kitchen for self-catering. Bakery goods and regional products for breakfast are available from a little shop* · **HISTORY** *The farmyard buildings, which have protected status, were opened as a guesthouse in 2023* · **X-FACTOR** *The pool and firepit add a feeling of Mediterranean holidays*

AUF FRANZÖSISCHE ART

Manchmal ist Südfrankreich näher als man denkt – ein Hauch davon liegt schon über diesem Winzerdorf im Markgräflerland südlich von Freiburg. Hier ist aus einem 200 Jahre alten Gutshof ein malerisches Gästehaus nach Art der „chambres d'hôtes" entstanden. Rund um einen Innenhof mit Kopfsteinpflaster und mediterranen Pflanzen gruppieren sich Scheune, Remise und Winzerhäuschen, die zu außergewöhnlich schönen Apartments umgebaut wurden. Für die behutsame Sanierung, Stilsicherheit und Selbstverständlichkeit, mit der hier Altes und Neues verbunden wird, bekam der Gasthof bereits einen Architekturpreis. Als „Le Logis" beherbergt die ehemalige Scheune jetzt Maisonettewohnungen, die Bruchstein, Stahl und Eiche effektvoll kombinieren, und im Erdgeschoss bietet „Le Patio" durch ein großes gläsernes Rundbogentor einen direkten Ausblick auf den Hof. „La Remise" heißt die Wohnung im einstigen Holzschuppen, sie bildet mit ihrer modernen Lamellenkonstruktion die alte Holzfassade nach. Ein kleines Schmuckstück mit blauem Kachelofen und historischen Küchenfliesen ist „La Maison", und „L'Atelier" unter dicken Balken verströmt Künstleratmosphäre. Nach dem Vorbild ihrer französischen Kollegen bringen die Gastgeber ihre Besucher beim wöchentlichen Apéro im Salon zusammen, veranstalten Weinproben im Keller und laden Köche aus der Region ein, deren Menüs an der langen Gemeinschaftstafel genossen werden. Wer in Le Rossignol auf den Geschmack gekommen ist und das Gefühl des Savoir-vivre vertiefen will, muss übrigens nur ein paar Kilometer fahren und ist bereits im echten Frankreich. Zwar noch nicht im Süden, aber immerhin im Osten, und das ist ja schon ein guter Anfang. Bon voyage! ◆ Buchtipp: „Hotel Pastis" von Peter Mayle

ANREISE *Blansingen liegt im äußersten Südwesten Deutschlands, nahe von Frankreich und der Schweiz. Der Flughafen Basel-Mulhouse-Freiburg ist knapp 30 Fahrtminuten entfernt* · **PREISE** *€€* · **ZIMMER** *5 Apartments und 3 Gästehäuser* · **KÜCHE** *Alle Wohnungen haben Küchen für Selbstversorger. Fürs Frühstück kann man in einem Lädchen Backwaren und regionale Produkte kaufen* · **GESCHICHTE** *Der denkmalgeschützte Hof wurde 2023 als Gästehaus eröffnet* · **X-FAKTOR** *Auch Pool und Feuerstelle sorgen für südländisches Ferienflair*

À LA FRANÇAISE

Le Sud de la France est parfois plus proche qu'on ne le croit: son air parfumé semble flotter sur ce village viticole du Markgräflerland, au sud de Fribourg. Ici, une ferme vieille de 200 ans a été transformée en une pittoresque maison d'hôtes. La cour intérieure pavée, décorée de plantes méditerranéennes, est entourée d'une grange, d'une remise et de maisonnettes de vignerons transformées en appartements d'une beauté exceptionnelle. L'auberge a déjà reçu un prix d'architecture pour la rénovation précise dont elle a fait l'objet, son style maîtrisé et la fluidité avec laquelle l'ancien s'y unit au moderne. Baptisée « Le Logis », l'ancienne grange abrite des appartements en duplex qui combinent magistralement la pierre de taille, le chêne et l'acier. Au rez-de-chaussée, « Le Patio » ouvre ses grandes baies vitrées arrondies sur la cour. « La Remise », l'appartement situé dans l'ancien hangar à bois, réinterprète l'ancienne façade avec un bardage à tasseaux résolument contemporain. « La Maison » est un petit bijou, avec son poêle en faïence bleue et ses carreaux de cuisine anciens, et « L'Atelier », avec ses poutres épaisses, dégage une atmosphère très artiste. À l'instar de leurs confrères français, les propriétaires réunissent leurs hôtes au salon une fois par semaine pour l'apéro. Ils proposent des dégustations de vin dans la cave et invitent des cuisiniers de la région dont les menus sont dégustés autour de la longue table commune. Ceux qui ont pris goût au Rossignol et souhaitent prolonger leur expérience de ce savoir-vivre n'ont qu'à parcourir quelques kilomètres pour découvrir la France véritable. Ce ne sera pas le Sud, certes, mais l'Est est déjà un bon début. Alors bon voyage ! ◆ À lire : « Hôtel Pastis » de Peter Mayle

ACCÈS *Blansingen se trouve au sud-ouest de l'Allemagne, tout près de la France et de la Suisse. L'aéroport de Bâle-Mulhouse-Fribourg est à un peu moins de 30 minutes de route* · **PRIX** *€€* · **CHAMBRES** *5 appartements et 3 chambres d'hôtes* · **RESTAURATION** *Tous les appartements sont dotés d'une cuisine pour plus d'indépendance. Pour le petit-déjeuner, on peut acheter pâtisseries et produits locaux dans une petite boutique* · **HISTOIRE** *La ferme classée monument historique est devenue maison d'hôtes en 2023* · **LES « PLUS »** *La piscine et la cheminée confèrent une atmosphère méridionale à vos vacances*

BADEN-WÜRTTEMBERG 223

SPIELWEG

MÜNSTERTAL, SCHWARZWALD

SPIELWEG

Spielweg 61, 79244 Münstertal
Tel. +49 7636 7090 · fuchs@spielweg.com
www.spielweg.com

A FAMILY MATTER

When the abbot of a nearby monastery granted this inn the right to serve customers in 1705, the document that he signed stated the following: "This house is to be the communal inn and hall in the Upper Münster Valley, where weddings and church holidays, carnival and new year celebrations are held." And so it was: since that date, big parties and meals for small groups have been held in the Spielweg inn, and for more than 160 years this has happened under the aegis of the Fuchs family. They have turned the inn into a popular country hotel, making it possible to enjoy the Black Forest, where Germany is as pretty as a picture, for a whole vacation. The sisters Kristin and Viktoria, the sixth generation, run the business with great verve. Kristin takes care of the service, while Viktoria, who brought back a love of Asian flavors from her apprenticeship and her travels, rules in the kitchen. She cooks creative and delicious dishes, often with game from her father's hunting grounds, combined with the aromas of herbs from her mother's garden. The in-house bakery produces rustic Black Forest bread, and the family even make cheese – using milk from cows that presumably lead a contented life on pastures at a height of 3,300 feet. The meals are served in tavern rooms with tiled stoves, wall paneling and coffered ceilings that are every bit as cozy as the guest rooms, which are spread over several buildings. Over the years, the hotel has grown to be a village within the village – it also has a tennis court and a pool, a lawn for sunbathing with a barrel sauna, and a splashing mountain stream, in which guests can cool their feet after a hike or a bike tour. ◆ Book to pack: "The Foxes Come at Night" by Cees Nooteboom

DIRECTIONS *South of Freiburg, 1.5 hours by car from Strasbourg airport and 2 hours from Zurich airport* · **RATES** *€€–€€€* · **ROOMS** *33 rooms and suites, 5 apartments* · **FOOD** *Fusion cuisine from Baden and Asia. Guests can also sign up for cookery courses and buy home-made products such as jam and cheese* · **HISTORY** *Since 1861 the hotel has been owned by the Fuchs family* · **X-FACTOR** *Walkers enjoy the Westweg, the oldest long-distance trail in the region. It was established as long ago as 1900 and crosses the Black Forest from north to south*

EINE FAMILIENANGELEGENHEIT

Als der Abt eines nahen Klosters 1705 diesem Gasthof das Wirtschaftsrecht verlieh, stand in der von ihm unterzeichneten Urkunde: „Das Haus soll im Oberen Münstertal das Gemeindewirtshaus und Stube sein, darin sollen Hochzeiten, Kirchenweihen, Fasnacht und Neujahrsfeiern abgehalten werden." So geschah es dann auch: Seit diesem Datum wird im Spielweg groß gefeiert oder im kleinen Kreis zusammengesessen, und seit mehr als 160 Jahren geschieht das unter der Regie der Familie Fuchs. Sie hat aus dem Hof ein Lieblingslandhotel gemacht, sodass man den Schwarzwald, wo Deutschland so schön wie im Bilderbuch ist, einen ganzen Urlaub lang genießen kann. Schon in sechster Generation führen derzeit die Schwestern Kristin und Viktoria mit jeder Menge Elan den Betrieb, Kristin im Service und Viktoria in der Küche. Letztere hat aus ihren Lehrjahren und von Reisen eine Vorliebe für asiatische Aromen mit nach Hause gebracht und kocht so kreativ wie köstlich, gerne Wild aus dem Jagdrevier ihres Vaters, kombiniert mit duftenden Kräutern aus Mutters Garten. Aus der hauseigenen Bäckerei kommt Schwarzwälder Bauernbrot, und die Familie stellt sogar Käse selbst her – die Milch stammt von Kühen, die auf 1000 Meter hoch gelegenen Weiden höchstwahrscheinlich glücklich leben. Serviert wird in Wirtsstuben, die mit Kachelofen, Wandvertäfelungen und Kassettendecken ebenso gemütlich sind wie die in mehreren Gebäuden untergebrachten Gästezimmer. Inzwischen ist das Hotel zum Dorf im Dorf gewachsen – auch ein Tennisplatz und Pool gehören dazu, zudem eine Liegewiese mit Fasssauna und ein plätschernder Bergbach, in dem man nach einer Wanderung oder Radtour die Füße kühlen kann. ◆ Buchtipp: „Nachts kommen die Füchse" von Cees Nooteboom

ANREISE *Südlich von Freiburg gelegen. Der Flughafen Straßburg ist 1,5 Fahrtstunden, der Flughafen Zürich 2 Fahrtstunden entfernt* · **PREISE** *€€–€€€* · **ZIMMER** *33 Zimmer und Suiten, 5 Apartments* · **KÜCHE** *Badisch-asiatische Fusionsküche. Gäste können auch an Kochkursen teilnehmen und Hausgemachtes wie Marmelade und Käse zum Mitnehmen kaufen* · **GESCHICHTE** *Seit 1861 ist das Hotel im Besitz der Familie Fuchs* · **X-FAKTOR** *Wanderer schätzen den schon im Jahr 1900 angelegten Westweg, den ältesten Fernwanderweg der Region, der den Schwarzwald von Nord nach Süd durchzieht*

UNE AFFAIRE DE FAMILLE

Le document par lequel l'abbé d'un monastère proche accorda le droit d'exploitation à cette auberge en 1705 stipule : « Cette maison doit être pour la Haute Vallée de Munster l'auberge et le salon communs ; on doit y célébrer les mariages, les eucharisties, le carnaval et les fêtes de fin d'année. » Ainsi fut fait, et aujourd'hui encore le Spielweg accueille des fêtes en grande pompe ou en petit comité, sous les auspices de la famille Fuchs depuis plus de 160 ans. L'auberge rustique s'est changée en hôtel de campagne recherché, depuis lequel on peut profiter des beautés de la Forêt-Noire, cette Allemagne des contes, pendant toutes les vacances. Kristin et sa sœur Viktoria, qui incarnent la sixième génération, dirigent l'affaire avec beaucoup de dynamisme, au service et en cuisine. Au cours de son apprentissage et de ses voyages, Viktoria s'est forgé une prédilection pour les saveurs asiatiques et elle propose des plats créatifs et délicieux, souvent du gibier provenant du terrain de chasse de son père combiné à des herbes aromatiques cueillies dans le jardin de sa mère. La boulangerie de la maison produit du pain fermier typique de la Forêt-Noire et la famille fabrique même son propre fromage – le lait provient des vaches qui paissent, vraisemblablement bienheureuses, sur un terrain perché à 1 000 mètres d'altitude. Avec leurs poêles en faïence, leurs lambris et leurs plafonds à caissons, les salles où sont servis ces bons produits sont aussi confortables que les chambres, réparties dans plusieurs bâtiments. Car au fil du temps l'hôtel est devenu un village dans le village, avec court de tennis et piscine, une pelouse immense, un bain nordique, un ruisseau de montagne qui murmure et rafraîchit les pieds après une randonnée ou une balade à vélo. ◆ À lire : « La nuit viennent les renards » de Cees Nooteboom

ACCÈS *Situé au sud de Fribourg. L'aéroport de Strasbourg est à 1,5 h de route, celui de Zürich, à 2 h* · **PRIX** *€€–€€€* · **CHAMBRES** *33 chambres et suites, 5 appartements* · **RESTAURATION** *Le menu fusionne traditions badoise et asiatique. Les clients peuvent aussi prendre des cours de cuisine et acheter des produits faits maison comme de la confiture et du fromage* · **HISTOIRE** *L'hôtel appartient à la famille Fuchs depuis 1861 !* · **LES « PLUS »** *Les randonneurs apprécient le Westweg depuis plus d'un siècle – il s'agit du plus ancien sentier de la région, qui traverse la Forêt-Noire du nord au sud*

BADEN-WÜRTTEMBERG

HOTEL SCHIEFES HAUS ULM

ULM

HOTEL SCHIEFES HAUS ULM

Schwörhausgasse 6, 89073 Ulm
Tel. +49 731 967 930 · hotelschiefeshausulm@t-online.de
www.hotelschiefeshausulm.de

EQUILIBRIUM

Schiefes Haus means "crooked house," and is exactly that: crooked, in fact very crooked. It leans out over the River Blau so much that you might think the window boxes of flowers will topple into the water at any moment – possibly followed by the façade and the whole building. Since the mid-15th century it has stood in this seemingly wobbly position in the historic fishermen's quarter of Ulm. The ground began to subside back then, as it was softer on the north side of the plot than on the south side, and the house, originally built of wood, inclined more and more to one side. At one time the space beneath the overhanging upper floor became a sheltered jetty for boats (and is a gallery with seating today). Residents of the house have tried again and again to prop it up with columns, stone walls, and concrete foundations. Finally, in the mid-1990s, it was stabilized as it now stands and carefully restored. The renovation won awards, and the building entered the Guinness Book of Records as the most crooked hotel in the world. Its outward appearance makes it one of the most popular motifs for photos in the city, alongside the Ulm Minster and town hall; inside, modern times have taken over as discreetly as possible. Guests sleep between ancient walls and beneath massive ceiling beams, and could easily feel dizzy at the sight of the uneven floorboards: the slope from wall to wall in the rooms measures as much as 16 inches! The beds, at least, are horizontal – as shown by the little spirit levels at their heads, which are in perfect equilibrium. ◆ Book to pack: "The World as I See It" by Albert Einstein, who was born in Ulm

DIRECTIONS *Ulm is situated between Augsburg and Stuttgart. Stuttgart airport is 1 hour's drive away* · **RATES** *€€* · **ROOMS** *11 rooms* · **FOOD** *The hotel serves only breakfast; for lunch and dinner it has a cooperation with local restaurants* · **HISTORY** *Built in 1406 as the house of a burgher and extended in 1443, it was restored and opened as a hotel in summer 1995* · **X-FACTOR** *The historic quarter of fishermen and tanners with its narrow alleys, half-timbered buildings, and mill wheels is one of the nicest parts of Ulm*

IN BALANCE BLEIBEN

Das Schiefe Haus hält, was es verspricht: Es ist schief, sehr schief sogar. Es neigt sich so stark über die Blau, dass man meint, jeden Moment würden die Blumenkästen von den Fenstern in den Fluss kippen – möglicherweise gefolgt von der Fassade und dem ganzen Gebäude. Seit Mitte des 15. Jahrhunderts steht es schon in dieser vermeintlich wackligen Position im historischen Fischerviertel von Ulm. Damals begann der Boden nachzugeben, der an der Südseite des Grundstücks weicher war als an der Nordseite, und das ursprünglich hölzerne Haus neigte sich mehr und mehr zur Seite. Irgendwann entstand unter dem vorhängenden ersten Geschoss sogar eine geschützte Anlegestelle für Boote. Heute ist an dieser Stelle eine Sitzgalerie. Mit Säulen, Steinwänden und Betonfundamenten versuchten Bewohner das Haus immer wieder zu stützen. Mitte der 1990er wurde es schließlich in seiner jetzigen Struktur stabilisiert und vorsichtig saniert. Die Sanierung wurde prämiert, und der Bau erhielt im Guinnessbuch der Rekorde als das schiefste Hotel der Welt einen Eintrag. Sein Äußeres ist neben dem Ulmer Münster und dem Rathaus eines der beliebtesten Fotomotive in der Stadt, und im Inneren hat die Moderne so dezent wie möglich Einzug gehalten. Man wohnt zwischen alten Mauern und unter mächtigen Deckenbalken, und es könnte einem schon leicht schwindlig werden angesichts der unebenen Dielen … in den Zimmern fällt der Boden von Wand zu Wand um bis zu 42 Zentimeter ab! Die Betten immerhin sind alle gerade – das beweisen die kleinen Wasserwaagen am Kopfende, die in perfekter Balance sind. ◆ Buchtipp: „Das Abenteuer des Denkens" von David Chotjewitz (ein Roman über Albert Einstein, der in Ulm geboren wurde)

ANREISE *Ulm liegt zwischen Augsburg und Stuttgart. Der Flughafen Stuttgart ist rund 1 Fahrtstunde entfernt* · **PREISE** *€€* · **ZIMMER** *11 Zimmer* · **KÜCHE** *Im Hotel wird nur Frühstück angeboten; für Mittag- und Abendessen arbeitet das Haus mit nahen Restaurants zusammen* · **GESCHICHTE** *Das ehemalige Bürgerhaus entstand 1406 und wurde 1443 erweitert. Nach der Sanierung eröffnete es im Sommer 1995 als Hotel* · **X-FAKTOR** *Das einstige Fischer- und Gerberviertel mit seinen verwinkelten Gassen, Fachwerkhäusern und Mühlrädern ist eines der schönsten Viertel Ulms*

GARDER L'ÉQUILIBRE

« Schiefes Haus » signifie « maison penchée », et on peut dire que la promesse est tenue : elle penche même beaucoup. Elle s'incline tellement au-dessus de la Blau qu'on a l'impression qu'à tout moment les jardinières fleuries des fenêtres vont basculer dans la rivière, peut-être suivies de la façade et de la bâtisse tout entière. Elle se maintient pourtant dans cette position précaire depuis le milieu du XVe siècle, au cœur du quartier historique des pêcheurs d'Ulm. À l'époque, le sol, plus meuble au sud qu'au nord du terrain, commence à s'affaisser, et la maison en bois suit le mouvement, au point qu'un quai protégé pour les bateaux est même créé un temps sous le premier étage en saillie – un espace occupé aujourd'hui par une galerie couverte qui tient lieu de petit salon. Les occupants successifs ont tenté d'étayer la maison avec des piliers, des murs en pierre et des fondations en béton, jusqu'à ce qu'elle soit finalement stabilisée dans sa posture incongrue, puis prudemment rénovée au milieu des années 1990. Cette restauration a été primée et vaut à l'établissement d'être inscrit au livre Guinness des records comme l'hôtel le plus penché au monde. Sa façade est, avec la cathédrale d'Ulm et la mairie, une icône incontournable de la ville. À l'intérieur, la modernité se fait aussi discrète que possible. Les murs sont anciens, les poutres imposantes et les planchers donneraient presque le vertige – dans les chambres, le sol « descend » parfois de 42 centimètres d'un mur à l'autre ! On y dort cependant à l'horizontale, comme en attestent les niveaux à bulle incrustés dans les têtes de lit. En parfait équilibre. ◆ À lire : « Danube » de Claudio Magris, qui consacre de longs passages à la ville d'Ulm

ACCÈS *Ulm est à mi-chemin entre Augsbourg et Stuttgart. L'aéroport de Stuttgart se trouve à environ 1 h de voiture* · **PRIX** *€€* · **CHAMBRES** *11 chambres* · **RESTAURATION** *L'hôtel ne propose que le petit-déjeuner. Pour le déjeuner et le dîner, l'établissement collabore avec des restaurants voisins* · **HISTOIRE** *La maison a été construite en 1406 et agrandie en 1443. Après sa rénovation, elle a ouvert ses portes en tant qu'hôtel à l'été 1995* · **LES « PLUS »** *L'ancien quartier des pêcheurs et des tanneurs, avec ses ruelles tortueuses, ses maisons à colombages et ses roues de moulin, est un des plus beaux endroits d'Ulm*

BADEN-WÜRTTEMBERG 239

BADEN-WÜRTTEMBERG

ZUM EGLE 1336

KONSTANZ, BODENSEE

ZUM EGLE 1336

Salmannsweilergasse 10, 78462 Konstanz
Tel. +49 7531 363 2190 · info@bnbkonstanz.de
www.bnbkonstanz.de

REVEALING THE PAST

When the Council of Constance was held from 1414 to 1418, cardinals and bishops from many countries debated here about the unity of the church, and elected and inaugurated a pope north of the Alps for the first time – and this house already stood in the Old Town. It was built in 1336, half-timbered with a stone façade, and extended or altered time and again in the following centuries. When the present owner, an architect, bought it in 2013, the four-year restoration was like a journey back in time. Layer by layer, he uncovered the history of the building. Masonry and traces left in the timbers, murals and remains of wallpaper tell the story of how the rooms were structured and decorated from the Middle Ages until the 20th century. These memories were not all modernized in a chic style but were retained as far as possible in their original condition as witnesses to the past. The two bed-and-breakfast rooms have been furnished in a deliberately plain manner to leave plenty of space for the long history and fascinating architecture of the house. One room looks out onto the little street, the other into a small lightwell. As they share a bathroom, the two rooms are available only for joint occupancy. The hosts, the owner and his family, live on the third floor directly above the bed-and-breakfast rooms, and are pleased to supply the ingredients that their guests desire to start the day. They also provide insiders' tips for a sightseeing tour in Konstanz – for all those visitors who want to see more than just the historic church council building on the shores of Lake Constance. ◆ Book to pack: "Runaway Horse" by Martin Walser

DIRECTIONS *5 minutes' walk from the train station in Konstanz. The nearest major airport is Zurich (almost 1 hour's drive)* · **RATES** *€–€€* · **ROOMS** *2 rooms* · **FOOD** *Guests can make breakfast in the small kitchen. On request, the owners cook lunch and dinner together with their guests in their own private apartment* · **HISTORY** *The building is a protected monument, opened in spring 2019 for bed and breakfast* · **X-FACTOR** *If desired, the owners hold seminars on various subjects, for example philosophy and architecture*

SPURENSUCHE

Als von 1414 bis 1418 das Konstanzer Konzil stattfand, Kardinäle und Bischöfe aus aller Herren Länder hier um die Einheit der Kirche stritten und einmalig ein Papst nördlich der Alpen gewählt und geweiht wurde, gab es dieses Haus in der Altstadt schon. Es entstand um 1336 als Fachwerkbau mit Steinfassade und wurde in den darauffolgenden Jahrhunderten immer wieder erweitert oder umgebaut. Als es der jetzige Besitzer, ein Architekt, 2013 kaufte, war die vierjährige Sanierung wie eine Reise in die Vergangenheit. Schicht für Schicht legte er die Geschichte des Gebäudes frei. Versteinerungen und Spuren im Holz, Wandmalereien und Tapetenreste erzählten davon, wie die Räume vom Mittelalter bis ins 20. Jahrhundert hinein strukturiert und gestaltet waren. All diese Erinnerungen wurden nicht schick modernisiert, sondern als Zeitzeugen möglichst original erhalten. Die beiden Zimmer des Bed and Breakfast sind absichtlich schlicht eingerichtet, sodass viel Raum für die lange Geschichte und spannende Architektur des Hauses bleibt. Ein Zimmer geht zur Gasse hinaus, das andere zum kleinen Lichthof. Das Bad teilen sie sich, daher werden die Räume nur zusammen vermietet. Die Gastgeber, der Eigentümer und seine Familie, leben im dritten Stock gleich über dem Bed and Breakfast und liefern morgens gerne die Wunschzutaten fürs Frühstück. Außerdem geben sie Insidertipps für eine Sightseeing-Tour in Konstanz – für alle, die mehr sehen möchten als nur das historische Konzilgebäude am Ufer des Bodensees.
◆ Buchtipp: „Ein fliehendes Pferd" von Martin Walser

ANREISE *5 Gehminuten vom Bahnhof Konstanz entfernt. Nächster großer Flughafen ist Zürich (knapp 1 Fahrtstunde)* · **PREISE** €–€€ · **ZIMMER** *2 Zimmer* · **KÜCHE** *In der Teeküche kann man Frühstück zubereiten. Auf Wunsch kochen die Besitzer gemeinsam mit den Gästen mittags und abends in ihrer Privatwohnung* · **GESCHICHTE** *Das denkmalgeschützte Haus wurde im Frühjahr 2019 als Bed and Breakfast eröffnet* · **X-FAKTOR** *Auf Wunsch bieten die Eigentümer Kolloquien zu unterschiedlichen Themen, wie Philosophie und Architektur, an*

SUR LES TRACES DE L'HISTOIRE

Quand évêques et cardinaux se sont réunis en concile à Constance de 1414 à 1418 pour réunifier l'Église et que pour la première fois un pape a été élu et consacré au nord des Alpes, cette maison de la vieille ville existait déjà. Bâtie vers 1336, la bâtisse à colombages et façade en pierre a été agrandie et transformée à plusieurs reprises au cours des siècles suivants. L'architecte qui l'a acquise en 2013, toujours propriétaire, a mené quatre années de rénovation comme on partirait en voyage dans le passé. Couche après couche, il a mis au jour l'histoire du bâtiment. Les pétrification, les traces laissées dans le bois, les peintures murales et les lambeaux de papier peint lui ont raconté comment les pièces avaient été structurées et aménagées au fil du temps, du Moyen Âge au XXe siècle. Tous ces vestiges n'ont pas été noyés dans une modernisation chic mais conservés comme des témoins de leur époque, autant que possible sans altération. Les deux chambres du bed and breakfast sont volontairement épurées, afin de laisser s'exprimer l'architecture passionnante de la maison et la longue histoire qu'elle raconte. L'une des chambres donne sur la ruelle, l'autre sur un petit atrium. La salle de bains étant commune, les deux chambres ne sont louées qu'ensemble. Le propriétaire et sa famille vivent au troisième étage, juste au-dessus des chambres d'hôtes, et livrent volontiers le matin les ingrédients souhaités pour le petit-déjeuner. Ils prodiguent aussi des conseils d'initiés pour une visite inoubliable de Constance si vous souhaitez voir autre chose que le bâtiment historique du Concile sur les rives du lac. ◆ À lire : « Un cheval qui fuit » de Martin Walser

ACCÈS *Situé à 5 min à pied de la gare de Constance. L'aéroport international le plus proche est celui de Zürich (à 1 h de route)* · **PRIX** €–€€ · **CHAMBRES** *2 chambres* · **RESTAURATION** *Une kitchenette est à disposition pour préparer le petit-déjeuner. Sur demande, les propriétaires peuvent cuisiner avec les hôtes midi et soir dans leur appartement privé* · **HISTOIRE** *La maison, classée monument historique, a ouvert son bed and breakfast en 2019* · **LES « PLUS »** *Sur demande, les propriétaires proposent des colloques sur divers thèmes, comme la philosophie et l'architecture*

BADEN-WÜRTTEMBERG 247

ALPENLOGE

SCHEFFAU, ALLGÄU

ALPENLOGE

Kirchenanger 6, 88175 Scheffau
+49 8381 912 3600 · stay@alpenloge.com
www.alpenloge.com

LEARNING AND DOING

The village school, where the children of Scheffau once learned reading and arithmetic, stood on this site. Today, guests from all over the world are taught the best ways to relax in the Allgäu. The Alpenloge is the seminar room of the photographer Michael Schott, who comes from nearby Lake Constance, and his wife Anja, a sociologist who came to the mountains from the coast, as she hails from Hamburg. From the outside, the pretty house with its wooden shingle roof, lattice windows, and shutters calls to mind the 1930s school that stood here, and the history lives on inside the new building, too: historic school prints hang on the walls of one room, restored armchairs found in the attic of the school building have been placed in another, and a third has panels of re-used wood behind the bed. These elements have been skillfully combined with design classics, wallpaper with botanical patterns, and wall paints in intense hues that take their cue from the colors of the surroundings: depending which way their room faces, guests have a view of the village, the gently sloping meadows and the Bregenz Forest, the Rotach Valley, or the Alps. Guests who want to add optional lessons to their timetable can hike up to the summit of the Hirschberg, take a trip to the Bregenz Festival, or in winter do cross-country skiing on wonderful trails. When they return, a gourmet menu restores their strength in the restaurant of the Alpenloge, where fresh, modern, and slightly experimental dishes are cooked exclusively for house guests. When has school been so much fun? ◆ Book to pack: "Austerlitz" by W. G. Sebald, who was born in the Allgäu

DIRECTIONS *In the West Allgäu where four countries meet: Germany, Austria, Liechtenstein, and Switzerland. The nearest train stations of any size are Bregenz and Oberstaufen (30 minutes' drive), the nearest international airports Zurich (2 hours' drive), Stuttgart (2.5 hours' drive), and Munich (2.5 hours' drive)* · **RATES** *€€€–€€€€* · **ROOMS** *9 suites (a suite is a "loge"), 4 with a kitchenette* · **FOOD** *Breakfast is served at the table on a tiered tray, and dinner as a three or four-course menu. The chef runs cookery courses* · **HISTORY** *Opened in 2019* · **X-FACTOR** *The spa is small but perfectly formed: fitted out in puristic style with natural stone and old wood, including a sauna and a salt steam-bath*

LIEBLINGSFACH: HEIMATKUNDE

Früher stand an dieser Stelle die Dorfschule, in der die Scheffauer Kinder lesen und rechnen lernten – heute wird hier Gästen aus aller Welt beigebracht, wie man im Allgäu am besten entspannt. Die Alpenloge ist der Unterrichtsraum des Fotografen Michael Schott, der vom nahen Bodensee stammt, und seiner Frau Anja, einer Soziologin, die von der Hamburger Waterkant in die Berge kam. Von außen erinnert das hübsche Haus dank Holzschindeln, Sprossenfenstern und Fensterläden an das ehemalige Schulgebäude aus den 1930ern, und auch im Inneren des Neubaus bleibt die Geschichte lebendig: So hängen in einem Raum historische Schuldrucke, in einem zweiten stehen restaurierte Sessel, die sich auf dem Dachboden des Schulgebäudes fanden, und ein dritter besitzt eine Altholzwand hinter dem Bett. Gekonnt kombiniert werden diese Elemente mit Designklassikern, Tapeten mit botanischen Mustern und satten Wandfarben, die die Töne der Umgebung aufgreifen: Je nach Ausrichtung der Zimmer blickt man auf das Dorf, die Wiesen, die sich über sanft geschwungene Hügel erstrecken, den Bregenzerwald, das Rotachtal oder die Alpen. Wer seinem lockeren Stundenplan Wahlfächer hinzufügen möchte, kann im Sommer zum Gipfel des Hirschbergs wandern oder einen Ausflug zu den Bregenzer Festspielen machen und im Winter über traumhafte Langlaufloipen gleiten. Nach der Rückkehr stärkt ein Gourmetmenü die Wanderer im Restaurant der Alpenloge, in dem exklusiv für die Gäste des Hauses frisch, modern und ein bisschen experimentell gekocht wird. Selten hat Schule so viel Spaß gemacht. ◆ Buchtipp: „Austerlitz" von W. G. Sebald, der im Allgäu geboren wurde

ANREISE Im Westallgäu im Vierländereck von Deutschland, Österreich, Liechtenstein und der Schweiz gelegen. Die nächsten Bahnhöfe sind Bregenz und Oberstaufen (jeweils etwa 30 Fahrtminuten), die nächsten großen Flughäfen Zürich (1,5–2 Fahrtstunden), Stuttgart und München (jeweils etwa 2,5 Fahrtstunden) · PREISE €€€–€€€€ · ZIMMER 9 Suiten („Logen"), 4 davon mit Kitchenette · KÜCHE Frühstück wird am Tisch auf Etageren serviert, abends gibt es ein Drei- oder Vier-Gänge-Menü. Der Küchenchef bietet auch Kochkurse an · GESCHICHTE 2019 eröffnet · X-FAKTOR Das Spa ist klein, aber fein: puristisch mit Naturstein und Altholz eingerichtet und mit Sauna sowie Sole-Dampfbad

MATIÈRE PRÉFÉRÉE : HISTOIRE LOCALE

Autrefois se trouvait ici l'école du village. Depuis, les enfants de Scheffau et les leçons de lecture et de calcul ont cédé la place à des hôtes du monde entier, qui viennent apprendre comment se détendre au mieux dans l'Allgäu. L'Alpenloge est devenue la salle de cours du photographe Michael Schott, originaire du lac de Constance voisin, et de sa femme Anja, une sociologue qui a quitté le port de Hambourg pour les montagnes. De l'extérieur, la jolie maison rappelle l'ancien bâtiment scolaire des années 1930 avec ses bardeaux, ses fenêtres à croisillons et ses volets anciens, et l'histoire palpite encore à l'intérieur du bâtiment rénové. Des planches pédagogiques d'époque sont accrochées dans une pièce, des fauteuils restaurés trouvés dans le grenier du bâtiment scolaire en meublent une autre, et une troisième est ornée d'une paroi en lattis anciens derrière le lit. Ces éléments sont habilement combinés avec des classiques du design, des papiers peints aux motifs botaniques et des couleurs murales saturées qui reprennent les teintes de l'environnement. Selon leur orientation, les chambres donnent sur le village, les collines aux courbes douces couvertes de prairies et le Bregenzerwald, la vallée de la Rotach ou les Alpes. Ceux qui le souhaitent ajouteront des matières optionnelles à leur emploi du temps décontracté : l'ascension du Hirschberg ou le festival de Brégence en été, les pistes de ski de fond dans un décor de rêve en hiver. Au retour, un menu gastronomique composé de plats frais, modernes et un peu expérimentaux redonne des forces aux randonneurs au restaurant que l'Alpenloge réserve à ses hôtes. L'école a bien changé ! ◆ À lire : « Austerlitz » de W. G. Sebald, qui est né dans l'Allgäu

ACCÈS Situé dans l'Allgäu occidental, au carrefour de l'Allemagne, de l'Autriche, du Liechtenstein et de la Suisse. Les gares les plus proches sont à Brégence et Oberstaufen (à environ 30 min de route) ; les aéroports les plus proches sont à Zurich (1,5–2 h de route), Stuttgart et Munich (environ 2,5 h) · PRIX €€€–€€€€ · CHAMBRES 9 suites (« Logen »), dont 4 avec kitchenette · RESTAURATION Le petit-déjeuner est servi à table sur des plateaux à étages et le soir, un menu à trois ou quatre plats est proposé. Le chef donne aussi des cours de cuisine · HISTOIRE Ouvert en 2019 · LES « PLUS » Le spa est petit mais raffiné. Décoration épurée, pierre naturelle et vieux bois, il comprend un sauna et un bain de vapeur d'eau saline

BAYERN 255

ANSITZ HOHENEGG

GRÜNENBACH, ALLGÄU

ANSITZ HOHENEGG

Hohenegg 6, 88167 Grünenbach
Tel. +49 160 9444 0179 · kontakt@ansitz-hohenegg.de
www.ansitz-hohenegg.de

IN COMPLETE PEACE

When first arriving at Ansitz Hohenegg, you already realize that it is a true place of refuge, as even the most up-to-date navigation system is lost. It is better to follow the analog directions given by the owners, taking the elevated ridge between West Allgäu and Oberallgäu as far as a clearing that would be an extremely suitable motif for photo-realistic wallpaper. Up here there is nothing but meadows and woods, sunshine, frequent snow in winter, fresh air and tranquility. And Ansitz Hohenegg itself, of course, which was originally built in 1730 and has been brought up to date with sensitivity. The Schindelhaus – Shingle House, taking its name from the historic wooden shingles – and the three rooms are a meeting of past and present, town and country. The owners, who run a brewery in Augsburg, have also demonstrated their talent for interior design: they have skillfully combined painted rustic cabinets and tables taken from taverns, with modern kitchen islands and settees by Italian designers, and have opted for warm colors and natural materials such as loden cloth or leather. Open fireplaces lend a special atmosphere to the rooms, as do the lovingly assembled accessories: here a hunting trophy hangs on the wall, there an old black-and-white photograph, and in the corner are grandma's first wooden skis. The apartment beneath the roof of the old storehouse is perfect for a romantic weekend for two, and the Schindelhaus itself can accommodate large families who want to enjoy some time out. Children are especially fond of Hohenegg – thanks to extras such as the area for playing football in front of the house, walks with alpacas and llamas, or the camp fire, where they can toast bread on sticks in the evening. ◆ Book to pack: "Birnam Wood" by Eleanor Catton

DIRECTIONS *Halfway between Kempten and Bregenz. As the house is reached via a track in the fields, four-wheel drive is advisable in winter* · **RATES** *€€–€€€* · **ROOMS** *1 house for 8 persons, 3 apartments for 2–6 persons* · **FOOD** *For self-catering there is a kitchen, provisions on neighboring farms or in village shops, and a herb garden where guests can help themselves. If desired, a private cook will come* · **HISTORY** *Opened at the turn of the year in 2018/19* · **X-FACTOR** *The little spa with its sauna is wonderful after a hike*

IN ALLER RUHE

Dass der Ansitz Hohenegg ein richtiger Rückzugsort ist, merkt man schon bei der Anreise, wenn sich selbst das neueste Navigationssystem verirrt. Dann folgt man besser der analogen Wegbeschreibung der Besitzer auf den Höhenzug zwischen West- und Oberallgäu und bis zu einer Lichtung, die sich hervorragend als Motiv für eine Fototapete eignen würde. Hier oben gibt es nur Wiesen und Wälder, Sonne und im Winter oft viel Schnee, Luft und Ruhe. Und den Ansitz Hohenegg selbst natürlich, der ursprünglich 1730 entstanden ist und mit viel Fingerspitzengefühl in die Gegenwart gebracht wurde. Im Schindelhaus, das seinen Namen den historischen Holzschindeln verdankt, sowie in den drei Stuben treffen sich Gestern und Heute, Land und Stadt. Die Besitzer, die in Augsburg eine Brauerei betreiben, haben auch als Innenausstatter Talent bewiesen: Gekonnt kombinierten sie bemalte Bauernschränke und ausrangierte Wirtshaustische mit modernen Kücheninseln und italienischen Designersofas und setzten auf warme Farben sowie Naturmaterialien wie Loden oder Leder. Offene Kamine verleihen den Räumen eine besondere Atmosphäre, wie auch die liebevoll zusammengestellten Accessoires: Hier hängt eine Jagdtrophäe an der Wand, dort eine alte Schwarz-Weiß-Aufnahme, und in der Ecke lehnen Großmutters erste Holzski. Die Dachwohnung in der Remise ist perfekt für ein romantisches Wochenende zu zweit, und das Schindelhaus selbst bietet genug Platz für Großfamilien, die sich eine gemeinsame Auszeit gönnen. Kinder lieben Hohenegg besonders – das liegt an Extras wie dem Bolzplatz vor der Tür, den Wanderungen mit Alpakas und Lamas oder dem Lagerfeuer, an dem abends Stockbrot gegrillt wird. ◆ Buchtipp: „Der Wald" von Eleanor Catton

ANREISE Auf halber Strecke zwischen Kempten und Bregenz gelegen. Die Anfahrt führt über einen Feldweg, im Winter ist Allradantrieb empfehlenswert · PREISE €€–€€€ · ZIMMER 1 Haus für 8 Personen, 3 Wohnungen für 2–6 Personen · KÜCHE Selbstversorger nutzen die eigene Küche, kaufen auf Nachbarhöfen oder in Dorfläden ein und bedienen sich im Kräutergarten. Auf Wunsch kommt ein Privatkoch ins Haus · GESCHICHTE Zum Jahreswechsel 2018/19 eröffnet · X-FAKTOR Wunderbar nach dem Wandern: das kleine Spa mit Sauna

EN TOUTE TRANQUILLITÉ

Le caractère isolé de l'Ansitz Hohenegg ne fait plus de doute quand même un système de navigation de dernière génération s'égare en chemin. Mieux vaut suivre les indications très analogiques fournies par les propriétaires pour atteindre la crête entre l'Allgäu-Occidental et le Haut-Allgäu, puis une clairière qui ferait un magnifique motif de papier peint. Ici, vous ne trouverez que des prairies et des forêts, du soleil, souvent beaucoup de neige en hiver, de l'air frais et du calme – et l'Ansitz Hohenegg lui-même, bien sûr, bâti en 1730 et progressivement remis au goût du jour avec beaucoup de doigté. Dans la Schindelhaus, traditionnelle maison à bardeaux et toit en shingle, comme dans les trois logements indépendants, hier croise aujourd'hui, la campagne rencontre la ville. Les propriétaires, qui exploitent une brasserie à Augsbourg, démontrent ici leurs talents de décorateurs : ils ont combiné avec bonheur des armoires de fermes peintes et des tables d'auberge usées à des îlots de cuisine modernes et des canapés de designers italiens, en misant sur des couleurs chaudes et des matières naturelles comme le loden ou le cuir. Les cheminées ouvertes confèrent aux pièces une atmosphère particulière, tout comme les éléments assemblés avec amour qui composent le décor : un trophée de chasse au mur, une vieille photo en noir et blanc et, debout dans un coin, les premiers skis en bois de la grand-mère. L'appartement mansardé aménagé dans la remise est idéal pour un week-end romantique et la maison bardée est assez grande pour accueillir les familles nombreuses désireuses de se détendre. Les enfants adorent Hohenegg – sans doute grâce au terrain de foot, aux randonnées avec alpagas et lamas ou au feu de camp où faire griller du pain le soir. ◆ À lire : « Eva dort » de Francesca Melandri

ACCÈS Situé à mi-chemin entre Kempten et Brégence. L'accès se fait par un chemin de terre, en hiver le 4x4 est recommandé · PRIX €€–€€€ · CHAMBRES 1 maison pour 8 personnes, 3 logements pour 2 à 6 personnes · RESTAURATION Ceux qui préfèrent préparer leurs repas disposent d'une cuisine et font leurs courses dans les fermes voisines ou dans les boutiques du village et se servent en herbes aromatiques dans le jardin. Sur demande, un chef se déplace pour cuisiner à demeure · HISTOIRE Hébergements ouverts entre fin 2018 et début 2019 · LES « PLUS » Merveilleux après une randonnée: le petit spa avec sauna

BAYERN 263

SCHLOSS ELMAU

ELMAU BEI KRÜN

SCHLOSS ELMAU

82493 Elmau
Tel. +49 882 3180 · info@schloss-elmau.de
www.schloss-elmau.de

A GRAND NAME

The journey here is a treat in itself: those who arrive in this alpine valley between the Zugspitze and Karwendel mountain ranges, and get their first glimpse of Schloss Elmau – majestically sited with a mountain backdrop and surrounded by woods and sloping meadows – cannot help but take a deep breath. It was built between 1914 and 1916 by the theologian and philosopher Johannes Müller with support from a wealthy countess and his brother-in-law, who was an architect. He wanted his followers to take a "holiday from themselves" amidst a pristine natural world. There were communal tables, evening dances, and concerts, brought to perfection in later years: stars of classical music as renowned as Yehudi Menuhin, Alfred Brendel, and Benjamin Britten performed in Elmau. Today the hotel is managed by Müller's grandson and has twice established its reputation in the world of politics as the venue for the G7 summit. Dietmar Müller-Elmau has skillfully restored the mansion after a devastating fire and continually expanded the cultural program – his artist agency has the caliber of an international concert hall, inviting audiences to master classes, readings by authors, and panel discussions. Alongside the old-established hotel, a few years ago the owner added a second refuge devoted entirely to wellness, complementing the spa facilities of the main building. Today it is possible in Elmau to enjoy oriental hammam rituals, take treatments according to traditional Chinese medicine, and relax in the Japanese onsen pool in water at a temperature of 105 Fahrenheit. If this is too exotic, guests can simply lie down on a lounger outside by the Ferchenbach stream and gaze into the blue-and-white Bavarian sky. ◆ Book to pack: "Munich" by Robert Harris

DIRECTIONS *Almost 30 minutes' drive from the train station in Garmisch-Partenkirchen, 2 hours south of Munich airport* · **RATES** *€€€€* · **ROOMS** *115 rooms and suites in the Hideaway, 47 rooms and suites in the Retreat* · **FOOD** *8 restaurants serving European and Asian dishes to suit every taste, from a location with two Michelin stars to traditional mountain-hut style. The hotel also has several bars, lounges and terraces* · **HISTORY** *The main building was reopened in 2007, and the second hotel was added in 2015* · **X-FACTOR** *Dance and yoga retreats with renowned teachers from various schools are held regularly*

EIN GROSSER NAME

Schon die Anreise ist ein Genuss: Wer dieses Hochtal zwischen Zugspitze und Karwendelgebirge erreicht und Schloss Elmau zum ersten Mal sieht – majestätisch vor den Bergen gelegen und von Wäldern und Buckelwiesen umgeben –, der atmet unwillkürlich durch. Von 1914 bis 1916 erbaute es der Lebensphilosoph Johannes Müller mit Unterstützung einer wohlhabenden Gräfin und seines Schwagers, der Architekt war. Hier sollten seine Anhänger inmitten fast unberührter Natur „Ferien vom Ich" machen. Es gab Gemeinschaftstische, Tanzabende und Konzerte, die in späteren Jahren perfektioniert wurden: In Elmau traten Klassikstars vom Kaliber eines Yehudi Menuhin, Alfred Brendel und Benjamin Britten auf. Heute führt Müllers Enkel das Haus, das sich als zweifacher G7-Gastgeber auch einen Namen in der Welt der Politik machte. Dietmar Müller-Elmau hat das Schloss nach einem verheerenden Brand versiert renoviert und das Kulturprogramm kontinuierlich ausgebaut – sein künstlerisches Betriebsbüro ist dem eines internationalen Konzerthauses würdig und lädt auch zu Meisterklassen, Autorenlesungen sowie Podiumsdiskussionen ein. Dem etablierten Hotel hat der Besitzer vor einigen Jahren ein zweites Refugium zur Seite gestellt, das ganz der Wellness gewidmet ist und das Spa-Angebot des Haupthauses ergänzt. Heute kann man in Elmau orientalische Hamam-Rituale genießen, sich mit traditioneller chinesischer Medizin behandeln lassen und im japanischen Onsen-Pool im 40 Grad warmen Wasser entspannen. Wem das zu exotisch ist, der legt sich einfach auf ein Tagesbett draußen am Ferchenbach und schaut in den blau-weißen bayerischen Himmel. ◆ Buchtipp: „Das Frühstücksei" von Loriot, der hier Stammgast war (auch im wohlsortierten Buchladen des Hotels erhältlich)

ANREISE *Knapp 30 Fahrtminuten vom Bahnhof Garmisch-Partenkirchen entfernt, etwa 2 Fahrtstunden südlich des Münchner Flughafens* · **PREISE** *€€€€* · **ZIMMER** *115 Zimmer und Suiten im Hideaway, 47 Zimmer und Suiten im Retreat* · **KÜCHE** *8 Restaurants mit europäischer und asiatischer Küche für jeden Geschmack, vom Zwei-Sterne-Lokal bis zur urigen Bergstube. Zudem hat das Hotel mehrere Bars, Lounges und Terrassen* · **GESCHICHTE** *2007 wurde das Haupthaus neu eröffnet, 2015 kam das zweite Hotel dazu* · **X-FAKTOR** *Regelmäßig finden Tanz- und Yoga-Retreats mit renommierten Lehrern verschiedener Schulen statt*

UN GRAND NOM

Le voyage est déjà un plaisir : lorsqu'on atteint cette haute vallée entre la Zugspitze et le massif du Karwendel, on est saisi par l'apparition du château d'Elmau, majestueux au milieu des pentes tapissées d'arbres denses et des prairies vallonnées. Le théologien Johannes Müller l'a fait bâtir entre 1914 et 1916 grâce au soutien d'une comtesse fortunée et de son beau-frère architecte. L'objectif était d'y convier des adeptes de sa philosophie pour des « vacances du moi », dans une nature presque intacte. La tradition des tables communes, des soirées dansantes et des concerts s'est perpétuée et perfectionnée avec le temps : ainsi, des stars de la musique classique comme Yehudi Menuhin, Alfred Brendel et Benjamin Britten s'y sont produites. Aujourd'hui, le petit-fils de Müller dirige l'établissement, qui s'est également fait un nom dans le monde politique en accueillant le G7 par deux fois. Dietmar Müller-Elmau a rénové le château après un incendie dévastateur et n'a cessé d'en étoffer le programme culturel – le département artistique est digne d'une salle de concert internationale et organise aussi des master classes, des lectures d'écrivains et des tables rondes. Il y a quelques années, le propriétaire a ajouté un deuxième bâtiment dédié au bien-être, qui complète le spa de la maison principale. Il dispense les rituels du hammam oriental, des soins de médecine traditionnelle chinoise, et d'une piscine japonaise onsen avec une eau à 40 degrés. Si vous n'êtes pas attirés par cet exotisme, vous pourrez vous allonger sur un lit de jour au bord du Ferchenbach et contempler le ciel bleu et blanc de Bavière. ◆ À lire : « Le Maître du haut château » de Philip K. Dick

ACCÈS *Situé à 30 petites minutes de la gare de Garmisch-Partenkirchen, à environ 2 h de route au sud de l'aéroport de Munich* · **PRIX** *€€€€* · **CHAMBRES** *115 chambres et suites au Hideaway, 47 chambres et suites au Retreat* · **RESTAURATION** *8 restaurants servent une cuisine européenne et asiatique qui satisfera tous les goûts, de la table gastronomique deux étoiles au restaurant de montagne rustique. L'hôtel dispose en outre de plusieurs bars, salons et terrasses* · **HISTOIRE** *Le bâtiment principal a rouvert en 2007 et le second s'est ajouté en 2015* · **LES « PLUS »** *Des stages de danse et de yoga sont régulièrement organisés avec des professeurs renommés de différentes écoles*

KLOSTER BEUERBERG

EURASBURG

KLOSTER BEUERBERG

Königsdorfer Straße/Klosterstraße, 82547 Eurasburg
Tel. +49 89 213 774 240 (Freising Diocesan Museum) · info@dimu-freising.de
www.klosterbeuerberg.de

A STAY IN A MONASTERY

For more than 900 years, Beuerberg Abbey has played its part in the life of the idyllic Loisach Valley near the Starnberger See lake. Augustinian canons and nuns of the Salesian order worked and prayed here. It has also served as a boarding school for girls, a military hospital, a home for migrants, and a space for art exhibitions. The Archdiocese of Munich and Freising, which now owns the abbey, has made it into a kind of hotel: in the Josef Wing, once the outbuildings for work on the estate, unique rooms for guests have been installed. Inspired by old monastic forms and colors, the Bavarian studio Zeitraum designed a modern furniture series, made from bright solid wood, with which the rooms are now fitted out in a straightforward, plain and stylish way. The interior designers from Formstelle in Grünwald took their cue from various traditional elements. The shapes of the quatrefoil and oval appear as fundamental design concepts, linen and porcelain as basic materials. The black, gray, and white typical of monastic life are enriched with "Beuerberg green" – a subdued decorative hue that adorned the interiors of the buildings in past times. Partitions and stair banisters of black steel make reference to the shape of the abbey grilles, and floor tiles of dark-gray cement display the emblem of Beuerberg: a heart pierced by arrows with a cross. In the spirit of Christian community, there is also a kitchen where the residents cook together. Here too, memories of the past can be found: still visible beneath the ceiling is the pulley that the monks once used to raise heavy loads. ◆ Book to pack: "The Gargoyle" by Andrew Davidson

DIRECTIONS *Beuerberg is part of the Eurasburg commune and lies south of Munich, about 1–1.5 hours from the airport* · **RATES** *€€* · **ROOMS** *23 rooms* · **FOOD** *There is a simple in-house restaurant, a small bakery and a shop* · **HISTORY** *The Beuerberg monastery was founded in 1121. In 2013 the last nuns left. It is now undergoing renovation and being converted step by step into a site for personal encounters and the arts. The guest rooms were opened in autumn 2024* · **X-FACTOR** *A visit to the former abbey church of St Peter and St Paul, a superbly restored 17th-century baroque building*

ZU GAST IM KLOSTER

Schon seit mehr als 900 Jahren prägt das Kloster Beuerberg einen Teil des Lebens im idyllischen Loisachtal nahe des Starnberger Sees. Augustiner-Chorherren und Salesianerinnen beteten und arbeiteten hier, es diente als Mädchenpensionat, Müttergenesungsheim und Lazarett, beherbergte Aussiedler und bot Kunstausstellungen Raum. Jetzt hat die Erzdiözese München und Freising, der das Kloster inzwischen gehört, eine Art Hotel daraus gemacht: Im Josefstrakt, dem ehemaligen Wirtschaftsgebäude der Anlage, sind einzigartige Gästezimmer entstanden. Inspiriert von alten klösterlichen Formen und Farben entwarf das bayerische Studio Zeitraum eine moderne Möbellinie aus hellem Massivholz, mit der die Räume geradlinig, schlicht und stilvoll eingerichtet wurden. Die Innenausstatter des Grünwalder Büros Formstelle nahmen dabei immer wieder auf traditionelle Elemente Bezug. So tauchen Vierpassornament und Oval als gestalterische Grundideen auf und Leinen sowie Porzellan als Basisstoffe. Klostertypisches Schwarz-Grau-Weiß wird mit „Beuerberger Grün" verschönert – einer gedämpften Schmuckfarbe, die das Innere der Gebäude schon in der Vergangenheit zierte. Raumteiler und Treppengeländer aus Schwarzstahl greifen die Form der Klostergitter auf, und Bodenfliesen aus dunkelgrauem Zement zeigen das Beuerberger Emblem, ein von Pfeilen durchbohrtes Herz mit Kreuz. Ganz dem christlichen Gemeinschaftsgedanken verpflichtet, gibt es zudem eine Küche, in der Bewohner zusammen kochen können und die ebenfalls an die Vergangenheit erinnert: Unter der Decke ist noch die Seilwinde zu sehen, mit der die Mönche einst schwere Lasten nach oben zogen. ◆ Buchtipp: „Gargoyle" von Andrew Davidson

ANREISE *Beuerberg gehört zur Gemeinde Eurasburg und liegt südlich von München, vom Flughafen fährt man 1–1,5 Stunden* · **PREISE** *€€* · **ZIMMER** *23 Zimmer* · **KÜCHE** *Zum Haus gehören ein einfaches Restaurant sowie eine kleine Bäckerei und Krämerei* · **GESCHICHTE** *Das Kloster Beuerberg wurde 1121 begründet, 2013 zogen die letzten Nonnen aus. Derzeit wird die Anlage saniert und Schritt für Schritt zur Begegnungs- und Kulturstätte umgebaut. Die Gästezimmer eröffneten im Herbst 2024* · **X-FAKTOR** *Ein Besuch in der ehemaligen Klosterkirche St. Peter und Paul, einem prächtig restaurierten Barockbau aus dem 17. Jahrhundert*

INVITATION AU COUVENT

L'abbaye de Beuerberg s'inscrit dans la vie quotidienne de la vallée idyllique de la Loisach, près du lac de Starnberg, depuis plus de 900 ans. Des chanoines augustins et des sœurs salésiennes y ont prié et travaillé, elle a servi de pensionnat de jeunes filles, de maison de convalescence pour parturientes et d'hôpital militaire, et accueilli des rapatriés comme des expositions d'art. Aujourd'hui, l'archidiocèse de Munich et Freising, qui en est propriétaire, en a fait un établissement hôtelier unique : des chambres d'hôtes ont été créées dans l'aile Josef, l'ancien bâtiment d'exploitation du site. En s'inspirant des antiques formes et couleurs monastiques, le studio bavarois Zeitraum a conçu une ligne de meubles modernes en bois massif clair qui équipent les chambres dans un style rectiligne, simple et sans chichis. Les décorateurs d'intérieur du bureau Formstelle de Grünwald aiment les références à des éléments traditionnels. Ainsi, l'aménagement se fonde sur les motifs ornementaux du quatre-feuilles et de l'ovale, avec le lin et la porcelaine comme matériaux récurrents. Le noir-gris-blanc typique des monastères est embelli par le « vert de Beuerberg », une teinte tamisée très décorative déjà employée autrefois dans les bâtiments. Les meubles séparateurs et les rampes d'escalier en acier noir reprennent la forme des grilles du monastère et les carreaux de ciment gris foncé au sol arborent l'emblème du Beuerberg, un cœur percé de flèches et surmonté d'une croix. Bien dans l'idée chrétienne de communauté, une cuisine permet aux résidents de faire à manger ensemble et rappelle le passé : on voit encore au plafond le treuil grâce auquel les moines soulevaient les lourdes charges. ◆ À lire : « Les Âmes brûlées » d'Andrew Davidson

ACCÈS *Beuerberg fait partie de la commune d'Eurasburg, au sud de Munich et à 1–1,5 h de route de son aéroport* · **PRIX** *€€* · **CHAMBRES** *23 chambres* · **RESTAURATION** *La maison comprend un restaurant simple ainsi qu'une petite boulangerie et une épicerie* · **HISTOIRE** *L'abbaye de Beuerberg a été fondée en 1121 et les dernières religieuses l'ont quittée en 2013. En cours de rénovation, elle se transforme peu à peu en lieu de rencontre et de culture. Les chambres d'hôtes ont ouvert à l'automne 2024* · **LES « PLUS »** *Une visite de l'ancienne église du couvent St-Pierre-et-St-Paul, édifice baroque du XVIIe siècle magnifiquement restauré*

BAYERN 279

BAYERN 281

BERGHOTEL ALTES WALLBERGHAUS

ROTTACH-EGERN

BERGHOTEL ALTES WALLBERGHAUS

Wallberg 2, 83700 Rottach-Egern
Tel. +49 8022 278 570 · servus@altes-wallberghaus.de
www.wallberg-haus.de

MOUNTAIN PARADISE

The Altes Wallberghaus can only be reached on foot – and for a true mountain hotel, that is right and proper. From the valley station of the Wallbergbahn cable car, a straightforward hike zig-zags upwards. To get there more easily, take the cable car and then walk 20 minutes from the summit station towards the hotel (when you can actually go downhill again). At the end of the 19th century it was already an inn. Today it is run by a hotelier from Tegernsee, Korbinian Kohler, who has turned it into an atmospheric alpine hotel. The simple rooms have whitewashed walls and floorboards that smell slightly of oranges. Guests sleep in old farmhouse beds in linen sheets, and look straight into the mountain world of Bavaria when they wake up – a simply wonderful experience. There is neither television nor Internet, and nobody misses them. Most rooms have a shared shower and toilet in the corridor, and the typical charm of an alpine hut is even stronger in the dormitory with its two-tier bunks. Hiking and fresh air give guests an appetite, so hearty dishes are served in the restaurant with its panorama terrace – a Bavarian meal of bread with cheese and meats, for example, or cheese spätzle (south German noodles) made with local mountain cheese, and freshly cooked Kaiserschmarrn pancakes to round it all off. The hotel is also open in winter, when sporty guests can sledge down into the valley: the nearby sledge run, 4 miles long with a descent of 2,700 feet, is one of the longest and most demanding in Germany. ◆ Film to watch: "Tales of a Young Scamp," based on a book by Ludwig Thoma, whose grave is in Rottach-Egern

DIRECTIONS *At an altitude of 1,512 m/4,960 ft, south of Rottach-Egern and above Tegernsee lake. The drive to Munich and its airport takes just under 1.5 hours* · **RATES** *€–€€ including half-board* · **ROOMS** *7 single or double rooms, 4 rooms with 4 beds, 1 room with 6 beds, 1 dormitory with 6 two-tier bunk beds* · **FOOD** *A generous breakfast is served in the cozy parlor of the Bergrestaurant* · **HISTORY** *The building dates back to 1899. Today's inn has existed since December 2016, the hotel since June 2017* · **X-FACTOR** *Those who find the mountain too lonely go down to the valley to the Bachmair Weissach, the best luxury hotel on Tegernsee, also run by Korbinian Kohler, situated where the wheel of the Weissach watermill turned back in 1834, with a fantastic spa that celebrates the art of Japanese bathing*

BERGGLÜCK

Wie es sich für ein echtes Berghotel gehört, ist das Alte Wallberghaus nur zu Fuß erreichbar. Von der Talstation der Wallbergbahn führt eine einfache Wanderung Serpentine um Serpentine hinauf – wer es gemütlicher haben möchte, nimmt erst die Bahn und wandert dann 20 Minuten von der Bergstation aus zum Haus (dann geht es sogar schon wieder bergab). Bereits Ende des 19. Jahrhunderts war es ein Gasthof, heute betreibt das Haus der Tegernseer Hotelier Korbinian Kohler, der ein atmosphärisches Alpenhotel daraus gemacht hat. Die schlichten Zimmer haben weiß getünchte Wände und Dielenböden, die leicht nach Orange duften. Man schläft in alten Bauernbetten in Leinenwäsche und schaut beim Aufwachen direkt in die bayerische Bergwelt, es ist einfach herrlich. Fernseher oder Internet gibt es nicht und werden auch nicht vermisst, die meisten Zimmer teilen sich Dusche und Toilette auf dem Flur, und für noch mehr Hüttencharme sorgt das Bettenlager mit Stockbetten. Da Wandern und frische Luft hungrig machen, wird im Restaurant mit Panoramaterrasse Deftiges serviert – eine bayerische Brotzeit zum Beispiel, Käsespätzle mit Bergkäse aus der Region und zum Abschluss Kaiserschmarrn frisch aus der Pfanne. Auch im Winter ist das Hotel geöffnet, dann können sportliche Gäste mit dem Schlitten ins Tal fahren: Die nahe, 6,5 Kilometer lange Naturrodelbahn, die 825 Höhenmeter überwindet, ist eine der längsten und anspruchsvollsten Deutschlands. ◆ Buchtipp: „Lausbubengeschichten" von Ludwig Thoma, der in Rottach-Egern begraben liegt

ANREISE *Südlich von Rottach-Egern und dem Tegernsee auf 1512 m Höhe gelegen. München mit seinem Flughafen ist knapp 1,5 Fahrtstunden entfernt ·* **PREISE** *€–€€ inklusive Halbpension ·* **ZIMMER** *7 Einzel-/Doppelzimmer, 4 Vierbettzimmer, 1 Sechsbettzimmer, 1 Lager mit 6 Doppelstockbetten ·* **KÜCHE** *Im Bergrestaurant mit gemütlicher Stube gibt's auch ein üppiges Frühstück ·* **GESCHICHTE** *Erbaut wurde das Haus 1899. Seit Dezember 2016 besteht der heutige Gasthof, seit Juni 2017 das Hotel ·* **X-FAKTOR** *Wem es am Berg zu einsam ist, der geht im Tal ins Bachmair Weissach: Das beste Luxushotel am Tegernsee, ebenfalls von Korbinian Kohler, steht dort, wo sich schon 1834 die Weißachmühle drehte, und besitzt ein fantastisches Spa, das die japanische Badekunst zelebriert*

PARADIS MONTAGNARD

Comme tout hôtel de montagne qui se respecte, l'Altes Wallberghaus n'est accessible qu'à pied. Une piste remonte la pente en sinuant gentiment depuis la station inférieure du téléphérique du Wallberg, mais certains préféreront s'arrêter à la station suivante, un peu plus haut, puis marcher 20 minutes en descente jusqu'à la maison. Elle servait déjà d'auberge à la fin du XIXe siècle. L'établissement est aujourd'hui géré par l'hôtelier de Tegernsee Korbinian Kohler, qui l'a transformé en hôtel alpin à l'atmosphère chaleureuse. Les murs des chambres sobres ont été blanchis à la chaux et le parquet sent légèrement l'orange. On y dort dans de vieux lits de ferme drapés de lin et on se réveille face au spectacle magnifique des montagnes bavaroises. Vous n'y trouverez ni télévision ni connexion Internet, et elles ne vous manqueront pas. La plupart des chambres se partagent une salle d'eau et des toilettes dans le couloir et les lits superposés ajoutent au charme sans chichis du chalet. Comme la randonnée et le grand air ouvrent l'appétit, le restaurant avec terrasse sert des plats consistants – casse-croûtes bavarois, spätzle à la tomme de montagne, Kaiserschmarrn tout juste sorti de la poêle pour le dessert. L'hiver, les hôtes peuvent descendre vers la vallée en luge : la piste naturelle longue de 6,5 kilomètres, sur 825 mètres de dénivelé, est une des plus longues et difficiles d'Allemagne. ◆ À lire : « Tu aurais dû t'en aller » de Daniel Kehlmann

ACCÈS *Situé au sud de Rottach-Egern et du Tegernsee, à 1512 m d'altitude. Munich et son aéroport sont à 1,5 h de route ·* **PRIX** *€–€€ demi-pension incluse ·* **CHAMBRES** *7 chambres simples ou doubles, 4 chambres à 4 lits, 1 chambre à 6 lits, 1 dortoir avec 6 lits superposés ·* **RESTAURATION** *Le restaurant de montagne, doté d'un salon confortable, propose aussi un copieux petit-déjeuner ·* **HISTOIRE** *La maison date de 1899. L'auberge existe depuis décembre 2016 et l'hôtel, depuis juin 2017 ·* **LES « PLUS »** *Si vous vous sentez trop seul en montagne, descendez dans la vallée, au Bachmair Weissach : le meilleur hôtel de luxe du Tegernsee, qui appartient aussi à Korbinian Kohler, se trouve à l'endroit où le moulin de Weissach tournait déjà en 1834 et possède un fantastique spa qui célèbre l'art du bain japonais*

BAYERN

TANNERHOF

BAYRISCHZELL

TANNERHOF

Tannerhofstraße 30, 83735 Bayrischzell
Tel. +49 802 3810 · info@tannerhof.de
www.tannerhof.de

GOOD HEALTH!

For more than a century, the von Mengershausen family of doctors ran a sanatorium in Bayrischzell: here patients took a cure according to Kneipp principles, followed the Buchinger rules of fasting, and reinvigorated their circulatory system, depending on which generation of the family was in charge. Then the classic health-cure business took a downturn and the owners decided to give it an all-round rejuvenation in the early 21st century. The Munich architect Florian Nagler renovated the main house and the outbuildings of the Tannerhof, which are situated like a village in the mountains, and added modern "cabin towers" to the hermitage-like "air cabins" of the early days. Here the rooms are stacked one above the other, and the upper story is reached via an ingenious flight of steps (the unique alpine architecture has received several awards). Guests can still come here for health fasting and intermittent fasting, but the range of services in the hotel has been extended to include massage, yoga, Pilates, and guided walks, as well as medical treatments focusing on preventive and dietary medicine. A few details are still reminiscent of the once-strict rules of the sanatorium: in the restaurant there is no à-la-carte choice of dishes, and the rooms have no television sets. To make up for this, the daily slow-food menu served to all visitors is truly delicious – and the hot-water bottle that is a standard amenity in the rooms sometimes proves more effective than anything high-tech in the mountains. ◆ Book to pack: "The Swan King: Ludwig II of Bavaria" by Christopher McIntosh

DIRECTIONS *Above Bayrischzell, 5 minutes' drive from the local train station and almost 1.5 hours by car from the international airport in Munich* · **RATES** *€€€–€€€€, including breakfast, soup and salad for lunch, and a fixed daily menu in the evening* · **ROOMS** *59 rooms in cabins and the hotel (some with very small bathrooms)* · **FOOD** *Regional, seasonal, and organic. Hotel residents eat in the dining room, non-residents in the restaurant "Pool"* · **HISTORY** *In 1905 Christian von Mengershausen, a specialist for lung diseases, founded the medical spa (the cabins on the alpine meadows from this period are still standing), and his descendants established the hotel in 2007* · **X-FACTOR** *The Tannerhof has its own stage and gallery for concerts, readings and exhibitions*

GESUNDHEIT!

Mehr als ein Jahrhundert führte die Arztfamilie von Mengershausen in Bayrischzell ein Sanatorium: Dort kurten die Patienten auf Kneipp'sche Art, befolgten die Buchinger Fastenregeln oder brachten ihr Herz-Kreislauf-System in Schwung, je nachdem, welche Generation gerade am Zug war. Doch dann schwächelte der klassische Kurbetrieb, und die Besitzer verschrieben ihm Anfang des 21. Jahrhunderts eine ganzheitliche Verjüngungstherapie. Der Münchner Architekt Florian Nagler renovierte Haupt- und Nebengebäude des Tannerhofs, die wie ein Dorf in den Bergen liegen, und fügte den einsiedlerartigen „Lufthütten" aus den Anfangstagen moderne „Hüttentürme" hinzu. Deren Räume stapeln sich gleichsam übereinander, und die obere Etage ist über eine raffinierte Treppe erreichbar (die einzigartige alpine Architektur wurde schon mit mehreren Preisen ausgezeichnet). Heil- und intervallfasten können Gäste hier noch immer, doch die Servicepalette des Hotels wurde um Massagen, Yoga, Pilates und geführte Wanderungen sowie Arztbehandlungen mit Schwerpunkten auf Präventiv- und Ernährungsmedizin erweitert. Ein paar Details erinnern noch an die einstmals strenge Sanatoriumsordnung: So gibt es im Restaurant keine À-la-carte-Auswahl und in den Zimmern keine Fernseher. Doch dafür ist das tägliche Slow-Food-Menü für alle wirklich köstlich – und die Wärmflasche, die in den Zimmern zum Standard zählt, erweist sich in den Bergen bisweilen hilfreicher als Hightech.
◆ Buchtipp: „Das große Spiel" von Céline Minard

ANREISE *Oberhalb von Bayrischzell gelegen, 5 Fahrtminuten vom Bahnhof des Orts und knapp 1,5 Fahrtstunden vom internationalen Flughafen München entfernt* · **PREISE** *€€€–€€€€, mit Frühstück, Suppe und Salat mittags, festem Tagesmenü abends* · **ZIMMER** *59 Zimmer in Hütten und Hotel (einige mit sehr kleinen Bädern)* · **KÜCHE** *Regional, saisonal und biologisch. Hotelgäste essen im Speisesaal, für externe Gäste gibt es das Restaurant „Pool"* · **GESCHICHTE** *1905 gründete der Lungenfacharzt Christian von Mengershausen das Kurheim (die Almhütten aus dieser Zeit stehen noch immer), seine Nachfahren gestalteten ab 2007 das Hotel* · **X-FAKTOR** *Zum Tannerhof gehören eine eigene Bühne und Galerie für Konzerte, Lesungen und Ausstellungen*

À VOTRE SANTÉ !

Pendant plus d'un siècle, la famille de médecins Von Mengershausen a tenu un sanatorium à Bayrischzell. Au fil des générations, les patients y ont suivi les cures à la mode : le soin Kneipp, le jeûne thérapeutique de Buchinger, puis la stimulation cardio-vasculaire. Quand la vogue de la cure classique s'est essoufflée, au début du XXIe siècle, les propriétaires lui ont prescrit un programme de rajeunissement holistique. L'architecte munichois Florian Nagler a rénové le bâtiment principal et les annexes du Tannerhof, posés à flanc de montagne comme un petit hameau, auxquels il a ajouté des « cabanes aériennes » d'ermites ancestraux, qui s'empilent pour former des « tours » éminemment modernes. On accède à la pièce la plus haute par un escalier ouvragé magnifique – une architecture alpine unique récompensée de plusieurs prix. Les clients peuvent toujours y pratiquer le jeûne thérapeutique ou intermittent, mais la gamme de services proposés a été élargie aux massages, au yoga, au Pilates et aux randonnées guidées, ainsi qu'aux traitements médicaux axés sur la médecine préventive et la nutrition. Quelques détails rappellent l'ancien règlement strict du sanatorium : le restaurant affiche un menu unique et les chambres sont dépourvues de télévision. Pas de triste mine pour autant, car la slow-food servie chaque jour est délicieuse et plaît à tous. Quant à la bouillotte, équipement standard dans ces montagnes et présente dans chaque chambre, elle se révèle souvent plus utile que la haute technologie. ◆ À lire : « Le Grand Jeu » de Céline Minard

ACCÈS *Situé dans les hauteurs de Bayrischzell, à 5 min en voiture de la gare et 1,5 h de l'aéroport international de Munich* · **PRIX** *€€€–€€€€, avec petit-déjeuner, soupe et salade au déjeuner et menu unique le soir* · **CHAMBRES** *59 chambres dans les cabanes et l'hôtel (certaines avec une très petite salle de bains)* · **RESTAURATION** *Cuisine locale, bio et de saison. Les clients prennent leurs repas dans la salle à manger et les convives extérieurs peuvent manger au restaurant « Pool »* · **HISTOIRE** *Le sanatorium (dont les chalets d'alpage existent toujours) a été fondé en 1905 par le pneumologue Christian von Mengershausen ; ses descendants ont aménagé l'hôtel à partir de 2007* · **LES « PLUS »** *Le Tannerhof est doté d'une scène et d'une galerie où ont lieu des concerts, des lectures et des expositions*

GASTHOF ALPENROSE

SAMERBERG

Gasthof Alpenrose

GASTHOF ALPENROSE

Kirchplatz 2, 83122 Samerberg
Tel. +49 8032 8263 · info@alpenrose-samerberg.de
www.alpenrose-samerberg.de

AT THE HEART OF THE VILLAGE

The Alpenrose stands in exactly the right spot for a village inn: next to the church, which occupies a slightly higher site. With its skillfully painted façade, traditional interior, and beer garden beneath lime trees, it looks just as a Bavarian inn is supposed to look. It has been family-run since 1868: as a little boy, the present owner, Florian Lerche, watched his grandmother cook. At the age of 100 she still occasionally stood in the kitchen, stoked the wood-fired oven, and baked sweet yeast dumplings to die for. Later Florian served his apprenticeship in the Austrian province of Styria, and when he returned was equally famous for his appearance with a beard and baseball cap and for his meat roasts, and even became a TV chef with the Bavarian regional broadcaster. If you would like to eat your way right through the menu of his Bavarian and Styrian creations, including his crispy Sunday roast, the best course is to move in with him: in the main house and the so-called Bauernstadl there are simple but spotlessly clean rooms and a holiday apartment. Samerberg is a good place to visit, especially in summer: this idyllic alpine vale between the Inn Valley and the Chiemgau, through which farmers once transported wine, grain and salt, is a paradise for hiking and biking today. Vacationers here can take a leisurely tramp from one alpine meadow to the next, climb to the summit of the Hochries mountain, or take a long-distance path, the Salzalpensteig, and reach Austria on foot. ◆ Book to pack: "The Wall" by Marlen Haushofer

DIRECTIONS *Samerberg lies to the southwest of the Chiemsee lake. The inn is part of the village of Grainbach. From Munich airport the journey takes 1–1.5 hours by car, from Salzburg airport about 50 minutes* · **RATES** *€–€€* · **ROOMS** *6 rooms with shared showers and WCs in the main building, 2 rooms with bathroom, and 1 apartment with 2 rooms in the Bauernstadl* · **FOOD** *Traditional dishes with a twist and seasonal products from the region. The wine cellar is well stocked!* · **HISTORY** *The house was mentioned in 1565 as a tavern. Today Florian Lerche and his wife Christina are the fifth generation of the family to run it* · **X-FACTOR** *The roof terrace at sunset with a view of the neighboring village and the Wendelstein mountain*

MITTEN IM DORF

Die Alpenrose steht dort, wo eine Dorfwirtschaft stehen muss: neben der leicht erhöht liegenden Kirche. Und mit ihrer kunstvoll bemalten Fassade, den urigen Stuben und dem Biergarten unter Linden sieht sie so aus, wie ein bayerischer Gasthof aussehen muss. Seit 1868 ist sie in Familienbesitz: Schon als kleiner Junge schaute der heutige Inhaber Florian Lerche seiner Oma beim Kochen zu – sie stand noch mit 100 Jahren gelegentlich in der Küche, schürte den Holzofen an und buk Dampfnudeln zum Niederknien. Später verbrachte der Chef seine Lehrzeit in der Steiermark, und als er zurückkam, wurde er für sein Outfit mit Bart und Baseballkappe genauso berühmt wie für seine Bratenkrusten und avancierte sogar zum Fernsehkoch beim Bayerischen Rundfunk. Damit man die Speisekarte mit seinen bayerisch-steirischen Kreationen inklusive knusprigem Sonntagsbraten einmal rauf- und runteressen kann, zieht man am besten bei ihm ein – im Haupthaus und im Bauernstadl gibt es einfache, blitzsaubere Zimmer sowie eine Ferienwohnung. Samerberg ist vor allem im Sommer ein lohnendes Ziel: Das idyllische Alpenhochtal zwischen Inntal und Chiemgau, durch das früher Bauern Wein, Getreide und Salz transportierten (oder „säumten" – daher kommt der Name der Gegend), gilt heute als Wander- und Radlerparadies. Hier können Urlauber gemächlich von Alm zu Alm ziehen, den Gipfel der Hochries bezwingen oder auf dem Weitwanderweg Salzalpensteig zu Fuß bis nach Österreich gehen. ◆ Buchtipp: „Ein Haus für viele Sommer" von Axel Hacke

ANREISE *Samerberg liegt südwestlich des Chiemsees. Der Gasthof gehört zum Dorf Grainbach. Vom Flughafen München sind es 1–1,5 Fahrtstunden, vom Flughafen Salzburg rund 50 Fahrtminuten* · **PREISE** *€–€€* · **ZIMMER** *6 Zimmer mit Etagendusche und -WC im Haupthaus, 2 Zimmer mit Bad und 1 Ferienwohnung mit 2 Zimmern im Bauernstadl* · **KÜCHE** *Traditionell mit Twist und saisonalen Produkten der Region. Der Weinkeller ist gut sortiert!* · **GESCHICHTE** *Das Haus wurde schon 1565 als Tavernwirtschaft erwähnt. Heute führt es Florian Lerche mit seiner Frau Christina in fünfter Generation* · **X-FAKTOR** *Die Dachterrasse bei Sonnenuntergang mit Blick auf das Nachbardorf und den Wendelstein*

AU CŒUR DU VILLAGE

L'Alpenrose se tient à la place que doit occuper toute auberge de village : légèrement en contrebas de l'église. Avec sa façade délicatement peinte, ses salles rustiques et son Biergarten sous les tilleuls, elle a l'allure qu'on attend d'une auberge bavaroise. Elle appartient à la même famille depuis 1868 ; tout petit déjà, l'actuel propriétaire Florian Lerche y observait sa grand-mère en cuisine – à 100 ans, elle s'y installait encore de temps en temps, allumait le four à bois et faisait des « Dampfnüdle » à tomber. Le chef s'est ensuite formé en Styrie, et depuis son retour, il est devenu aussi célèbre pour sa barbe et sa casquette de base-ball que pour ses rôtis ; il a même joué le chef vedette pour la télévision bavaroise. Pour savourer ses créations bavaroises et styriennes, notamment le rôti croustillant du dimanche, le mieux est encore de séjourner chez lui ! La maison principale et le Bauernstadl proposent des chambres simples et bien entretenues ainsi qu'un appartement indépendant. Samerberg est une destination particulièrement agréable en été : cette haute vallée alpine idyllique qui s'étend entre la vallée de l'Inn et le Chiemgau, que les paysans empruntaient autrefois pour transporter vin, céréales et sel, est aujourd'hui un paradis pour les randonneurs et les cyclistes. Ici les vacanciers se déplacent sans hâte d'alpage en alpage, pour conquérir le sommet du Hochries ou gagner l'Autriche à pied, par le sentier du Salzalpensteig. ◆ À lire : « Le Mur invisible » de Marlen Haushofer

ACCÈS *Samerberg est situé au sud-ouest du Chiemsee. L'auberge fait partie du hameau de Grainbach. À 1–1,5 h de route de l'aéroport de Munich et environ 50 min de celui de Salzbourg* · **PRIX** *€–€€* · **CHAMBRES** *6 chambres avec salle d'eau et toilette sur le palier dans la maison principale, 2 chambres avec salle de bains privée et un appartement de vacances avec 2 chambres dans le Bauernstadl* · **RESTAURATION** *Traditionnel avec une touche d'audace, des produits locaux et de saison. La cave à vin est bien fournie !* · **HISTOIRE** *La maison est citée comme taverne depuis 1565. Elle est aujourd'hui dirigée par la cinquième génération de la même famille, représentée par Florian Lerche et son épouse Christina* · **LES « PLUS »** *La terrasse du toit au coucher du soleil, avec vue sur le village et le Wendelstein*

Jezt baut Man die Häuser wohl fest, darinen sein war doch nur fremde Gest
Jezt ist das Haus zwar mein aber wie lang nur kurze Zeit ist mein Leben aus Ich muß daraus

20 * C + M + B * 24

STUBN IN DER FRASDORFER HÜTTE

FRASDORF

STUBN IN DER FRASDORFER HÜTTE

Am Zellboden, 83112 Frasdorf
booking@stubn.co
www.stubn.co

A MOUNTAIN CABIN

Bavaria and Berlin are two different worlds that sometimes collide. But not in the case of this hotel: its owner comes from an old-established Bavarian family, and has two trendy restaurants in Berlin. When he reopened the Frasdorfer Hütte, he brought the first chef with him from the German capital, since when a young team that would be perfectly at home running a hip establishment has been serving modern alpine food in modern alpine surroundings. The "Frasi," as locals call this cabin, has a beautiful, lonely location on a plateau in the Chiemgau Alps at a height of 3,100 feet. Visitors can reach it only on foot, or if necessary with a shuttle, and once they have arrived, their mobile phones receive a signal only in one spot behind the building. To compensate, the natural surroundings are wonderful, and the interior design is contemporary: the Munich architect Philipp Moeller has freshened up its traditional cabin-style charm, combining old and new wood, adding touches of subdued olive green and terracotta red, revealing a view of the kitchen and giving it an open fire, and installing black industrial lamps in the guest rooms above rustic beds. After dinner, guests only have to climb the creaking wooden stairs, sink into the pillows, listen briefly to the quietness round about, and fall asleep contentedly.
◆ Film to watch: "Heart of Glass," directed by Werner Herzog, about a glass maker in a Bavarian village

DIRECTIONS *Frasdorf is located about 1 hour by car south of Munich airport. From the Lederstube car park, it is reached on foot via a forest track, taking around 50 minutes to walk to the cabin* · **RATES** *€–€€* · **ROOMS** *9 double rooms, 1 three-bed and 1 four-bed room. One room has a bathtub and washbasin, the others have individual showers and toilets in the corridor* · **FOOD** *Seasonal alpine dishes. The ingredients are supplied by farmers and businesses from the region that work sustainably* · **HISTORY** *The Frasdorfer Hütte has been family-owned for generations and was reopened in May 2022; it is part of a foundation* · **X-FACTOR** *If the snow is deep enough in winter, sledges are hired out for the return trip*

HÜTTENZAUBER

Mit Bayern und Berlin prallen in Deutschland ja manchmal Welten aufeinander. Nicht so im Fall dieses Hotels: Sein Besitzer stammt aus einer alteingesessenen bayerischen Familie und hat in Berlin zwei hippe Restaurants. Aus der Hauptstadt brachte er dann auch gleich den ersten Küchenchef mit, als er die Frasdorfer Hütte neu eröffnete. Seither serviert in der Stubn ein junges Team, das sich problemlos in jedem Szenelokal zurechtfinden würde, moderne Alpenküche in modernem Alpenambiente. Die „Frasi", wie die Einheimischen sie nennen, liegt wunderschön und einsam auf einem 950 Meter hohen Plateau in den Chiemgauer Alpen. Besucher erreichen sie nur zu Fuß oder bei Bedarf mit dem Shuttle, und oben angekommen, haben Handys nur an einer einzigen Stelle hinter dem Haus Empfang. Dafür gibt es draußen herrliche Natur und drinnen zeitgemäßes Design: Der Münchner Architekt Philipp Moeller hat den traditionellen Hüttencharme aufgefrischt, alte mit neuen Hölzern kombiniert, Akzente in gedämpftem Olivgrün und Terrakottarot gesetzt, die Küche einsehbar gemacht und mit einer offenen Feuerstelle versehen und in den Gästezimmern schwarze Industrieleuchten über Betten im Bauernstil montiert. Nach dem Abendessen muss man also nur die knarzende Holztreppe nach oben steigen, in die Kissen sinken, kurz der Ruhe ringsum lauschen und zufrieden einschlafen. ◆ Buchtipp: „Erfolg" von Lion Feuchtwanger

ANREISE *Frasdorf liegt rund 1 Fahrtstunde südlich des Münchner Flughafens. Ab dem Parkplatz Lederstube wandert man über den Forstweg in etwa 50 Minuten zur Hütte* · **PREISE** *€–€€* · **ZIMMER** *9 Doppelzimmer, 1 Dreibett- und 1 Vierbettzimmer. Ein Zimmer mit Badewanne und Waschbecken, ansonsten Einzelduschen und Toiletten auf dem Flur* · **KÜCHE** *Saisonale Alpenküche. Die Zutaten stammen von Landwirten und Betrieben der Region, die nachhaltig arbeiten* · **GESCHICHTE** *Die Frasdorfer Hütte ist seit Generationen in Familienbesitz und wurde im Mai 2022 neu eröffnet; der Betrieb ist Teil einer Stiftung* · **X-FAKTOR** *Liegt im Winter genug Schnee, werden für die Rückfahrt Schlitten verliehen*

MAGIE DE LA CABANE

En Allemagne, un monde semble souvent séparer la Bavière de Berlin. Cet hôtel les réunit pourtant : son propriétaire est issu d'une vieille famille bavaroise et possède deux restaurants branchés à Berlin. C'est aussi de la capitale qu'il a ramené son premier chef de cuisine lorsqu'il a rouvert la Frasdorfer Hütte. Depuis, le Stubn sert une cuisine alpine moderne dans une ambiance à l'avenant, grâce à une équipe qui serait à sa place dans n'importe quel établissement branché. La « Frasi », comme la surnomment les locaux, est magnifiquement située, isolée sur un plateau à 950 mètres d'altitude dans les Alpes du Chiemgau. On n'y accède qu'à pied ou, si nécessaire, en navette, et une fois en haut les téléphones portables ne captent plus qu'à un endroit, derrière la maison. Ces légers inconvénients sont amplement compensés par la magnificence de la nature alentour et la qualité de la décoration intérieure, résolument contemporaine : l'architecte munichois Philipp Moeller a rafraîchi le charme traditionnel du chalet en combinant bois anciens et neufs, avec des accents rouge brique et vert olive estompé ; il a ouvert la cuisine sur la salle, l'a dotée d'une cheminée, et dans les chambres, des lampes industrielles noires pendent au-dessus de lits rustiques. Après le dîner, il n'y a plus qu'à monter l'escalier dont le bois grince, s'enfoncer dans les oreillers, écouter brièvement le calme qui règne et s'endormir, satisfait. ◆ À lire : « Sur la route des Alpes bavaroises » de Minh-Triêt Pham

ACCÈS *Frasdorf se trouve à 1 h de route au sud de l'aéroport de Munich. Il faut environ 50 min pour atteindre la cabane par un chemin forestier depuis le parking Lederstube* · **PRIX** *€–€€* · **CHAMBRES** *9 chambres doubles, 1 triple et 1 chambre pour quatre. Une chambre avec baignoire et lavabo, les autres disposent de salles d'eau individuelles et de toilettes dans le couloir* · **RESTAURATION** *Cuisine alpine de saison. Les ingrédients sont fournis par des agriculteurs et des entrepreneurs de la région engagés dans une démarche durable* · **HISTOIRE** *Le refuge de Frasdorf est une propriété familiale depuis des générations et a rouvert ses portes en mai 2022 ; l'établissement fait partie d'une fondation* · **LES « PLUS »** *En hiver, s'il a suffisamment neigé, on peut louer des luges pour redescendre au parking*

GUT SONNENHAUSEN

GLONN

BAYERN

GUT SONNENHAUSEN

Sonnenhausen 2, 85625 Glonn
Tel. +49 8093 57770 · info@sonnenhausen.de
www.sonnenhausen.de

A HOLISTIC ESTATE

When a tobacco magnate commissioned Wilhelm Spannagel, a star architect of the day, to design this estate in 1900, he wanted to have a stud farm, and acquired 50 English thoroughbred horses for Munich society to gallop across the fields at weekends. 85 years later the German ecological pioneer Karl Ludwig Schweisfurth and his family discovered Gut Sonnenhausen, an enchanting estate near Glonn, and transformed it into a out-of-the-ordinary organic hotel with conference facilities. A slightly bohemian atmosphere still prevails in the rooms around the yellow-painted courtyard. They are individually fitted out with old and new furniture, as well as art, and the walls are painted in wonderful colors. The farmhouse in the clearing dates from 1800 and has been restored in country-house style with loam rendering, fir wood, old ceiling beams and original rustic cabinets. There is a long view from the windows, some of which extend to floor level, of the meadows and gardens where vegetables and herbs are cultivated for the in-house restaurant. The estate has a total area of 65 acres used for sustainable agriculture. In the "Farmer's Club," meat is roasted and barbecued skillfully over a fire: organically produced meat is important to the owners, who used to run a large butcher's business. Guests at Sonnenhausen can eat well and healthily, party until morning, stroll through the house and courtyard and look at paintings, sculptures, and installations as if in a private museum, and finally get round to reading a good book at last – or simply do nothing, which is sometimes what they need most. ◆ Book to pack: "Crome Yellow" by Aldous Huxley

DIRECTIONS *Glonn lies to the southeast of Munich, about 45 minutes' drive from the airport* · **RATES** *€€–€€€* · **ROOMS** *30 rooms in the manor house, 16 rooms in the farmhouse* · **FOOD** *The restaurant on the estate serves breakfast, lunch and dinner, with the option of dining on the terrace in summer. In addition to the "Farmer's Club" in the farmhouse, for larger groups there is the "Kochstall," where cookery courses are also organized* · **HISTORY** *The estate opened as a hotel in 1997, and the farmhouse was added in 2018* · **X-FACTOR** *From live music to yoga and herb-gathering walks, there are many extras on the program*

EIN GANZHEITLICHES GUT

Als ein Tabakbaron im Jahr 1900 dieses Gut beim damaligen Stararchitekten Wilhelm Spannagel in Auftrag gab, wünschte er sich ein Gestüt und stellte dort dann 50 englische Vollblüter ein, auf denen die Münchner Society an den Wochenenden über die Äcker preschte. 85 Jahre später entdeckten der deutsche Ökopionier Karl Ludwig Schweisfurth und seine Familie das verwunschene Gut Sonnenhausen, das bei Glonn liegt, und verwandelten es in ein ganz besonderes Bio- und Tagungshotel. In den Zimmern des gelb getünchten Gutshofs herrscht noch immer ein bisschen Boheme-Atmosphäre. Die Räume sind mit alten und neuen Möbeln, wunderbaren Wandfarben und Kunst individuell gestaltet. Das Bauernhaus auf der Lichtung nebenan stammt von 1800 und wurde mit Lehmputz, Fichtenholz, alten Deckenbalken sowie originalen Bauernschränken im Landhausstil renoviert – aus seinen zum Teil bodentiefen Fenstern kann der Blick weit über die Wiesen und Gärten schweifen. Dort wachsen Gemüse und Kräuter für die hofeigenen Restaurants; insgesamt gehören 25 Hektar zum Gelände, auf denen nachhaltig Landwirtschaft betrieben wird. Im „Farmer's Club" wird über dem Feuer zudem gekonnt gebraten und gegrillt: Biofleisch liegt den Besitzern besonders am Herzen, besaßen sie doch früher eine große Metzgerei. Man kann auf Sonnenhausen also gut und gesund essen und auch mal bis zum Morgen feiern, man kann durch Haus und Hof schlendern und die Bilder, Skulpturen und Installationen wie in einem privaten Museum betrachten, und man kann endlich mal wieder ein gutes Buch lesen – oder einfach nichts tun und durchatmen, das ist ja manchmal am nötigsten. ◆ Buchtipp: „Eine Gesellschaft auf dem Lande" von Aldous Huxley

ANREISE *Glonn liegt südöstlich von München, die Fahrt vom Flughafen dauert etwa 45 Minuten* · **PREISE** €€–€€€ · **ZIMMER** *30 Zimmer im Gutshaus, 16 Zimmer im Bauernhaus* · **KÜCHE** *Das Restaurant im Gutshof serviert Frühstück, Mittag- und Abendessen, im Sommer auch auf der Terrasse. Neben dem „Farmer's Club" im Bauernhaus gibt es den „Kochstall" für größere Gruppen; dort werden auch Kochkurse organisiert* · **GESCHICHTE** *Das Gut eröffnete 1997 als Hotel, das Bauernhaus kam 2018 hinzu* · **X-FAKTOR** *Von Livemusik über Yoga bis zu Kräuterwanderungen stehen zahlreiche Extras auf dem Programm*

UN HÔTEL HOLISTIQUE

C'est un baron du tabac qui commanda ce domaine au célèbre architecte Wilhelm Spannagel en 1900, pour y établir un haras. Il y installa bientôt 50 pur-sang anglais, que la bonne société munichoise prenait plaisir à chevaucher à travers champs le week-end. En 1985, le pionnier allemand de l'écologie Karl Ludwig Schweisfurth et sa famille découvrent le magnifique domaine de Sonnenhausen, près de Glonn, et décident de le transformer en un hôtel-restaurant bio exceptionnel, qui accueille aussi conférences et congrès. Dans la maison de maître peinte en jaune soleil, il règne toujours une atmosphère un peu bohème. La décoration diffère d'une pièce à l'autre mais compte toujours des meubles anciens et récents, des couleurs et des œuvres magnifiques aux murs. La ferme située dans la clairière voisine date de 1800 et a été rénovée dans un style campagnard avec enduit à l'argile, bois d'épicéa, poutres anciennes et armoires de ferme d'époque. Depuis ses fenêtres, dont certaines touchent le sol, la vue s'étend loin sur les prairies et les jardins. Le potager et le jardin d'herbes aromatiques fournissent les restaurants de l'établissement. Au total, le domaine s'étend sur 25 hectares, sur lesquels est pratiquée une agriculture durable. Au « Farmer's Club », la viande bio à laquelle les propriétaires, anciens bouchers, portent une attention particulière, est habilement rôtie ou grillée au feu de bois. À Sonnenhausen, on peut donc se régaler d'une cuisine saine et faire la fête jusqu'au matin, parcourir la maison et la cour, contempler les tableaux, les sculptures et les installations qui les parsèment, comme dans un musée privé, s'installer avec un bon livre – ou tout simplement ne rien faire et respirer, ce qui est souvent le plus indispensable. ◆ À lire : « Jaune de Crome » d'Aldous Huxley

ACCÈS *Glonn se trouve au sud-est de Munich, à environ 45 min en voiture de l'aéroport* · **PRIX** €€–€€€ · **CHAMBRES** *30 chambres dans le manoir, 16 chambres dans la ferme* · **RESTAURATION** *Le restaurant du manoir sert petit-déjeuner, déjeuner et dîner, sur la terrasse en été. La ferme abrite le « Farmer's Club » et le « Kochstall », dans les anciennes écuries, pour les grands groupes. Des cours de cuisine y sont aussi organisés* · **HISTOIRE** *L'établissement a rouvert comme hôtel en 1997; la ferme s'y est ajoutée en 2018* · **LES « PLUS »** *Beaucoup d'extras au programme, des concerts au yoga en passant par des randonnées de découverte de la flore*

BAYERN

GASTHOF ZANTL

BAD TÖLZ

GASTHOF ZANTL

Salzstraße 31, 83646 Bad Tölz
Tel. +49 8041 9794 · info@zantl-toelz.de
www.zantl-toelz.de

CHEERS!

Before it became a spa, Tölz was the Bavarian beer town for a long period: at its peak there were 22 breweries here. The brewers transported their beer by horse and cart or by raft on the River Isar to nearby towns and monasteries, and even as far as Munich – city-dwellers liked the country beer, which was kept cool in the tufa caves at Tölz and thus stayed fresh for longer. For lots of beer, the brewers needed lots of barrels, of course, so at the same time the trade of the barrel makers – coopers – flourished, and they still perform their old guild dance at traditional fairs. It was a cooper who bought this building in 1767. It has remained in family ownership ever since, and in 1828 became a tavern. For the most recent renovation, the present owner gave the building, a protected monument, an elegant pale grey façade and combined historic with modern features inside. The six new suites with pinewood boards, hand-made furniture, and painted rustic wardrobes bear the names of members of the family from six generations. In the ground-floor parlor she retained typical elements such as the "Herrgottswinkel" – "the Lord's Corner" with a wooden crucifix – and treats her guests to a hearty breakfast that includes Bavarian specialties such as white sausage, which is traditionally eaten in the province only in the morning up to noon. For those who still have an appetite later, there is excellent roast pork at midday, served out of respect for tradition with a sauce made from dark beer. The people of Tölz still produce beer, by the way: three breweries have survived in the town – better than none at all! ◆ Book to pack: "Royal Highness" by Thomas Mann, who owned a country house in Bad Tölz from 1909 to 1917

DIRECTIONS *Bad Tölz is situated to the south of Munich, about 1 hour by car from the airport* · **RATES** *€€* · **ROOMS** *6 suites* · **FOOD** *Typical Bavarian food. For private parties there is a historic room in Biedermeier style for up to 20 guests* · **HISTORY** *The house was built in 1692, and was reopened in 2023 after a three-year renovation* · **X-FACTOR** *In summer the inn has a beer garden and – exclusively for hotel guests – a rose garden with sunny areas*

ZUM WOHL!

Ehe es zum Kurort wurde, war Tölz lange Bayerns Bierort: Zu seinen besten Zeiten gab es hier 22 Brauereien, die ihr Bier per Pferdefuhrwerk oder auf Isar-Flößen in die nahen Orte und Klöster und sogar bis nach München transportierten – die Städter schätzten das Bier vom Land, das in den Tuffsteinhöhlen von Tölz kühl lagerte und damit lange frisch blieb. Für viel Bier benötigten die Braumeister natürlich viele Fässer, und so blühte parallel das Handwerk der Fassbauer, der Schäffler, die ihren alten Zunfttanz bis heute auf Volksfesten vorführen. Es war auch ein Schäffler, der 1767 dieses Gebäude erwarb; seither ist es im Familienbesitz, und seit 1828 dient es als Wirtshaus. Bei der jüngsten Renovierung ließ die jetzige Eigentümerin dem inzwischen denkmalgeschützten Bau eine elegante hellgraue Fassade verpassen und kombinierte im Inneren historische mit modernen Elementen. Die sechs neuen Suiten mit Tannenholzböden, handgefertigten Möbeln und bemalten Bauernschränken benannte sie nach Familienmitgliedern aus sechs Generationen. In der Stube im Erdgeschoss bewahrte sie Typisches wie den „Herrgottswinkel", eine Ecke mit Holzkreuz, und serviert ihren Gästen morgens ein reichhaltiges Frühstück inklusive bayerischer Spezialitäten wie Weißwurst, die man im Freistaat traditionell nur vor zwölf Uhr isst. Wer anschließend noch Platz im Magen hat, bekommt mittags einen vorzüglichen Schweinsbraten, der als Hommage an die Geschichte mit Dunkelbiersauce angerichtet wird. Bier stellen die Tölzer übrigens noch immer her: Drei Brauereien haben sich in der Stadt behauptet – immerhin! ◆ Buchtipp: „Königliche Hoheit" von Thomas Mann, der von 1909 bis 1917 in Bad Tölz ein Landhaus besaß

ANREISE *Bad Tölz liegt südlich von München, rund 1 Fahrtstunde vom Flughafen entfernt* · **PREISE** €€ · **ZIMMER** *6 Suiten* · **KÜCHE** *Typisch bayerisch. Für private Feiern gibt es ein historisches Biedermeierzimmer für bis zu 20 Gäste* · **GESCHICHTE** *Das Haus stammt aus dem Jahr 1692. Nach dreijähriger Sanierung wurde es 2023 neu eröffnet* · **X-FAKTOR** *Im Sommer gehört ein Biergarten zum Haus und – exklusiv für Hotelgäste – ein Rosengarten mit Sonnenplätzen*

À LA VÔTRE !

Avant de devenir une station thermale, Tölz a longtemps été la capitale de la bière bavaroise : à son apogée, elle comptait 22 brasseries qui transportaient leur bière par charrette ou par des radeaux posés sur l'Isar, tirés par des chevaux jusqu'aux villages et monastères voisins et même jusqu'à Munich. Car les citadins appréciaient beaucoup cette bière venue de la campagne, qui restait fraîche plus longtemps pour avoir été conservée dans les grottes de tuf de Tölz. Les maîtres brasseurs avaient bien sûr besoin de fûts pour toute cette bière, et c'est ainsi que l'artisanat des tonneliers y a prospéré. La danse traditionnelle de cette corporation est d'ailleurs toujours pratiquée lors des fêtes populaires. Ainsi, c'est un tonnelier qui s'est offert cette bâtisse en 1767 ; elle est restée dans la famille depuis et sert d'auberge depuis 1828. Lors de la dernière rénovation, l'actuel propriétaire a paré d'un élégant gris-clair la façade de cette maison désormais classée monument historique, et habilement associé des éléments anciens et modernes dans la décoration intérieure. Les six suites aux planchers de sapin, aux meubles faits à la main et aux armoires de ferme peintes portent le nom de membres de la famille sur six générations. Au rez-de-chaussée, le salon a conservé des éléments typiques, notamment le « Herrgottswinkel », « petit coin de Dieu le père » avec sa croix en bois ; il accueille les hôtes pour un copieux petit-déjeuner avec des spécialités bavaroises comme la saucisse blanche, qui ne se mange traditionnellement que le matin. Ceux qui ont encore un peu de place dégusteront au déjeuner un excellent rôti de porc servi avec une sauce à la bière brune, en hommage à l'histoire des lieux. Les habitants de Tölz produisent d'ailleurs toujours de la bière, puisque trois brasseries perdurent dans la ville ! ◆ À lire : « Altesse royale » de Thomas Mann, qui posséda une maison de campagne à Bad Tölz de 1909 à 1917

ACCÈS *Bad Tölz se trouve au sud de Munich, à environ 1 h de route de son aéroport* · **PRIX** €€ · **CHAMBRES** *6 suites* · **RESTAURATION** *Typiquement bavaroise. Une salle privée dans le plus pur style Biedermeier accueille jusqu'à 20 convives* · **HISTOIRE** *La maison date de 1692. Elle a rouvert ses portes en 2023 après trois ans de rénovation* · **LES « PLUS »** *En été, l'hôtel dispose d'un Biergarten et d'une roseraie ensoleillée, réservée à ses clients*

BAYERN 327

HOFGUT HAFNERLEITEN

BAD BIRNBACH

HOFGUT HAFNERLEITEN

Brunndobl 16, 84364 Bad Birnbach
Tel. +49 8563 91511 · post@hofgut.info
www.hofgut.info

A MEDITERRANEAN FEELING

The area around Bad Birnbach is sometimes called the "Bavarian Tuscany," as its pretty, hilly countryside with well-cultivated fields, winding roads, farmhouses and villages are reminiscent of that part of Italy. Only the Tuscan cypresses are left to the imagination, but even without these famous trees, this region is perfectly suited for the Mediterranean feeling that the owners of this estate would like to convey to their guests. Originally they only ran a cookery school here (the proprietor is a trained cook and master barista), but when more and more of his pupils wanted to stay for the night, over time they added cottages: first of all the Bootshaus was built, then the architects from Studio Lot designed six compact one-room buildings and placed them in the woods, by the water, or on a meadow, in accordance with the local custom of scattered settlements. The tree house with its own sauna seems to be suspended in the air. This was followed by the spa, which is divided between five cubes, and finally by three holiday cottages with high-class black façades of larch wood, conceived by the Format Elf practice. For its remarkably appealing architecture, which employs a lot of wood and glass, with clean lines and rooms that concentrate on essentials, Hafnerleiten has won a number of awards. Television and radio are not part of the plan, and there is an Internet connection only in the main house – looking out into the natural surroundings or up to the stars is much nicer than staring at a screen, and it is more enjoyable to swim in the pond than to scroll through Instagram. Every morning a breakfast basket is delivered to the door, and if requested every evening the main course of dinner. Guest collect the starters and desserts from the kitchen themselves, and chat with the hosts and other guests over an aperitif. ◆ Book to pack: "We Are Prisoners" by Oskar Maria Graf

DIRECTIONS *Bad Birnbach is in the Rott Valley, southwest of Passau. The airports in Munich and Salzburg are each about 1.5 hours' drive away* · **RATES** *€€€–€€€€* · **ROOMS** *10 houses, 2 suites and 5 single rooms* · **FOOD** *The "Genusshof" serves coffee and cake. Communal spaghetti evenings and beer tastings, as well as cookery and barista courses, are held there. The larger holiday cottages have kitchens; recipes and ingredients are supplied if desired* · **HISTORY** *The cookery school started up in 1999, the cottages and the spa followed in 2001* · **X-FACTOR** *The shop sells souvenirs such as wine, olive oil and soap*

MEDITERRANES FLAIR

„Bayerische Toskana" wird die Gegend um Bad Birnbach manchmal auch genannt – so sehr erinnert ihre liebliche Hügellandschaft mit gepflegten Feldern, gewundenen Straßen, Höfen und Dörfern an den Süden. Lediglich die Zypressen muss man sich dazudenken, doch auch ohne die berühmten Bäume ist die Umgebung wie geschaffen für das mediterrane Lebensgefühl, das die Besitzer dieses Hofguts ihren Gästen vermitteln wollen. Ursprünglich betreiben sie hier nur eine Kochschule (der Hausherr ist gelernter Koch und Baristameister), doch als mehr und mehr Schüler auch übernachten wollten, kamen im Lauf der Zeit noch Häuschen hinzu: Zunächst entstand das Bootshaus, dann entwarfen die Architekten von Studio Lot sechs kompakte Einraumhäuschen und setzten sie nach dem Vorbild der hiesigen Streusiedlungen in den Wald, ans Wasser oder auf die Wiese – das Baumhaus mit eigener Sauna scheint sogar in luftiger Höhe zu schweben. Danach folgten der Wellnessbereich, der auf fünf Kuben verteilt ist, und schließlich drei Ferienhäuser mit edler schwarzer Lärchenfassade, erdacht vom Büro Format Elf. Für seine außergewöhnlich ansprechende Architektur, die mit viel Holz und Glas, klaren Linien und aufs Wesentliche konzentrierten Räumen arbeitet, wurde Hafnerleiten schon mehrfach prämiert. Fernseher und Radio gehören nicht zum Konzept, und Internet gibt es nur im Haupthaus – ist es doch so viel schöner, in die Natur oder in die Sterne statt auf den Bildschirm zu schauen und durch den Teich zu schwimmen statt durch Instragram zu scrollen. Jeden Morgen wird der Korb fürs Frühstück an die Tür geliefert und auf Wunsch jeden Abend der Hauptgang des Dinners. Vor- und Nachspeise holt man sich persönlich an der Küche ab und plaudert beim Aperitif mit den Gastgebern und anderen Gästen. ◆ Buchtipp: „Das bayrische Dekameron" von Oskar Maria Graf

ANREISE *Bad Birnbach liegt im Rottal südwestlich von Passau. Die Flughäfen München und Salzburg sind etwa 1,5 Fahrtstunden entfernt* · **PREISE** *€€€–€€€€* · **ZIMMER** *10 Häuser sowie 2 Suiten und 5 Einzelzimmer* · **KÜCHE** *Im „Genusshof" gibt es Kaffee und Kuchen, gemeinsame Spaghetti-Abende und Bierverkostungen sowie Koch- und Baristakurse. Die größeren Ferienhäuser haben Küchen; auf Wunsch gibt es auch Rezepte und Zutaten* · **GESCHICHTE** *1999 eröffnete die Kochschule, ab 2001 folgten die Häuser und das Spa* · **X-FAKTOR** *Der Hofladen verkauft Souvenirs wie Wein, Olivenöl oder Seife*

UN AIR DE MÉDITERRANÉE

La région de Bad Birnbach est parfois surnommée la « Toscane bavaroise », tant ses paysages vallonnés, ses routes qui sinuent entre les champs bien soignés, ses fermes et ses villages évoquent le Sud. Il manque bien quelques cyprès, mais les propriétaires de ce lieu ont su s'en passer et l'imprégner d'une joie de vive méditerranéenne qu'ils ont plaisir à partager avec leurs hôtes. À l'origine, ils n'exploitaient ici qu'une école de cuisine (le maître de maison est cuisinier de formation et maître barista), mais comme de plus en plus d'élèves souhaitaient également y passer la nuit, d'autres maisonnettes ont été aménagées au fil du temps, à commencer par le Bootshaus. Les architectes du Studio Lot ont ensuite conçu six maisonnettes compactes d'une pièce qu'ils ont posées dans la forêt, au bord de l'eau ou dans la prairie, sur le modèle des habitats dispersés de la région – la cabane dans les arbres avec son propre sauna semble même en lévitation. Un espace bien-être a ensuite été ajouté, réparti dans cinq cubes, puis le cabinet Format Elf a imaginé trois maisons de vacances bardées de majestueux mélèze noir. Hafnerleiten a remporté plusieurs prix pour son architecture exceptionnelle, qui combine bois et verre, des lignes claires et des espaces concentrés sur l'essentiel. La télévision et la radio ne font pas partie du concept et Internet n'est accessible que dans la maison principale, mais il est tellement plus agréable de regarder la nature et les étoiles qu'un écran, de nager dans l'étang que de surfer sur Instagram. Des paniers repas sont déposés devant la porte chaque matin et, sur demande, le soir. Les hôtes vont chercher entrée et dessert à la cuisine et discutent avec les autres convives à l'heure de l'apéritif. ◆ À lire : « Choucroute maudite » de Rita Falk

ACCÈS *Bad Birnbach se trouve dans la vallée de la Rott, au sud-ouest de Passau. Les aéroports de Munich et Salzbourg sont à environ 1,5 h de route* · **PRIX** *€€€–€€€€* · **CHAMBRES** *10 maisons ainsi que 2 suites et 5 chambres individuelles* · **RESTAURATION** *Le « Genusshof » (cour des délices) propose du café et des gâteaux, des soirées spaghettis, des dégustations de bière, des cours de cuisine et de barista. Les grandes maisons de vacances sont équipées de cuisines ; sur demande, le personnel fournit recettes et ingrédients* · **HISTOIRE** *L'école de cuisine a ouvert en 1999, la maison et le spa ont suivi en 2001* · **LES « PLUS »** *La boutique vend des souvenirs comme du vin, de l'huile d'olive ou des savons*

BAYERN 333

Joseph Ottenkoster
Der Eltere Weinhändler
1734.

ENGELWIRT APARTMENTS

BERCHING

338 BAYERN

ENGELWIRT APARTMENTS

Reichenauplatz 16, 92334 Berching
Tel. +49 8462 200 3387 · mail@engelwirt.com
www.engelwirt.com

HISTORY AND ART

The wall surrounding the historic center of Berching is more than 500 years old and still completely intact. Its towers tell the history of the town: there is the Biersiederturm where the master brewers once lived, the Pulverturm (Powder Tower), where arms and ammunition were stored, and the Bettelvogtturm, where the official responsible for beggars collected alms for the poor. The Badturm (Bath Tower) stood next to a bathhouse where by order of the magistracy a bride and groom had to wash before they got married, and in the case of the Frauenturm (Women's Tower), historians are unsure whether it was used as a prison or a refuge for women. Guests at this new hotel, too, can rack their brains about this – as the Engelwirt is right next door. Its buildings were once the seat of the bailiff and a servants' house dating from 1686, with two modern additions. They house wonderful apartments beneath plaster ceilings or wooden beams with inlaid floors, and combine antiques with classic designer items. The individually furnished apartments share a color scheme of bold reds, oranges and blues, and the fine selection of art on the walls reveals that the owner runs a gallery.

Each room has a small library, and those who need more holiday reading will find poetry, novels and even children's books in the in-house shop. Travel guidebooks are also on sale, so that guests can spend full days in and around Berching. Among the worthwhile destinations for an excursion are Neumarkt in the Oberpfalz region, formerly seat of the counts palatine, and Eichstätt, a university city with a cathedral. ◆ Book to pack: "The Art of Rivalry" by Sebastian Smee

DIRECTIONS *Berching is north of Ingolstadt, right on the Main-Danube Canal. The airports at Nuremberg and Munich are each about 1 hour's drive away* · **RATES** *€€–€€€* · **ROOMS** *15 apartments* · **FOOD** *12 apartments have a kitchen; breakfast packages are supplied if desired, but guests can also breakfast in the salon and courtyard. The Engelwirt also has a café* · **HISTORY** *Opened in spring 2024* · **X-FACTOR** *Discussions and concerts are sometimes held in the courtyard; this includes performances of works by the composer Christoph Willibald Gluck, who was born in Berching*

GESCHICHTE UND KUNST

Mehr als 500 Jahre alt und noch vollständig erhalten ist die Wehrmauer, die sich rund um Berchings historisches Zentrum zieht. Ihre Türme erzählen von der Geschichte der Stadt: Da gibt es den Biersiederturm, in dem früher der Braumeister wohnte, den Pulverturm, der als Munitionslager diente, und den Bettelvogtturm, in dem der Bettelrichter Almosen für Bedürftige sammelte. Der Badturm stand neben einer Badestube, in der sich auf Anweisung des Magistrats Brautpaare vor ihrer Hochzeit waschen mussten, und beim Frauenturm sind sich die Historiker nicht ganz sicher, ob er einst als Frauengefängnis oder Frauenhaus genutzt wurde. Gäste dieses neuen Hotels können miträtseln – steht der Engelwirt doch gleich daneben. Er umfasst einen ehemaligen Vogtsitz und ein Gesindehaus von 1686 sowie zwei moderne Gebäude und kombiniert in traumhaften Apartments unter Stuckdecken oder Holzbalken und auf Intarsienböden Antiquitäten und Designklassiker. Ein Farbschema mit kräftigen Rot-, Orange- und Blautönen verbindet die individuell eingerichteten Wohnungen, und dass der Besitzer Galerist ist, erkennt man an der ausgesuchten Kunst an den Wänden. Eine kleine Bibliothek gehört in jedem Zimmer mit dazu; wer noch mehr Ferienlektüre braucht, findet im hauseigenen Laden Gedichte, Romane und sogar Kinderbücher. Reiseführer gibt es auch, sodass die Tage in und um Berching gut gefüllt werden können. Ausflüge lohnen sich zum Beispiel in die ehemalige Pfalzgrafenstadt Neumarkt in der Oberpfalz oder in die Dom- und Universitätsstadt Eichstätt.
◆ Buchtipp: „Kunst und Rivalität" von Sebastian Smee

ANREISE *Berching liegt nördlich von Ingolstadt direkt am Main-Donau-Kanal. Die Flughäfen Nürnberg und München sind jeweils rund 1 Fahrtstunde entfernt ·* **PREISE** *€€–€€€ ·* **ZIMMER** *15 Apartments ·* **KÜCHE** *12 Wohnungen haben Küchen; Frühstückspakete werden auf Anfrage geliefert, man kann aber auch im Salon und Innenhof frühstücken. Zum Haus gehört zudem ein Café ·* **GESCHICHTE** *Im Frühjahr 2024 eröffnet ·* **X-FAKTOR** *Im Hof finden gelegentlich Gesprächsrunden und Konzerte statt; auch mit Werken von Christoph Willibald Gluck, der in Berching geboren wurde*

HISTOIRE ET ART

Le mur défensif qui entoure encore le centre historique de Berching a plus de 500 ans et ses tours racontent l'histoire de la ville : la tour Biersieder accueillait autrefois le maître brasseur, la tour Pulver servait de dépôt de munitions, et dans la tour Bettelvogt, le prévôt chargé de la mendicité recueillait les aumônes pour les nécessiteux. La Badturm (tour du Bain) jouxtait des bains où, sur ordre du magistrat local, les jeunes fiancés allaient se laver avant de se marier. Quant à la Frauenturm (tour des Femmes), les historiens n'ont pas pu déterminer s'il s'agissait d'une prison ou d'un refuge pour femmes. Les clients de ce tout nouvel hôtel peuvent réfléchir à cette énigme car l'Engelwirt se trouve juste à côté. Il comprend un ancien siège de bailli et une maison de domestiques datant de 1686, mais aussi deux bâtiments modernes ; il combine antiquités et classiques du design dans des appartements de rêve, avec plafonds en stuc ou poutres apparentes et sols en marqueterie. Les différents logements, aménagés individuellement, sont liés par une palette de rouges, d'oranges et de bleus vifs, et les œuvres d'art exposées aux murs révèlent le talent du propriétaire, galeriste. Chaque chambre dispose d'une petite bibliothèque, et si vous êtes encore en manque de lecture, vous trouverez à la boutique de l'hôtel des poèmes, des romans et des livres pour enfants. Des guides de voyage sont également disponibles, ce qui permet de bien remplir les journées à Berching et dans ses environs. Certaines excursions valent vraiment le détour, comme l'ancienne ville des comtes palatins de Neumarkt dans le Haut-Palatinat, ou la ville universitaire d'Eichstätt et sa cathédrale. ◆ À lire : « Les Grands Rivaux dans l'art » de Sebastian Smee

ACCÈS *Situé au nord d'Ingolstadt, au bord du canal Main-Danube. Les aéroports de Nuremberg et de Munich sont à environ 1 h de route ·* **PRIX** *€€–€€€ ·* **CHAMBRES** *15 appartements ·* **RESTAURATION** *12 appartements ont une cuisine; des paniers de petit-déjeuner sont livrés sur demande mais on peut aussi petit-déjeuner au salon ou dans le patio. L'établissement compte aussi un café ·* **HISTOIRE** *Ouvert au printemps 2024 ·* **LES « PLUS »** *Des concerts et des tables rondes ont parfois lieu dans la cour, notamment autour des œuvres de Christoph Willibald Gluck, né à Berching*

ENGELWIRT HOTEL & LADEN

GASTHOF GENTNER

GNOTZHEIM, FRANKEN

346 BAYERN

GASTHOF GENTNER

Spielberg 1, 91728 Gnotzheim
Tel. +49 9833 988 930 · info@gasthof-gentner.de
www.gasthof-gentner.de

A TRIP BACK IN TIME

With perimeter walls 16 feet high, it stands majestically on a hill, proudly looking down on Gnotzheim and the south of Franconia: Schloss Spielberg is a castle straight from a story book. Since the 14th century it has belonged to the counts and princes of Oettingen, one of the oldest noble dynasties in Bavaria. In the 1980s they commissioned the painter and sculptor Ernst Steinacker to renovate it and to design a kind of all-round work of art – and since then, Steinacker's modern paintings and sculptures have been on display in the rooms and gardens. Gasthof Gentner is closely connected to the history of the castle, as it was constructed as the builders' yard and brewery of Spielberg, catering for the owners of the castle and visitors. Although beer is no longer brewed here, guests are still welcome: two sisters have restored the ensemble, which has belonged to their family for generations, so well that they have received conservation awards for the work. In the spaces that were once the owners' parlor, the brewer's room, or the flour store, seven guest rooms furnished with Franconian antiques have been created.

Beneath old beams and with a view of painted chests and ornate rustic beds, guests take a trip back into the past. A hearty country breakfast in the historic wood-paneled tavern room sets guests up for the day: not only art lovers, but also hikers come to this area, where several long-distance trails meet, including the Franconian Way and the Way of St James. ◆ Book to pack: "The Puppeteers" by Tanja Kinkel

DIRECTIONS *Gnotzheim is about 1 hour by car southwest of Nuremberg. From Nuremberg airport the journey takes about 1 hour by car, from Munich airport about 2 hours* · **RATES** *€€* · **ROOMS** *7 rooms* · **FOOD** *The inn is a hotel garni, i.e. without a restaurant. For celebrations three rooms and the former brewery can be hired, and hearty Franconian dishes are then served* · **HISTORY** *The building, dating from 1672, was restored in 2004* · **X-FACTOR** *The region is part of the Altmühltal nature park, where spectacular fossils of a prehistoric bird, the archaeopteryx, have been found*

EINE ZEITREISE

Mit fünf Meter hohen Ringmauern thront es auf einem Hügel und blickt stolz über Gnotzheim und den Süden von Franken: Schloss Spielberg ist eine Burganlage wie gemalt. Seit dem 14. Jahrhundert gehört es den Grafen und Fürsten von Oettingen, einem der ältesten Adelsgeschlechter Bayerns. Sie ließen es in den 1980ern vom Maler und Bildhauer Ernst Steinacker renovieren und zu einer Art Gesamtkunstwerk gestalten – seither sind in den Gärten und Räumen Steinackers zeitgenössische Bilder und Skulpturen ausgestellt. Mit der Geschichte des Schlosses ist auch der Gasthof Gentner eng verbunden, wurde er einst doch als Bauhof und Brauhaus von Spielberg errichtet und versorgte Besitzer sowie Besucher der Burg. Bier wird hier heute zwar nicht mehr gebraut, doch Gäste sind noch immer willkommen: Zwei Schwestern haben das Anwesen, das ihrer Familie seit Generationen gehört, so gelungen saniert, dass sie dafür Denkmalpreise erhielten. Wo früher die gute Stube der Gutsleute war, das Zimmer des Brauers oder das Mehllager, sind sieben mit fränkischen Antiquitäten eingerichtete Zimmer entstanden – unter alten Balken und mit Blick auf bemalte Truhen und verzierte Bauernbetten reist man ein Stück in die Vergangenheit. Ein herzhaftes Landfrühstück in der historischen holzvertäfelten Gaststube stärkt für den Tag: Neben Kunstliebhabern steuern auch Wanderer gerne die Gegend an, in der sich mehrere Fernwanderrouten kreuzen, darunter der Frankenweg und der Jakobsweg. ◆ Buchtipp: „Die Puppenspieler" von Tanja Kinkel

ANREISE *Gnotzheim liegt etwa 1 Fahrtstunde südwestlich von Nürnberg. Der Flughafen Nürnberg ist rund 1 Fahrtstunde und der Flughafen München rund 2 Fahrtstunden entfernt* · **PREISE** *€€* · **ZIMMER** *7 Zimmer* · **KÜCHE** *Der Gasthof ist ein Hotel garni. Für Feste können drei Stuben sowie das ehemalige Sudhaus gemietet werden; dann werden bodenständige fränkische Speisen serviert* · **GESCHICHTE** *Das Gebäude stammt aus dem Jahr 1672 und wurde 2004 saniert* · **X-FAKTOR** *Die Region gehört zum Naturpark Altmühltal, wo spektakuläre Fossilien des Urvogels Archaeopteryx entdeckt wurden*

UN VOYAGE DANS LE TEMPS

Avec ses murs d'enceinte de cinq mètres de haut, il trône sur une colline et domine fièrement Gnotzheim et le Sud de la Franconie : le château de Spielberg évoque les gravures médiévales. Depuis le XIVe siècle, il appartient aux comtes et princes d'Oettingen, une des plus anciennes familles nobles de Bavière. Dans les années 1980, ils l'ont fait rénover par le peintre et sculpteur Ernst Steinacker, qui l'a transformé en une sorte d'œuvre d'art totale. Des peintures et des sculptures contemporaines sont exposées dans les jardins et les pièces du château. L'auberge Gentner est étroitement liée à l'histoire du lieu puisqu'elle abritait à l'origine l'atelier de construction et la brasserie de Spielberg, et nourrissait les propriétaires et leurs invités. On n'y brasse plus de bière aujourd'hui, mais les hôtes y sont toujours les bienvenus : deux sœurs ont rénové l'établissement, également dans leur famille depuis des générations, avec tant de talent qu'elles ont reçu plusieurs prix décernés aux trésors patrimoniaux allemands. Là où se trouvaient autrefois la salle commune des fermiers, la chambre du brasseur et l'entrepôt de farine, elles ont créé sept chambres meublées d'antiquités franconiennes : sous les poutres anciennes, parmi les coffres peints et les lits de ferme sculptés, on fait un bond dans le passé. Un copieux petit-déjeuner campagnard est servi dans la salle aux boiseries d'origine, histoire de prendre des forces pour la journée. Car si l'endroit est apprécié des amateurs d'art, les marcheurs aussi y trouvent leur bonheur puisque plusieurs sentiers de grande randonnée y convergent, dont le Frankenweg et la route de Saint-Jacques de Compostelle. ◆ À lire : « Le Montreur de marionnettes » de Tanja Kinkel

ACCÈS *Gnotzheim se trouve à environ 1 h de route au sud-ouest de Nuremberg. L'aéroport de Nuremberg est à 1 h de route et celui de Munich est à 2 h* · **PRIX** *€€* · **CHAMBRES** *7 chambres* · **RESTAURATION** *L'auberge est un meublé. Trois salles se louent pour des fêtes ainsi que l'ancienne salle de brassage, où sont servis des plats franconiens traditionnels* · **HISTOIRE** *La bâtisse date de 1672 et a été rénovée en 2004* · **LES « PLUS »** *La région fait partie du parc naturel de l'Altmühltal, où ont été découverts des fossiles spectaculaires d'un oiseau préhistorique, l'archéoptéryx*

ROMANTIK HOTEL MARKUSTURM

ROTHENBURG OB DER TAUBER, FRANKEN

ROMANTIK HOTEL MARKUSTURM

Rödergasse 1, 91541 Rothenburg ob der Tauber
Tel. +49 9861 94280 · info@markusturm.de
www.markusturm.de

VIEWS OF THE TOWN

The silhouette of Rothenburg is marked by so many towers that back in the 16th century, it already had the nickname "Franconian Jerusalem." 46 historic towers can still be counted in the Old Town, which is completely enclosed by a wall. One of the most famous towers is the Markusturm on the east side, which was built around 1200 – shortly after Konrad III, the first king of the Staufer dynasty, built the Rote Burg (the eponymous Red Castle) on a rocky outcrop above the River Tauber and the first ring of fortifications was erected around the settlement there. With its conspicuous roof, often a home for nesting storks, the tower is said to have inspired architects as far away as London, and along with the picturesque Röderbogen, the arch with its slender clock tower, is one of the most popular motifs for tourists' photos. Anyone who takes out a camera here will probably also have the half-timbered house right next to the arch in the picture. It used to be a toll house and is now a pretty hotel that has accommodated travelers for some 500 years. Here the owners, a family who have run the hotel for four generations, tell their guests about the eventful history of Rothenburg. There are rooms in the Empire and the Biedermeier style, and also in Fifties or Sixties design – but the nicest are the rooms where the timbers and historic stone walls have been uncovered. For sightseeing tours, this hotel is an ideal starting point: in the quest to identify all of the 46 towers, it is best to follow the Rothenburger Turmweg, a walk of 2.5 miles on and along the nearby town wall. ◆ Book to pack: "A Time of Gifts" by Patrick Leigh-Fermor

DIRECTIONS *Rothenburg is in Franconia, to the west of Nuremberg and its airport (about 1.5 hours by car)* · **RATES** *€€–€€€* · **ROOMS** *20 rooms in the main building and 2 apartments at a distance of 150 m/500 ft* · **FOOD** *The pleasant restaurant serves excellent, hearty regional dishes* · **HISTORY** *The building dates back to 1264* · **X-FACTOR** *The hotel is only a five-minute walk from the Church of St Jakob with its world-famous altar by Tilman Riemenschneider*

STADTANSICHTEN

Seine Silhouette prägen so viele Türme, dass Rothenburg schon im 16. Jahrhundert den Spitznamen „fränkisches Jerusalem" bekam. 46 historische Türme kann man in seiner rundum von einer Mauer eingeschlossenen Altstadt noch heute zählen. Einer der berühmtesten ist der Markusturm im Osten, der bereits um 1200 entstand – kurz nachdem der erste Stauferkönig, Konrad III., auf einem Felssporn über der Tauber die „Rote Burg" errichten ließ und ein erster Befestigungsring um die Burgsiedlung gezogen wurde. Mit seinem markanten Dach, auf dem oft Störche nisten, inspirierte der Turm einst sogar Architekten im fernen London und gehört im Duo mit dem malerischen Röderbogen samt seinem schlanken Uhrtürmchen zu den gefragtesten Fotomotiven der Touristen. Wer hier auf den Auslöser drückt, hat wahrscheinlich auch das Fachwerkhaus direkt neben dem Bogen im Bild: Das ehemalige Zollhaus, inzwischen ein pittoreskes Hotel, beherbergt seit rund 500 Jahren Reisende. Hier erzählt die Inhaberfamilie, die das Haus seit vier Generationen führt, ihren Gästen von Rothenburgs abwechslungsreicher Geschichte.

Es gibt Zimmer im Empire- und Biedermeierstil, im Design der Fifties und Sixties – am schönsten aber sind die Räume, in denen das Fachwerk und historische Mauerwerk freigelegt wurden. Für Sightseeingtouren ist das Hotel ein idealer Ausgangspunkt: Wer versuchen möchte, alle 46 Türme ausfindig zu machen, geht am besten den Rothenburger Turmweg entlang, ein vier Kilometer langer Spaziergang auf und entlang der nahen Stadtmauer. ◆ Buchtipp: „Die Räuberbande" von Leonhard Frank

ANREISE *Rothenburg liegt in Franken, westlich von Nürnberg und seinem Flughafen (etwa 1,5 Fahrtstunden)* · **PREISE** *€€–€€€* · **ZIMMER** *20 Zimmer im Haupthaus und 2 Apartments in einem 150 m entfernten Gebäude* · **KÜCHE** *Im gepflegten Restaurant steht sehr gute regionale Hausmannskost auf der Karte* · **GESCHICHTE** *Das Haus stammt aus dem Jahr 1264* · **X-FAKTOR** *Vom Hotel aus sind es nur 5 Gehminuten bis zur St.-Jakobs-Kirche mit ihrem weltberühmten Altar von Tilman Riemenschneider*

VISIONS DE LA VILLE

La silhouette de Rothenburg est hérissée de tant de tours que la ville était déjà surnommée au XVIe siècle « la Jérusalem franconienne ». Pas moins de 46 tours se dressent encore dans la vieille ville historique cernée de murs. Une des plus célèbres est la tour Markus, érigée vers 1200, peu après que le premier roi des Staufer, Conrad III, eut fait bâtir le « château rouge » sur un éperon rocheux surplombant la Tauber et qu'un premier cercle de fortifications eut été tracé autour de la cité fortifiée. Avec son toit caractéristique, sur lequel nichent souvent des cigognes, la tour a même inspiré autrefois des architectes de la lointaine Londres et, associée au pittoresque Röderbogen avec son petit clocher élancé, elle fait partie des sites les plus photographiés par les touristes. Ce faisant, ils immortalisent souvent aussi la maison à colombages qui jouxte l'arche : l'ancienne douane. Devenue un charmant hôtel, elle accueille des voyageurs depuis près de 500 ans. La famille qui possède et dirige l'établissement depuis quatre générations raconte avec plaisir la riche histoire de Rothenburg. Les chambres sont de style Empire, Biedermeier, années 1950 ou 1960, mais les plus belles sont celles où le colombage et la maçonnerie ancienne ont été mis au jour. L'hôtel est un point de départ idéal pour les visites touristiques : si vous voulez essayer de trouver toutes les 46 tours, le mieux est de suivre le Rothenburger Turmweg, une promenade de quatre kilomètres sur et le long des remparts de la ville. ◆ À lire : « La Ferme du crime » d'Andrea Maria Schenkel

ACCÈS *Situé en Franconie, à l'ouest de Nuremberg et de son aéroport (à environ 1,5 h de route)* · **PRIX** *€€–€€€* · **CHAMBRES** *20 chambres dans la maison principale, 2 appartements dans un autre bâtiment à 150 m* · **RESTAURATION** *Le restaurant sert une très bonne cuisine régionale* · **HISTOIRE** *La maison date de 1264* · **LES « PLUS »** *L'église Saint-Jakob, célèbre pour son autel créé par Tilman Riemenschneider, se trouve à 5 min à pied de l'hôtel*

356 BAYERN

PHOTO CREDITS

6 **Seesteg Norderney**
Photos supplied by the hotel
(pp. 6-7: Markus Kebschull;
p. 11 above: Nils Hasenau)

12 **Severin's Resort & Spa**
Photos supplied by the hotel (pp. 12-13, 18 below: Axel Steinbach; pp. 17, 18 above, 19 below: Tom Kohler)

20 **Aarskogs Boutique Hotel**
Photos supplied by the hotel (Anika Magnussen and Carola Schmeling)

30 **Weissenhaus Private Nature Luxury Resort**
Photos supplied by the hotel
(pp. 30-31, 32, 37 above: Sarah Russ; p. 35 above: Michael Poliza; p. 35 below: Oliver Lassen; p. 36 above: Joee Wong; pp. 36 below, 37 below: Kolja Erdmann)

38 **Die Reederin**
Photos supplied by the hotel (pp. 40, 43 above, 44, 45 above, 45 below left: Anne Krämer; p. 43 below: Daniel Bunu)

46 **Seehotel am Neuklostersee**
Photos supplied by the hotel (pp. 46-47: Hauke Dressler; pp. 51 above, 52 above left: Ben Donath; pp. 51 below, 52 below left: Ken Schluchtman; p. 52 above right: Markus Tollkopf; p. 53: Gernot Nalbach)

54 **Grand Hotel Heiligendamm**
Photos supplied by the hotel

64 **Hotel Neptun**
Photos supplied by the hotel

70 **Kranich Museum & Hotel**
Photos supplied by the hotel (pp. 70-71, 72, 75 below, 76-79: Philipp Obkircher; p. 75 above: Clemens Klein)

80 **Gut Üselitz**
Photos supplied by the hotel (Robert Rieger and Ulrike Meutzner)

90 **Gutshaus Rensow**
Photos supplied by the hotel
(Yannic Schon and Susann Probst/KRAUTKOPF)

98 **Glamping im Gutspark**
Photos supplied by the hotel

108 **St. Oberholz Retreat**
Photos supplied by the hotel (pp. 108-109, 115 above right, 116 above, 117 below: Pavel Becker; pp. 110, 113, 114, 115 above left and below, 116 below, 117 above: Nils Hasenau)

118 **St. Oak**
Photos supplied by the hotel (Laura Muthesius and Nora Eisermann)

126 **Stimbekhof**
Photos supplied by the hotel

134 **Resort Baumgeflüster**
Photos supplied by the hotel (Mittmann)

140 **Bauhaus Dessau Atelierhaus**
Photos supplied by the hotel

148 **Hotel Villa Sorgenfrei**
Photos supplied by the hotel (Anke Wolten-Thom)

158 **Burgkeller Meißen**
Jan Kobel/TASCHEN

170 **Schloss Prossen**
Photos supplied by the hotel (pp. 170-171, 172, 175 below, 176 above, 177 below: Till Schuster; pp. 175 above, 176 below, 177 above, 178-179: Torsten Wiesner)

180 **Hotel Stadthaus Arnstadt**
Photos supplied by the hotel (Jan Kobel)

190 **Waldhaus Ohlenbach**
Photos supplied by the hotel

198 **Purs**
Photos supplied by the hotel

204 **WeinKulturgut Longen-Schlöder**
Photos supplied by the hotel (Christopher Arnoldi)

210 **Gut Cantzheim**
Endpapers, pp. 210-217: photos supplied by the hotel

218 **Le Rossignol**
Photos supplied by the hotel (Christine Bauer)

226 **Spielweg**
Photos supplied by the hotel

234 **Hotel Schiefes Haus Ulm**
Jan Kobel/TASCHEN

242 **Zum Egle 1336**
Photos supplied by the hotel

250 **Alpenloge**
Photos supplied by the hotel

258 **Ansitz Hohenegg**
Photos supplied by the hotel

266 **Schloss Elmau**
Photos supplied by the hotel

274 **Kloster Beuerberg**
Photos supplied by the hotel (pp. 274-275, 276, 279, 280 below, 281 above left, 281 below, 283: Thomas Dashuber; pp. 280 above, 281 above right, 282: Nava Rapacchietta)

284 **Berghotel Altes Wallberghaus**
Photos supplied by the hotel (p. 359: Stefan Bogner/Wallberghaus)

294 **Tannerhof**
Photos supplied by the hotel

302 **Gasthof Alpenrose**
Jan Kobel/TASCHEN

310 **Stubn in der Frasdorfer Hütte**
Photos supplied by the hotel

316 **Gut Sonnenhausen**
Photos supplied by the hotel (pp. 316-317: Ekkehard Winkler; pp. 318, 321 above: Vivi D'Angelo; p. 321 below: Anneliese Kompatscher)

322 **Gasthof Zantl**
Photos supplied by the hotel

328 **Hofgut Hafnerleiten**
Photos supplied by the hotel (G. Standl and M. Ortner/Hofgut Hafnerleiten)

336 **Engelwirt Apartments**
Photos supplied by the hotel (Erich Spahn)

344 **Gasthof Gentner**
Photos supplied by the hotel

350 **Romantik Hotel Markusturm**
pp. 2-3, 350-357: Jan Kobel/TASCHEN

IMPRINT

EDITING, ART DIRECTION AND LAYOUT
Angelika Taschen, Berlin
With special thanks to Judith Rüber
and Jan Kobel, Arnstadt

PROJECT MANAGER
Stephanie Paas, Cologne

DESIGN
Maximiliane Hüls, Cologne

TEXTS
Christiane Reiter, Brussels

ENGLISH TRANSLATION
John Sykes, Cologne

FRENCH TRANSLATION
Alice Pétillot, Paris

EACH AND EVERY TASCHEN BOOK PLANTS A SEED!
TASCHEN is a carbon-neutral publisher. Each year, we offset our annual carbon emissions with carbon credits at the Instituto Terra, a reforestation program in Minas Gerais, Brazil, founded by Lélia and Sebastião Salgado. To find out more about this ecological partnership, please check: www.taschen.com/zerocarbon
Inspiration: unlimited. Carbon footprint: zero.

Want to see more? Visit *taschen.com* to view our current publications, browse our latest magazine, and subscribe to our newsletter.

The published information, addresses and pictures have been researched with the utmost care. However, no responsibility or liability can be taken for the correctness of details.

© 2025 TASCHEN GmbH
Hohenzollernring 53, D-50672 Köln
www.taschen.com

© VG Bild-Kunst, Bonn 2025
for the works of Walter Gropius

Printed in Slovakia
ISBN 978-3-7544-0067-8

FRONT COVER
Gut Sonnenhausen, Glonn
Photo: Vivi D'Angelo

BACK COVER
St. Oak, Kyritz
Photo: Laura Muthesius and Nora Eisermann